LIVING COLOR

OTHER BOOKS BY SARAH ROSSBACH:

Feng Shui: The Chinese Art of Placement

Interior Design with Feng Shui
(with Lin Yun)

LIVING COLOR

Master Lin Yun's Guide to Feng Shui and the Art of Color

SARAH ROSSBACH AND LIN YUN

KODANSHA INTERNATIONAL

New York • Tokyo • London

Kodansha America, Inc.
114 Fifth Avenue, New York, New York 10011, U.S.A.

Kodansha International Ltd.
17-14 Otowa 1-chome, Bunkyo-ku, Tokyo 112, Japan

Published in 1994 by Kodansha America, Inc.

95 96 97 7 6 5 4

PRINTED IN THE UNITED STATES OF AMERICA

Jacket and book design by Nina Ovryn
Calligraphy by Lin Yun
Drawings by Edward T. Emerson

Photo Credits:
Front cover
Yellow tassels: Maria Taglienti / The Image Bank. Tulips: Den Reader / The Image Bank.
Pool by William John Wallis, ASLA: Ken Druse / The Natural Garden.
Staircase: Al Satterwhite / The Image Bank.

Color insert
p. 2: Michael Melford / The Image Bank. p. 3: Lisl Dennis / The Image Bank.
pp. 4-5: Michael Luppino. pp. 6-8: Steven Mark Needham.

Library of Congress Cataloging-in-Publication Data
Rossbach, Sarah.
 Living Color : Master Lin Yun's guide to Feng shui and the art of
color / Sarah Rossbach and Lin Yun.
 p. cm.
 Includes bibliographical references.
 ISBN 1-56836-014-2
 1. Feng-shui. 2. Colors. I. Lin, Yün, 1932– . II. Title.
BF1779.F4R69 1994
 133.3'33—dc20 94-10152

Printed and bound by R.R. Donnelley, Crawfordsville, Indiana

The text of this book was set in Weiss Roman, Italic, Bold, and Extrabold,
with additional faces in Futura, ITC Fenice, Lithos, and ITC Zapf Dingbats

Dedicated to the most colorful people I know:
Ellie, Douglas, Bebo, Cho-cho, and, of course, Lin Yun

—S.R.

Dedicated to people in need, as well as to those
I want to thank: Sarah Rossbach and the disciples,
students, and friends of the Yun Lin Temple

—L.Y.

CONTENTS

Preface by Sarah Rossbach. *page 3*

Introduction by Lin Yun. *page 9*

Chapter One:

FENG SHUI AND THE ART OF COLOR
page 13

CH'I AND COLOR...*14* BALANCE, HARMONY, AND LIFE...*15* COLOR IN CHINA...*15*
COLOR TODAY...*15* LIN YUN'S COLOR THEORY...*16*

Chapter Two:

THE PHILOSOPHICAL ROOTS OF LIN YUN'S COLOR THEORY
page 19

TAO...*19* YIN AND YANG...*21* CH'I...*22* THE FIVE ELEMENTS...*23* THE *I CHING*...*25*
BUDDHISM: COLOR IS EMPTINESS, EMPTINESS IS COLOR...*26* THE SIX TRUE COLORS:
WHITE, RED, YELLOW, GREEN, BLUE, BLACK...*28* LIN YUN'S THREE BASIC
COLOR CONCEPTS...*28* Five Element Color Theory...*28* Five Element Ba-gua...*29*
THE SEVEN-COLOR SPECTRUM...*30* THE CURES *SYING* AND *YI*...*30* The Six True
Colors...*30* Static Cures...*31* Cyclical Cures...*31*

Chapter Three:

COLOR IN CHINA: HISTORICAL AND CULTURAL ROOTS OF LIN YUN'S COLOR THEORY
page 33

HEAVEN, EARTH, AND MAN...33 COLOR IN CHINESE ART...37 MYSTICAL COLOR CURES...39 Red Envelopes...41 MEDITATION...41 SUN - MOON DHARMA WHEEL...43 GREAT SUNSHINE BUDDHA MEDITATION...43 OM-AH-HUM PURIFICATION PRACTICE...43 GREEN TARA MEDITATION...44 RAINBOW BODY MEDITATION...44 CHINESE COLOR ASSOCIATIONS...45 Red...45 Purple...46 Yellow...46 Green...46 Blue...46 Blue-Green...46 Black...47 Gray...47 Brown...47 Tan...47 Orange...47 Pink...47 Peach...48

Chapter Four:

FENG SHUI OUTDOORS: THE LANDSCAPE OF COLOR IN COUNTRY AND CITY
page 49

THE HISTORY OF COLOR IN THE LANDSCAPE...50 THE REGENERATIVE POWER OF NATURE'S COLORS...51 URBAN COLORS...52 Roads...54 Bridges...55 Schools and Businesses...55 EXTERIORS: BUSINESS-BY-BUSINESS COLORS...56 Agent's Office...56 Art Gallery...56 Artist's Studio...56 Bakery...56 Beauty Salon...56 Car Wash...56 Card and Stationery Shop...56 Computer or Software Company...56 Construction Firm...57 Executive Offices in Creative Fields...57 Film, Recording, or Television Studios...57 Funeral Parlor...57 Grocery Store...57 Library...57 Lighting Store...57 Music Shop...57 Pharmacy...57 Psychic...59 Psychologist's Office...59 Real Estate Office...59 Supermarket...59 Toy Store...59 Video Store...59 Wine Store...59 COLORS IN LANDSCAPING...59 ENHANCING THE LANDSCAPE WITH COLOR...61 Five-Element Ba-gua Color Scheme...61 Land Plots...62 Plot and House Shapes...63 Pools...64 Fountains...65 Exterior Lighting...65 Driveways...65 Fences...66 EXTERIOR HOUSE COLORS...66 Using the Five-Element Color Cycles...67 DECORATIVE EXTERIOR ELEMENTS...69 Window Boxes...69 Window Glass Color...70 Porches...70 HEAVEN, MAN, AND EARTH COLOR

CONTENTS

Chapter Five:

FENG SHUI INDOORS:
CHINESE COLOR THEORY CAN IMPROVE YOUR CH'I AND YOUR LUCK
page 75

THE BA-GUA FIVE-ELEMENT COLOR OCTAGON...77 THE HOME: ROOM-BY-ROOM COLORS...77 Foyer...77 Kitchen...78 Bedroom...79 Living Room...80 Meditation Room...80 Library...80 Dining Room...80 Bathroom...80 INTERIORS: BUSINESS-BY-BUSINESS COLORS...81 Accounting Firm...83 Agent's Office...83 Appliance Store and Supermarket...83 Architect's or Designer's Office...83 Art Gallery...83 Artist's Studio...83 Bakery...84 Bank...84 Beauty Salon...84 Bookstore...84 Car Wash...84 Card and Stationery Shop...84 Clothing Store...84 Computer Company...84 Computer Store...85 Construction Firm...85 Doctor's Office...85 Executive Offices in Creative Fields...85 Film, Recording, or Television. Studio...85 Funeral Parlor...85 Furniture Store...85 Grocery Store...85 Import-Export Office...85 Jewelry Store...85 Lawyer's Office...86 Library...86 Lighting Store...86 Music Shop...86 Parking Lot...86 Pharmacy...86 Police Station...86 Psychic...86 Psychologist's Office...87 Publishing House...87 Real Estate Office...87 Restaurant...87 Shoe Store...88 Software Company...88 Supermarket...88 Toy Store...88 Video Store...88 Wine Store...88 Writer's Study...88 THE FIVE-ELEMENT COLOR SCHEME IN BUSINESS INTERIORS...88 EDUCATION: SCHOOLS...89 ROOM AND HOUSE SHAPES...89 THE FIVE-ELEMENT COLOR SCHEME...90 The Creative Cycle...91 The Destructive Cycle...92 FURNITURE AND WINDOW TREATMENTS...92 MYSTICAL CURES TO RESTORE AND ENHANCE GOOD LUCK WITHIN THE HOME...93

Chapter Six:

CLOTHING: USING COLOR TO INFLUENCE THE OUTSIDE WORLD
page 97

THE COLOR OF CLOTHES IN CHINESE HISTORY...98 COLOR IN THE CHINESE THEATER...99 CLOTHES TODAY: DRESSING FOR SUCCESS...100 CLOTHING COLORS BY OCCUPATION...100 Architect...100 Banker...100 Businessperson...101 College

Professor...102 Health Care Worker...102 Interior Decorator...102 Lawyer...102 Meditation Teacher...102 Real Estate Agent...102 School Teacher...103 Stock Market Trader...103 Therapist or Psychologist...103 Visual Artist or Graphic Designer...103 Writer or Editor...103 CLOTHING COLOR AND PERSONAL GOALS...103 COLOR, CH'I, AND OUR CLOSET...105 IMPROVING WARDROBE COLORS...106 THE FIVE-ELEMENT COLOR SCHEME...107 The Creative Cycle...107 The Destructive Cycle...108 STATIC COLOR SCHEMES...110

Chapter Seven:

FOOD AND HEALTH
page 111

BALANCING HEALTH WITH THE FIVE-ELEMENT DIET...113

Chapter Eight:

TRANSPORTATION: GOING PLACES WITH COLOR
page 115

CARS...117 THE FIVE-ELEMENT COLOR SCHEME...117 The Creative Cycle...117 The Destructive Cycle...117 USING THE CHINESE ZODIAC TO SELECT CAR COLORS...118

Chapter Nine:

CH'I: USING COLOR TO INFLUENCE THE INNER WORLD
page 121

USING COLOR TO BALANCE PERSONALITY: CH'I AND THE FIVE ELEMENTS...123 Wood...125 Fire...125 Earth...125 Metal...127 Water...127 THE FIVE-ELEMENT COLOR CURES...128 PSYCHOLOGICAL AILMENTS...131 Improving Minor Character Flaws...132 Enhancing Personal Assets...132 COLOR AND RELATIONSHIPS...133 COLOR AND AGE...133 Children...133 DIAGNOSING AND FORTUNE-TELLING THROUGH PHYSICAL AILMENTS...134 Physical Ailments...134 Face-Reading...134 HEALING PHYSICAL AILMENTS WITH COLOR...135 MYSTICAL COLOR CURES TO STRENGTHEN CH'I...136

CONTENTS

Chapter Ten:
MYSTICAL CURES AND HEALING PRACTICES
page 137

COLORED LINE RUNNING FROM HEAVEN TO EARTH...138 SEALING THE DOOR...139 TOUCHING THE SIX POINTS...139 CANCER TREATMENT...140 HOUSEWARMING...140 PRENATAL CARE...140 RED CURES...141 Cure Against Nightmare...141 Red Egg Rebirth...141 Four Red Strings Cure...142 Four Red Ribbons Marriage Cure...142 Acquiring Auspicious or Marriage Ch'i...142 Red Cloth Travel Cure...143 WHITE CURES...143 Heart Disease Treatment...143 Cure for Litigation...144 Cure for Backache...144 String of Pearls Cure for Determining the Gender of Your Child...144 GREEN CURES...144 Conception Ritual...144 Operation Cure...145 Yu Nei – Interior Blessing...145

Chapter Eleven:
VISUALIZED COLOR: MEDITATIONS
page 147

THREE SECRETS REINFORCEMENT...148 VISUALIZING THE SUN-MOON DHARMA WHEEL...149 LYIO DWAN JIN: SIX-SECTOR MEDITATION...150 THE CONSTANTLY TURNING DHARMA WHEEL...151 THE HEART SUTRA MEDITATION...152 GREEN TARA MEDITATION...153 VISUALIZING RED SUNLIGHT...155 VISUALIZING THE GREAT SUNSHINE BUDDHA...156 OM-AH-HUM PURIFICATION PRACTICE...158 VISUALIZING THE RAINBOW BODY...159 CRYSTAL RAINBOW BODY DISAPPEARING MEDITATION...161

APPENDIX. *page 165*
THE CHINESE ZODIAC...165 BTB PALMISTRY...169 Five-Element Ba-gua Palmistry...170

BIBLIOGRAPHY. *page 173*

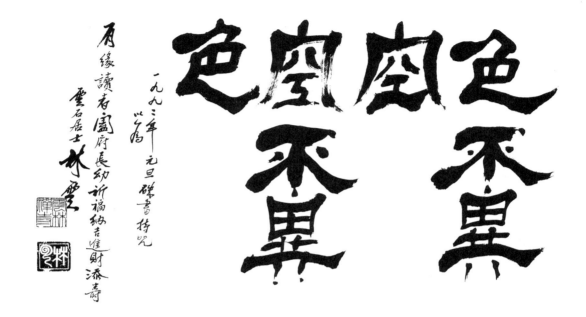

Color is emptiness, emptiness is color.
—HEART SUTRA

LIVING COLOR

Preface

Writing this book has been a difficult sort of treasure hunt, with Lin Yun leaving behind a trail of well-placed but enigmatic clues. I have been the hunter, examining, researching, and piecing together the clues that seemed to zig and zag over a vast terrain of Chinese philosophy, religion, art, medicine, design, and culture. Lin Yun's color theory, like many things Chinese, spans a broad area of disciplines ranging from specific to more cosmic dimensions, uniting the practical with the philosophical and even the mystical. Lin Yun's theories pertain to everything from simple color cures, such as what color to wear when job hunting or which car colors help us avoid accidents, to esoteric ideas on color, linking color to both the tangible and intangible elements of the universe.

In 1977, I was living, studying, and working in Hong Kong. I began Chinese lessons with a Yale-in-China professor named Lin Yun, who, it turned out, taught me more than just the basics of Mandarin. During our classes, Lin Yun instructed

me in Chinese philosophy, mystical knowledge, and folk practices, such as *feng shui*, the Chinese art of placement. Since then, Lin Yun and I have worked together on projects and books chronicling Chinese feng shui: *Feng Shui: The Chinese Art of Placement* and *Interior Design with Feng Shui*. In *Living Color*, Professor Lin unveils his theory on how color affects us and explores its philosophical and visual role in our lives. Here, I am at once scribe, struggling interpreter, and researcher.

The subject of color arose several years ago while strolling up Avenue of the Americas in New York with Lin Yun and a bevy of his admirers—all beautiful Chinese women. They were querying him on what colors would elevate their ch'i, or personal energy. Each seemed to need a different color. Professor Lin advised me to wear red or purple. I asked him to explain, but he was off to the airport. While I did not rush out and change my wardrobe, his suggestion stuck in my mind, especially when I happened to wear red or purple. When we started this book, I reminded Lin Yun of his advice. He explained there is an old Chinese saying, "It is so red, it is purple," meaning that something is so "hot" it cannot be hotter. By wearing those colors I would become a walking symbol of the best in fortune, fame, and luck. Not bad.

This book was conceived out of my own curiosity about color and Professor Lin's knowledge and wisdom. When Lin Yun and I first discussed a book on his theory of color, I must confess I thought this would be a simple, straightforward explanation of how all of us respond to colors—colors in our surroundings, clothes, and food.

To prepare myself for this project, I read a cross section of books on color, ranging from the *Color Me Beautiful* books and Faber Birren's studies to Goethe's theories and modern scientific texts. However, I soon found that while the fascination with color and how it affects us is an age-old, worldwide preoccupation, I had to leave these other works behind. The best way to tackle Professor Lin Yun's theory on color was from an angle of its uniqueness, on its own terms. This requires understanding how his color theory evolved from Asian roots—the philosophy, the cultural customs, the art and folklore, the religion and the early medicine, science, and superstition. I had not bargained for the wealth of philosophical, religious, and mystical information he spouted as we began our interviews in earnest.

Over six months, I tried to track down an increasingly elusive Lin Yun, who when I caught up with him would drop philosophically enigmatic bombs, such as

"Color is emptiness, emptiness is color," sending me reeling, first to the library to research and digest, and then to the typewriter to try to explain that, in fact, it all made perfect sense.

The primary research for this book began in Berkeley, California, at the Yun Lin Temple, which Lin Yun set up as the first American temple of Black Sect Tantric Buddhism, also referred to as BTB. Lin Yun is the spiritual leader of the Black Sect and today teaches its philosophy and Chinese culture around the world.

The dialogue continued back in New York, where Lin Yun would drop in for a couple of lectures at the United Nations or at the New York chapter of the American Institute of Architects or on his way to a symposium at Harvard University. In New York I would take Lin Yun and a few of his students to lunch and interview him in Chinese, hoping his voice would rise clearly over the din of clattering plates, noisy eaters, and Muzak, so that my tape recorder could do its job. During those interviews, Lin Yun often spoke of color concepts already familiar to anyone steeped in feng shui. At other times, he raised theories, concepts, and practices that were new to my ears and often very esoteric. While the basic premises of *Living Color* may not be new to students of ch'i or followers of Lin Yun, his practical application and philosophical conclusions seem to break new ground in the old territory of Chinese mystical practice and thought.

Lin Yun's philosophy on color and its effect on life is highly subjective. Those people with scientific and medical backgrounds may totally disagree with his notions. Others with artistic inclinations may blanch at his color schemes, which

The character for "color" cradles the paradoxical Buddhist phrase, "Color is emptiness, emptiness is color. Color is not emptiness, emptiness is not color."

■ ■ ■

may not always seem aesthetically pleasing. But this is not a scientific or aesthetic study of color. This book represents Lin Yun's vision of one important aspect in the complex interplay between humans and the universe. The merits of his theories lie in his using colors to explain the interrelated philosophical, emotional, and physical responses to color—in short, the relationship between color and life. Some of Lin Yun's ideas may work for you, while others may not. It is up to the reader to pick and choose what is of use.

Personally, I had some qualms about some of the applied color systems. To the average Western eye, such as this author's, some theories and color schemes in a strict sense defy taste. For example, an outfit based on the five-element color cycles may have white shoes, a black skirt, and a green or blue blouse as a particularly auspicious color scheme. I'd feel uncomfortable in such an outfit—I'd as soon mix plaids with florals. However, I don't feel I need to take this as gospel. Instead, I use it as a source of knowledge about color sequences that might enhance our well-being or improve our energy levels. These colors may be used as accents to enliven bland wardrobes and thus activate our ch'i. The use of the cycle aids the wearer in visualizing the dynamic development of energy—aligning his or her energy with a creative cycle that raises ch'i.

While some of Lin Yun's theories derive from Buddhist tradition, this is not a religious book. One need not be a Buddhist to grasp and use *Living Color*. I have tried to represent truly and completely Lin Yun's theories and practices, as well as to fill in the philosophy and history that may explicate his teachings. I have not edited out information that might be difficult to accept or prove. As with my other books, the value of the book depends on the intelligence, judgment, intuition, and insight the readers bring to the book. I see the use of color in one's life as a way to achieve a desired end and not necessarily as an absolute cure. After all, black or green might help you to do better on a test, but if you haven't studied, nothing will help. Or if you are suffering from an illness, merely using color may not be a remedy, but applying color while following your doctor's advice may reinforce the medical treatment.

During my research, I discovered that if you go to China, you will not find a color specialist. Yet color plays a major role in many aspects of Chinese culture and is part of this strongly symbolic tradition. Information in *Living Color* is a marriage of traditional Chinese color values and philosophy and a modern reinterpretation and

embellishment by Professor Lin Yun. This marriage of old and new, East and West, is in complete harmony with the eclectic nature of Lin Yun's philosophy and religion: Black Sect Tantric Buddhism. The Black Sect Tantric Buddhism (BTB) is an outgrowth of various religious disciplines. A dynamic combination of tradition and continually evolving practice, it originated from the indigenous Bon religion of Tibet and was influenced by Tantric Buddhism from India. In each place, it absorbed local teachings. From Tibet, it brought the mystical chants and charms of Bon. From India, it incorporated an organized church replete with yoga, chants, compassion, nirvana, karma, and the sacred discipline of transmitting teachings from master to pupil. In China, it adopted the *I Ching*, and Taoist and folk religions and customs such as feng shui, palmistry, and faith healing.

And now in the West, Black Sect Tantric Buddhism brings ancient wisdom to bear on modern concerns. It has absorbed Western customs, inventions, and know-how, while embracing the age-old tenets of balance, ch'i, and spirituality, and drawing from Chinese medicine, poetry, and early science. *Living Color* is one result of this dynamically evolving teaching. It takes ancient philosophy and applies it through color to our daily life: our environment, our clothing, our health and nourishment, our personalities, and our own spiritual development.

Considered by some as a holy man, Lin Yun began his training when he was six years old. Born in Peking in 1932, he used to play with friends on the grounds of a Tibetan Buddhist temple near his family's home. The temple housed several lamas trained in the mystical Black Sect Tantric Buddhism. One day, a monk approached the boys and offered them lessons in religion. Though his friends ran away, Lin Yun ventured closer to hear what the monk had to say. For the next nine years, Lin Yun was instructed by Lama Da De on the scriptures and rituals of the sect. These included Tibetan Tantric mystical arts and traditional Chinese texts and practices, such as the *I Ching* and feng shui. Since then, he continued his studies with another Black Sect guru, as well as other Buddhist masters and Chinese philosophers. He also studied law, calligraphy, and urban planning and now lectures extensively on Chinese philosophy and traditions, which include feng shui, ch'i development, and meditation.

The Chinese have an old saying, "Green derives from blue, and surpasses it." This colorful statement refers to a student who gains wisdom and knowledge from a teacher and then takes the learning several steps further and excels beyond the

teacher. A neat saying, but no student I know of has outshone Professor Lin Yun in knowledge, wisdom, theory, or practice. Furthermore, this book represents more than the efforts of just two people. Many others have contributed to its creation. Some of Lin Yun's more senior students provided specifics on meditation, while others helped in gathering illustrations or in fielding my continual questions. I wish to thank the following people for their time, personal stories, and patience: Crystal Chu, Lynn Ho Tu, Ken Yeh, Wilson and Tsu-wei Chang, Professor Chin-chuan Lee, Professor and Mrs. Leo Chen, Christine Chen, Francis Li, Shena Huang, Professor Catherine Yi-yu Woo, Lyping Wu, Patricia Shiah, Patty Cheng, Alice Yang, Mimi Tsai, Lily Wang, Kodansha editors Barbara Einzig and Paul De Angelis, Kodansha staff members Gordon Wise and Lauren Brey, designer Nina Ovryn, photographers Steven Mark Needham and Judy Angelo Cowen, my agent, Caroline Press, and, finally, Trip Emerson, the very patient illustrator. My sincere appreciation also goes to Dolores MacKinnon and Victoria Ward for their typing assistance, and to Linda Pignataro for helping me during all stages of this manuscript. My gratitude is also extended to our granny-nannies, Connie and Ellie, for helping with two infants who arrived during this project, thus prolonging it, and to my husband, Douglas, who must be almost as happy as I am that this book is finished. Above all, I would like to thank Lin Yun, who gave his time, knowledge, and wisdom to make this book possible.

—Sarah Rossbach

Introduction

序

M uch about our lives is uncertain. There is little we can claim surely to know about the world, nature, the cosmos. Ordinarily we attempt to reveal a tiny portion of the mystery of our lives by applying certain *ru-shr* ("logical") principles, secure within the boundaries of our present knowledge and experience. This effort, while indispensable, is wholly inadequate. Black Sect Tantric Buddhism—presently at its fourth stage of development—seeks to provide what we call a *chu-shr* ("transcendental") approach in order to take us beyond the narrow confines of conventional wisdom.

"Color is no different than emptiness; emptiness is no different than color. Color is emptiness; emptiness is color." The realm of the logical is to that of the transcendental as color is to emptiness in Buddhist philosophy. Since "color" refers to concrete and visible elements of life, it is often accepted as having "substance" and as being an integral part of established knowledge. On the other hand, the realm of transcendental knowledge, that of "emptiness," defies our fixed cognitive

categories or conceptual patterns. Since this body of knowledge is yet to be discovered or systematized, trained incapacity may provoke among some intellectuals a reckless urge to dismiss it as irrelevant, groundless, or superstitious. As a matter of fact, many of the transcendental practices—with their epistemological roots in folk wisdom, philosophy, and religion—have outlasted the history of modern science and continue to exert amazingly powerful results on many people in their lives and work. Transcendental knowledge can be provisionally characterized as non-scientific, but not as unscientific. Not only is it hospitable to scientific discoveries; it may even inspire creative hypotheses for further inquiries. Even so, transcendental knowledge nonetheless provides a dimension of insight into the human life-world that cannot be neatly subsumed or replaced by the advanced science and technology of today.

To return to Buddhist philosophy: color *is* emptiness, and emptiness *is* color; they are fundamentally indistinguishable from each other. The key to understanding my approach hinges on an accurate interpretation of the relationship between "color" and "emptiness." If visible "color" stands for "somethingness," then invisible "emptiness" does not necessarily translate itself into "nothingness." Rather, emptiness paradoxically embraces both "somethingness" and "nothingness." For example, the Chinese refer to air as "empty ch'i." While an "empty" bag of air may mean "nothing" to laypeople because it is neither visible nor tangible, scientists may turn this very "nothing" into "something" by analyzing its complex physical composition. Therefore, "somethingness" and "nothingness" constitute different sides of "emptiness." "Somethingness" for some may be "nothingness" for others. Both elements may converge or depart, contingent on various conditions. This leads to my interpretation of *Tao*, or the way: Tao consists of *yin* and *yang*, which form a unified whole to operate ceaselessly according to the law of nature. This concept of Tao applies to the oscillating status of a person's fortunes, as well as to the ups and downs of a nation's history. Similarly informed, I shall try to develop in this book my theory of color not only from the perspective of unknown "color" but also from that of transcendental "emptiness."

Why do I choose to focus on color? As a Buddhist scripture suggests, we come to grips with the meaning of our life-world through six primary media: the eyes, the ears, the nose, the tongue, the body, and the idea. The former five elements, analogues of what we know as the five senses, govern the realm of

R *u-shr* encompasses the logical, rational, and mundane— that which is within the scope of our experience and knowledge.

■ ■ ■

matter, while the sixth element falls into the realm of the *mind*. We may have grown too accustomed to it to appreciate fully the extent to which these five senses define our reality in everyday language. Thus, we *smell* an air of joy or sorrow, *hear* about someone's dubious reputation, and *taste* bittersweet success. I have decided to explore the relationship between color and our life-world primarily because color is perceived through the organ of the eye, which is the first of the five sensory organs. My investigations of the relationships between the other senses and the human life-world will be reserved for the future. It is important to emphasize that my approach, based on Black Sect Tantric Buddhism, accords utmost importance to the role of the *idea*, which harmonizes the mind with the physical matter of our life-world.

How does color influence our life-world? First, color defines for us what exists and what does not exist. Second, color discloses the status of one's health and fortunes; thus, traditional Chinese doctors are versed in reading the color of one's face or one's ch'i (vital energy). For this reason, color has formed a core element in such branches of centuries-old transcendental learning as face reading, palmistry, and fortune-telling. Third, color inspires emotion. For example, green conveys vitality; red symbolizes justice, as loyal officials invariably wear red masks in Peking operas; white represents pureness, destruction, demise, and death; and black connotes a sense of awe, grandeur, and depth. We feel upbeat and satisfied if the status of our ch'i matches the color of our clothes; when in low spirits, therefore, we shun red apparel. Fourth, color also structures our behavior. No color is universally or uniformly favored; different colors suit diverse contexts and professions. We wear one set of colors for attending church ceremonies, and quite another for going to a picnic. Lawyers, merchants, and actresses may likewise prefer unique colors to facilitate their roles and work situations.

This book aims to illuminate how color affects various domains of our life-world: food, clothing, the living place, transportation, education, and recreation. It will also provide guidance to people of different professions regarding their selection of particular colors to enhance their life-world. It is hoped that a more refined attunement to environmental ch'i through the wise arrangement of color will help our readers to increase their happiness, enhance their wealth, and foster their marital harmony. The effects are particularly cumulative if we combine, integrate, and coordinate the mutually enriching and destructing relationships of five

C*hu-shr* encompasses the illogical, irrational, and mystical— that which is outside our realm of experience.

∎∎∎

colors (white, green, black, red, yellow) with the traditional Chinese theory of the five elements (metal, wood, water, fire, earth) and the theory of the five positions (east, west, south, north, center). The skilled application of these insights is useful in all cultures for the maintenance of internal harmony within individuals and external harmony between them and nature.

This book is the sequel to two previously published volumes, *Feng Shui: The Chinese Art of Placement* (New York: E. P. Dutton, 1983) and *Interior Design with Feng Shui* (New York: E. P. Dutton, 1987), both by Sarah Rossbach. In the past decade she has enunciated my theory to English-speaking readers with unusual lucidity. I am both grateful for her unfailing efforts and heartened by the critical acclaim she has received, as demonstrated by the translation of these two books into several languages. As in the past, my exposition of my own ideas in this volume seeks to incorporate elements of Buddhist teaching, Tibetan Bon, Chinese Taoism, Confucianism, *I Ching*, yin-yang theory, and traditional Chinese folk wisdom. My interpretations, drawing on the confluence of mundane and transcendental knowledge, welcome scientific scrutiny and confirmation. It is the belief of Black Sect Tantric Buddhism that most people can only afford to cultivate and perfect their ch'i, virtue, and morality here and now in this mundane world, rather than taking refuge in the luxurious tranquility of a remote temple. With this in mind, I now present with much pleasure my theory of color, in hopes of enhancing your ch'i and harmony.

—Lin Yun

Chapter One:
FENG SHUI AND THE ART OF COLOR

■

"A BRIEF INTRODUCTION
TO THIS BOOK."

■

n New York, a Chinese import-export firm installed a blue-green carpet to ensure steady business growth. In Washington, an entrepreneur painted each room of his office a different shade of red in hopes of encouraging good fortune and prosperity. (The new abundance of red also evoked violence—an unlikely bar brawl ensued—so he countered the passion-inducing hue with cool green plants and has stayed out of trouble ever since.) A New Jersey couple applied a red stripe to their new charcoal-gray Volvo to create compatibility and safety while driving.

These are only a few examples of the uses of color Chinese-style. As an outgrowth and complementary discipline to feng shui, the art of placement, Chinese color theory offers a way to enhance nearly every aspect of our lives—improving our moods and stimulating our minds, increasing our effectiveness at work and in society, and creating better physical and mental health. Color has been a component of many Chinese practices and beliefs: medicine, art and poetry, food

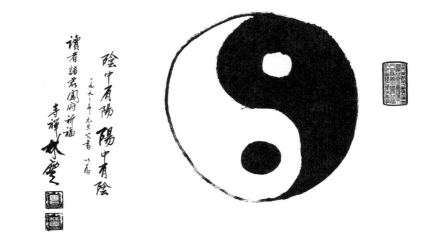

preparation, and feng shui. In fact, color is one of the nine basic cures of feng shui. It is also a secondary aspect in the eight other cures. In feng shui, color can enhance a land plot, a house, a room, and even businesses and schools.

• Ch'i and Color •

As with feng shui, Lin Yun's color theory is rooted in the ancient Chinese belief that our lives and destinies are interwoven with the workings of nature and the universe. All permutations, from cosmic to atomic, resound in us. The force that links us with color is ch'i (translated as human spirit, energy, or cosmic breath). There are different kinds of ch'i: a kind that circulates in the earth, a kind that permeates the atmosphere, a kind that animates our bodies. Each of us possesses ch'i, but its characteristics and ways of moving us vary. Ch'i is the nonbiological self—our spirit, our psyche, our essence. Without ch'i, we are merely flesh and bones. Our cells may continually regenerate, yet our self is basically the same—that constant self is ch'i.

Ch'i is the breath essential to maintaining physical, environmental, and emotional balance. And an ever-present factor that can stimulate or depress our ch'i is color. Color also can harmonize and balance our ch'i and thus improve our life and destiny. We each have a destiny that can be altered, not just by our own rational efforts or karma, but by mystical means that seem to defy logic. The color "cures" introduced in this book tell us how to improve our destiny for the better. The reader can pick and choose from an array of color cures that range from the mundane to the mystical.

• Balance, Harmony, and Life •

To the Chinese, harmony and balance are desirable in our physical and emotional makeup and in our environment. They pervade the process linking man and the universe: Tao. Out of the balancing and harmonizing of yin and yang arises ch'i—the most essential feature of life. Human ch'i, which determines our movements as well as our physical and personal traits, is greatly affected by color.

• Color in China •

From ancient times in highly ritualistic China, color played a significant role in religious and political ceremonies and practices. Court and ritual clothing was codified according to color, so rank could be distinguished by the hue of an official's attire. The official imperial color was yellow. Confucius, always aware of decorum, was said to eschew red and purple for ordinary dress occasions.

From the second millennium B.C., the Chinese used color to indicate cardinal directions, seasons, the cyclical passage of time, and the internal organs of the human body. They analyzed their surroundings and prospects of survival by examining the varying hues of nature: earth, sky, sun, moon rings, leaves, and rocks. Color is regarded as a manifestation of cosmic energy—ch'i—that can also shape an individual's personal energy and, therefore, their destiny. Adding a new color to an environment can stimulate a positive or negative response. So Chinese color theory and practice can open a spectrum of new possibilities in our lives and counterbalance existing problems.

Throughout the world, colors describe emotional properties. We feel blue, are green with envy, or describe someone as "a yellow-bellied coward." To the Chinese, the properties of color are both emotional and physical. The term for funeral is "white event," while the literal translation of "honorable official" is " blue sky." Yellow has always been so closely associated with the imperial household that the entrance to the palace is known as the "yellow door."

• Color Today •

One should not underestimate the power of color associations for today's Chinese, as one Irish beer producer discovered when it sought to increase

consumption of its ale in Hong Kong. Sales were said to drop off significantly after the airing of a television advertisement that featured the tossing of a green hat. It was finally pulled after the company was informed that "wearing a green hat" was a Chinese euphemism for being cuckolded.

Fortunately for Mao, red, the color associated with communism, is also the most auspicious Chinese color, resulting, perhaps, in the popularity of the little red book and the all-pervasive power of the Red Guards.

Today in the United States, red, green, and gold are highly visible colors in Chinatowns. Sometimes, however, East and West do not harmoniously meet. One Chinese-born ophthalmologist living in California asked Lin Yun what color to paint the exterior of her office. He replied purple, because of the Chinese saying that something is so red it is purple, meaning it is so hot it will stand out, bringing luck and fame. Indeed, the building stood out and hot it got under the collars of Western neighbors. They objected so strongly to the fuchsia facade that the incident was covered by the local news. The ophthalmologist became known not for aiding eyesight but for creating an eyesore. Nonetheless, she gained fame, or at least notoriety, and business was good. Humor aside, Lin Yun's approach to color offers a different way of approaching everything we see, a sensitivity to how profoundly we are affected by color in every aspect of the world around us.

• Lin Yun's Color Theory •

The direct impact of color on our existence is easy to understand. Some colors make us happy, other colors make us sink into gloom, and still others relax, distract, or energize us. If you understand the relationship between color and human ch'i you can enrich your life: you can use colors to improve the state of your ch'i. Six areas of our lives are affected by color: transportation, shelter, clothes, leisure activities, food, and personal cultivation—the latter category includes meditation, education, mystical rituals, and the use of color as a prenatal influence.

Color influences our ch'i from morning to night. As Lin Yun explains, "When we open our eyes in the morning, lying in bed, we see the color of the ceiling of our bedroom. When we leave home, we see the color of our entrances, then the color of our car. As we drive, we see the colors of other

commuters' cars. In the office or school, we see other co-workers' or class-mates' clothes, the work and study interiors. All of these have a defining color or hue, and when these colors come in contact with our eyes our ch'i is affected, creating a physical chain reaction." This chain reaction begins with our sight: "Within the human body, the brain has several functions. One area of the brain controls our physical behavior, another stimulates our emotions, another part controls our speech, while yet another helps our thought processes. Whatever we look upon and see through our eyes will, through our optic nerve, send sensory signals to each area of the brain, which, in turn, will send signals to our body to react to what our eyes see. So the colors of every-thing our eyes come in contact with will influence our temperament, physical movements, language and thoughts—in short, our lives."

This is one man's keen observation of the phenomenon of color, and his conclusions are drawn from many influences. His theory on life and color is fed by religion—Buddhism and Taoism; philosophy—*I Ching*, Taoism, yin-yang theory; culture—Chinese poetry and arts, ancient wisdom, folk customs, and modern customs from both East and West; and by his own personal observance of life, nature, and ch'i. Lin Yun's theory is a natural outgrowth of Black Sect Tantric Buddhism, which itself is an amalgamation of other cultures, beliefs, and practices. BTB offers philosophy, religious rituals, and practices based upon an odd but compelling mixture of mystical knowledge, common sense, observation of the environment, and intuition.

Living Color is a compendium of various techniques and systems of Professor Lin that are associated with color. While the practices may seem diverse and unrelated at first glance, the guiding philosophy supporting each practice is ultimately the same—"Color is emptiness, emptiness is color." This philosophy, plucked from a Buddhist sutra, equates being or the tangible aspects of life with nonbeing and the intangible. It harmonizes the present, visual, and sensual aspects of life with the unseen forces that may affect us—be they environmental, mystical, psychological, or visualized—and ultimately brings us into relation with the universe and beyond.

Lin Yun's theory is appropriately paradoxical. It is both Eastern and Western, old and new, this-worldly (how to use color to improve ourselves) and transcen-dental (how to use color in a metaphysical way to deepen and broaden knowledge and compassion, and to balance body and mind). These mundane and transcendental

The Buddha: The color theories of this book spring from the Black Sect Tantric Buddhism.

∎∎∎

aspects are united by a fundamental Taoist and Buddhist view linking existence with nonexistence, color with emptiness.

The basic concept behind this book—and Lin Yun's theories—is that color affects us—our moods, our impulses and behavior, our mental activity, and even our physical existence. By understanding this simple concept, we can positively alter our ch'i and our lives. Certain chapters will deal with our immediate response to colors: how the colors we wear, the colors we see in our physical surroundings, the colors of the food we eat, all influence our lives and our ch'i. Later chapters and the appendix will deal with the spiritual realm of color.

More specifically, chapters 2 and 3 provide the philosophical, cultural, and historical background of the color theories and practices. Chapter 2 presents brief explanations of the philosophical ideas and systems that underlie the color theory: tao, yin-yang, ch'i, the *I Ching*, Buddhism in China. Chapter 2 also explores the key concepts of Lin Yun's teaching: the Five-Element Color Theory, the Six True Colors, the Seven-Color Spectrum. Chapter 3 recounts the early use of color in Chinese architecture, divination, legends, painting, meditation, and mystical cures and also outlines the traditional Chinese color associations. The rest of the book is organized according to life applications, progressing from more practical needs—shelter, clothing, food, and health—to esoteric pursuits—ch'i cultivation, mystical cures, and meditation.

Lin Yun looks at color as both an entity in itself and a symbol of the visual world. As he says, color defines all things. Though the book's basic premise that we are affected by color is easy to grasp and use, an understanding of early Chinese precepts will usher the reader into a deeper, fuller understanding of *Living Color*.

Chapter Two:

THE PHILOSOPHICAL ROOTS
OF LIN YUN'S COLOR THEORY

The philosophy of color presented in this book is a reinterpretation for the modern world of ideas deriving from ancient Chinese cultural traditions. This chapter therefore provides some background in Chinese religion and philosophy, particularly in Buddhism and Taoism, introducing such basic concepts as Tao, yin and yang, ch'i, the five elements, the *I Ching* ba-gua, and fundamental precepts of Buddhism. Each basic concept will be followed by a brief outline of the various possible modes of applying it in all areas of our lives through Lin Yun's practical philosophy of color. A greater explanation of the applications and how they embody these basic philosophical ideas can be found in chapters 4 through 9 of this book.

• *Tao* •

The Taoist theory of yin and yang, which thrives on paradox, is helpful in understanding Lin Yun's ideas concerning both the effect of color upon

■
"PHILOSOPHY."
■

19

[1]William Theodore De Bary, ed., *Sources of Chinese Tradition* (New York and London: Columbia University Press, 1970), vol. 1, pp. 53–54.

he character "Tao" underlines the phrase: "One yin and one yang together create one entity that follows the laws of nature and continually changes."

■ ■ ■

us and, on a more profound level, the sameness of color and emptiness. Tao can be literally translated as "the way." The Chinese have a saying—"Everything in accordance with Tao." Tao is the natural way, the way of the universe. This concept grew out of ancient rural Chinese life and its techniques of identification with and dependency on nature. The idea was for humans to mirror the patterns and harmony of nature. In fact, the ancient Chinese saw life and destiny as part of the universal fabric of nature. Tao is seen both as the vastness of time and space and as a void, an uncarved block. As Lao-tzu, a sixth-century B.C. philosopher, wrote in the *Tao-te Ching*, "You look at it, but it is not to be seen; its name is formless…continuous, unceasing, and unnameable, it reverts to nothingness."[1] Tao is the source of all existence. Tao is the unity that resolves all contradictions and distinctions. Tao, ultimately, is a philosophy that helps humans transcend the mundane. Lin Yun explains Tao's paradoxical juxtaposition and unity of emptiness and substance by drawing an analogy: "You look at the sky and see emptiness, but looking through a telescope reveals other things—the moon and the stars." Out of nothingness comes somethingness.

Tao maintains a primary duality—the concept of yin and yang, complementary opposites that are born from and are harmoniously united in Tao. When you understand these concepts you will be able to grasp the dynamic concept of balance that permeates all things Chinese and Lin Yun's color theory.

• Yin and Yang •

Yin and yang are primordial forces that govern the universe and make up all aspects of life and matter. Yin is dark, while yang is light. Yin is female, yang is male. Yin is passive, yang is active. Together, yin and yang create a harmonious whole—the Tao. They are interdependent: without cold, the concept of heat does not exist; without an outside, there is no inside; without life, there is no death. These opposites exist within each other: within the male, there is a bit of the female, and vice versa. Through the complementary opposites of yin and yang, the Chinese link man to heaven and earth. According to Lin Yun, Tao links humans to their surroundings in this way: "Tao and the universe is empty—and yet it is full. Full of atmosphere, sun, moon, and stars. Out of the sky comes heaven (yang) and earth (yin). Within the earth's boundaries exist mountains and plains (yin) and rivers and streams (yang). On the mountains and plains live people (yang) who build houses (yin). Within the shelters live men (yang) and women (yin), and each has an exterior (yang) and an interior (yin)."

We can now understand the relevance of yin and yang to Chinese color theory. Just as one yin and one yang create the unity of Tao, one color and one emptiness create one universe. For, if any form (any object) can be known to exist, it must possess color. Out of the void of the universe come all things.

And within the Taoist view of the universe, how do we know these things, how do we differentiate nothingness from somethingness? The difference, on the most basic level, is color. Or, to put it another way, there is no difference.

Yin-yang: Yin and yang are complementary opposites. Yin is dark, receptive, and female. Yang is light, active, and male. Together they make a whole—Tao.

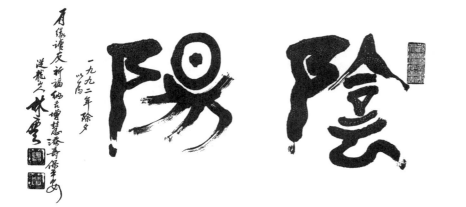

C h'i is
the cosmic breath or
energy of all beings,
the earth,
and the atmosphere.
Understanding the
effect of color on human
ch'i is crucial
to using
the ideas in this book.

■ ■ ■

As the sages say: "There is no color, no emptiness." This sense of unity is considered the highest thought.

· Ch'i ·

Ch'i is the key to understanding the significance of Chinese color in our lives. Literally translated as "breath" or "vitality," ch'i is a unifying principle of energy. Ch'i circulates in the earth, creating mountains—their color and shape—directing rivers and brooks, and nourishing trees and crops. Ch'i also is the energy that moves our bodies. Atmospheric ch'i helps to mold human ch'i. Ch'i encompasses the ch'i of the exercise ch'i kung, of Chinese meditation, of spiritual ch'i, of medical ch'i, of artistic ch'i. Ch'i is the true self. Ch'i is the entity within us that makes us recognizable after ten years, even though our body's cells have regenerated several times.

All humans are just a breath of ch'i. This ch'i flows through our bodies, so we can move. It stimulates our brains, so we can think. It moves our tongue, so we can speak. It flows to our hands, so we can write or grasp, and to our feet, so we can walk or run. Ch'i must flow smoothly throughout the entire body. If it is too weak, we cannot move. If ch'i flows only to the left side of our body, then the right side will be paralyzed. If it flows only to the upper part of our body, then our legs will be paralyzed. If ch'i cannot reach the heart, then we die. As Lin Yun says, "If ch'i cannot move our body, no matter how beautiful you are, how much power or wealth you have accumulated, how important or lucky you are—without ch'i you expire—all else is empty. You are merely an empty shell. The body is a sack of skin and bones." Within a person's body, the ch'i essence never changes, but its precise state can alter. Sometimes the state of our ch'i is good, sometimes it is bad—but it is always the same ch'i, the same basic self.

Ch'i, in a sense, is a person's destiny, a general blueprint of our personality, talents, and life course. At the moment of conception, *ling* (tiny airborne particles of embryonic ch'i circulating in the universe) enters a woman's womb, providing the spark of life. Ch'i flows through the child's body, determining physical characteristics, intelligence, movement, behavior, and mental state.

There are as many manifestations of human ch'i as there are people in the world. Some people possess a ch'i that circulates through the body, flowing

upward and rising through the head, creating a halo. This is the best state of ch'i, called "supreme ch'i." Holy and evolved humans, such as the Buddha, Christ, and saints, possess supreme ch'i. Because we all can't be perfect, many states of chi exist—"choked ch'i," "bamboo ch'i," "porcupine ch'i." These states of ch'i, and methods of balancing them, are detailed in chapter 9 of this book. There are many ways to improve our individual ch'i, and one way is to apply color. Within this application of color, the concept of the five elements is crucial.

· *The Five Elements* ·

The concept of the five elements is a mystical tool that can be used to analyze, harmonize, and improve our ch'i. This concept is also integral in understanding Lin Yun's ideas for enhancing all spheres of your life—clothes, cars, interiors, exteriors, health, and food.

Out of the interplay of yin and yang arise five manifestations of ch'i: fire, earth, wood, metal, and water. These five elements are not physical substances but powers or essences describing all matter and all attributes. The Chinese assign to these elements colors, seasons, directions, and internal organs. For example, the element fire is associated with red, summer, the south, the heart. Earth, positioned at the center, stands for yellow, orange, or brown, midautumn, and the spleen and pancreas. Wood is correlated with green, spring, the East, and the liver. Metal is white, autumn, and the lungs and gall bladder. Water is black (the deeper the water, the darker it gets), winter, the north, and the kidneys.

The five elements have relative effects on one another, creating and destroying one another in a fixed sequence. The Five-Element Creative Cycle proceeds like this: fire produces earth (ash); earth creates metal (minerals); metal produces water (although water rusts metal, this part in the creative sequence derives from the observation that when cold water is in a metal container, water forms on the outside of the vessel); water cultivates wood (trees need water to grow); and wood feeds fire.

The Five-Element Destructive Cycle is: wood upheaves earth; earth obstructs water; water extinguishes fire; fire melts metal; and metal chops down wood. The essence of this sequence is not generally negative. In fact, this series of mutually destructive or overpowering relationships connotes eternal recycling.

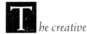he creative
cycle proceeds like this: fire
produces earth (ash);
earth creates metal (minerals);
metal produces water
(when cold water is in a
metal container, water
condenses on the outside);
water cultivates wood
(trees need water to grow);
and wood feeds fire.

■■■

he chain
of destruction is: wood upheaves
earth; earth obstructs
water; water extinguishes fire;
fire melts metal; and
metal chops down wood.
The essence of this
sequence is not generally
negative. Instead,
these mutually destructive or
overpowering
relationships connote
eternal recycling.

■■■

FIVE-ELEMENT CREATIVE CYCLE

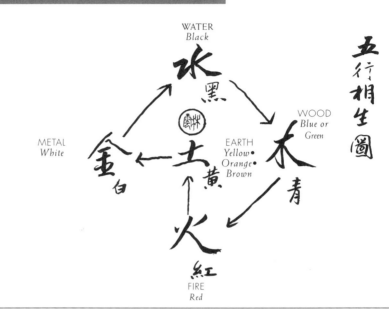

WATER
Black

WOOD
Blue or
Green

METAL
White

EARTH
Yellow •
Orange •
Brown

FIRE
Red

FIVE-ELEMENT DESTRUCTIVE CYCLE

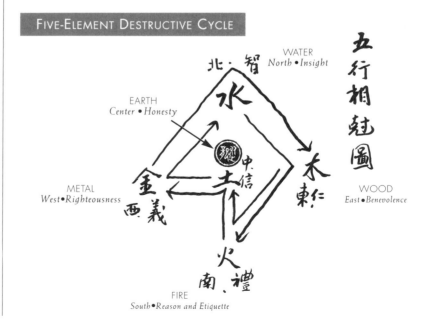

WATER
North • Insight

EARTH
Center • Honesty

WOOD
East • Benevolence

METAL
West • Righteousness

FIRE
South • Reason and Etiquette

The Five-Element Color Theory is a mystical tool with many uses. The Chinese apply the five elements when defining a person's ch'i, determining a person's destiny (reading palms and face), and enhancing and cultivating human ch'i. Such enhancement may be achieved through choice of colors and color sequences in our clothes and surroundings (feng shui).

The five-element theory can be applied to color in a number of ways. The five elements can be aligned with the eight fortunes of the *I Ching* (see below) to enhance a specific area of a person's life by using color in a strategic area of a room. The Five-Element Color Theory can also be employed to cure physical ailments and emotional imbalances by employing the color theory in what we wear, eat, and think. In addition, a color scheme solely based on these cycles can offer unusual ways to improve one's ch'i through clothing color sequences and building color sequences.

· *The* I Ching ·

The *I Ching* is integral to applying the Five-Element Color Theory to a plot of land, a building, or a human body. Considered the "mother of Chinese thought," the *I Ching* grew out of early divination. It instructed emperors and their advisors on important decisions, such as whether to wage war, or if an army should advance or retreat. The *I Ching* guided Taoist priests and scholars in the performance of sacrifices and consecrations and helped to determine particularly auspicious moments for hunting and fishing, sowing and harvesting. Imparting wisdom and divination at the same time, the *I Ching*'s hexagrams augur fortune and instruct on the natural workings of the universe and its cycle of constant change. The *I Ching* ties human destiny to the way of nature, the ebb and flow of yin and yang.

In fact, yin, represented by a broken line – – , and yang, represented by a solid line ———, are the basic building blocks that compose the *I Ching*. These yin and yang lines are arranged in eight different trigrams, or orders of three lines, which represent heaven, earth, thunder, mountain, fire, wind, lake, and water. The eight trigrams in turn recombine into sixty-four hexagrams, expressing the primal workings of Tao and its constant cyclical change. These trigrams and hexagrams have been discerned since ancient times through the tossing of wooden blocks, yarrow sticks, and coins.

Over time, the eight trigrams acquired additional significance. They could be applied to directions, seasons, family relations, parts of the palm (palmistry), face (physiognomy) and body (mystical medicine), and even to parts of houses, rooms, and furniture (feng shui), not to mention color. The trigrams also symbolize eight fortunes, ranging from wealth and marriage to career and fame. The eight trigrams in combination with the five elements create a mystical octagon (ba-gua) of symbolic correlations. This ba-gua can be used as a map of how color can enhance health, personal luck, and the environment. For instance, the kidney is associated with the water element, which has a corresponding color, black. A person with kidney problems, while following an appropriate medical regime, can assist their healing process by eating dark-colored foods. Applying the ba-gua to an office environment, a red flower in the "fame" area may help to secure a promotion. While the ba-gua of traditional feng shui relies on distinguishing cardinal directions, Lin Yun's relies on where the door is and then orients the octagon accordingly.

• Buddhism: Color is Emptiness, Emptiness Is Color •

The practical applications of Lin Yun's color theory relate on a profound level to the basic precepts of Black Sect Tantric Buddhism (BTB): the concepts of karma, nirvana, emptiness, and compassion, all of which are furthered by the practice of meditation. BTB is an eclectic form of Buddhism that incorporates doctrines and practices from India, Tibet, and China. From Indian Buddhism,

I Ching:
The I Ching *is an early mystical text of divination. As the "mother of Chinese thought," it parcels out both spiritual guidance and fortune-telling.*

■ ■ ■

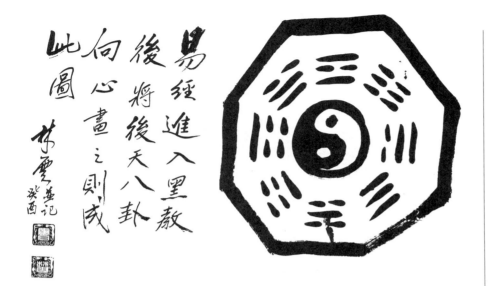

此圖　向心畫之則成　後將後天八卦　易經進入黑教

林雲癸酉記

*The Ba-gua:
The Five-Element Ba-gua
is a crucial
BTB tool for the specific use
of color in every
aspect of your life. Note the
eight trigrams
surrounding the yin and
yang symbol.*

▪▪▪

BTB derives the concept of karma, the chain of causation. The inevitable karmic process of life, death, and rebirth (reincarnation) is viewed as a painful phenomenon. Human desire and attachment to this world create suffering, continuing the cycle of rebirth. Only by embracing the knowledge that life and matter are illusory can an individual approach a state of enlightenment. The ultimate state of enlightenment is nirvana, the end of all desire, the escape from the cycle of existence, ultimate transcendence—emptiness.

Each sequential life is linked to the former by karma. To Chinese Buddhists, one's destiny is determined by the good and bad deeds performed during one's present and past lifetimes. Good deeds, abstinence, and compassion are all considered important to achieving enlightenment.

As Buddhism developed and traveled toward China, the concept of bodhisattvas, or "enlightened existences," arose, creating a pantheon of popular gods. These deities were believed to have performed an act of self-sacrifice by delaying their own *achieving* of nirvana in order to help other lesser creatures to improve their karmic lot and ultimately to achieve salvation. Bodhisattvas could be worshiped according to their benevolent specialty, be it medicine, mercy, or fertility. Among the most popular Chinese bodhisattvas is Kuan Yin, the goddess of mercy, known for her compassion.

Meditation came to China from India. It is a crucial means of achieving a higher state of being: compassion, selflessness, and supreme knowledge. Through meditation one can emulate the Buddha and achieve the Buddha self. The teachings of the Buddha, who lived in the fifth century B.C., originally were an oral tradition. Around the first century B.C., his teachings were recorded. Among the Buddhist scriptures are a number of sutras or doctrines. Professor Lin Yun is particularly influenced by the Heart Sutra, from which he extracts the phrase "Color is emptiness, emptiness is color," the underlying theme of his theories and this book.

The Buddhist concept of emptiness has many levels. One level relates to the transience of things, the closeness between being and nonbeing, life and death. Once that transience is accepted, another level of emptiness is attained—the emptiness of transcendental wisdom, the understanding that reality itself is empty, beyond grasp. The Buddhist concept of emptiness also ties in neatly with Chinese Taoist philosophy. This is one reason Buddhism became so popular and accepted in China. Taoists link the "great void" or the "uncarved block" of the great ultimate (*wu chi*) with the universe (*yu zhou*). Wu chi represents nothingness and cannot be measured by weight or size. It has no beginning or end. Yu zhou is everything and can be defined by space and time.

The Buddhist phrase "Color is emptiness, emptiness is color" links the universe and human life with the great void, or nirvana. It is a mantra, a six-word way for human life to disengage from the shackles of mundane vanities, desires, needs, and attachments. "Emptiness is color" also connotes the mysterious unseen aspects that govern our lives. These invisible forces relate to both metaphysical concepts, such as Tao, yin and yang, or ch'i, and to the as-yet-undiscovered qualities or powers in the universe and beyond. These forces or entities may exist, but we cannot see them, or have yet to find them. Tao or ch'i may be unseen and yet may determine and shape visible reality.

• *The Six True Colors:*
White, Red, Yellow, Green, Blue, Black •

In sequence, these six colors represent a holy figure—a god or the Buddha—and are conceived of as conjuring increased spiritual power. Each color is linked to a sound from the Buddhist six true syllables "Om mani padme hum"

LIN YUN'S THREE BASIC COLOR CONCEPTS

The reader will find three key concepts and systems recurring over and over in each chapter of Living Color: the Five-Element Color Theory, the Six True Colors, and the Seven-Color Spectrum.

Key Concept 1:
FIVE-ELEMENT COLOR THEORY

The most prevalent of Lin Yun's key concepts is the Five-Element Color Theory, which offers both "static" and "cyclical" cures. The five-element colors are an ordered sequence of colors based on natural elements that can either generate or destroy one another. This set of color sequences is useful when choosing clothing colors to "dress for success" or when painting the interior or exterior of a house. The five-element colors are essential to feng shui, Chinese medicine, palmistry, and face-reading. The Five-Element Ba-gua (see next page and the color insert) is also fundamental throughout Living Color.

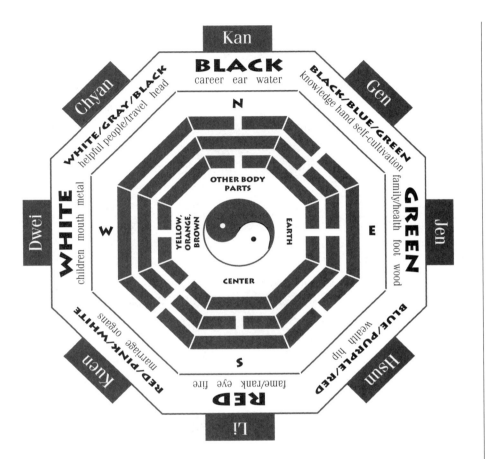

and, if used separately, can evoke that sound. According to BTB, the philosophical roots of the Six True Colors return to the duality of emptiness and substance being opposite ends of the same thing. The sequence's initial color, white, represents a beginning (yang). Black symbolizes the end (yin). "When you add all of the sequence's intervening colors, symbolizing all things in the universe, the sum is black," explains Lin Yun. "White therefore represents a blank slate, and black stands for everything in the universe. White is like an empty piece of paper. When it is inscribed with a black character, the white becomes more apparent in contrast to the black. Without black the white is nothing. On the deepest level of meaning, there is a continuing cycle: white helps create black, from which white is born."

When the five-element colors are superimposed on the ba-gua of the I-Ching, the result is a mystical octagon, the Five-Element Ba-gua. The octagon is a map of eight life fortunes with corresponding colors, body parts, and directions. The ninth direction—the center—is associated with the element earth, the color yellow, and all body parts not aligned with the trigrams. The Five-Element Ba-gua has infinite applications, but the concept always remains the same: superimpose the octagon onto a room, a yard, a body, a face, or a palm. You can enhance your fortune by applying an appropriate color in the right location. In addition, the basic color of each area of the octagon has corresponding "complementary" colors. These colors have a positive relationship to the basic color, and both create and are created by it, according to the sequence of the five elements.

• The Seven-Color Spectrum •

The Seven-Color Spectrum refers to the seven colors of the rainbow. Color is a manifestation of light and energy. Refracted in the sky or through a prism, light creates a sequence of red, orange, yellow, green, blue, indigo, and purple. It also should be noted here that light—the source of the seven-color sequence—can be used as a cure for some design problems raised in the feng shui chapters.

The Seven-Color Spectrum can be employed in many other ways. When a person is particularly unlucky, an outfit with all seven colors will improve the wearer's luck and ch'i. A crystal hung in a window facing west can convert an annoying hot afternoon sun into a delightful array of colors, filling a space with positive ch'i. The seven colors can also be part of a mystical cure—the Colored Line Running from Heaven to Earth. Here a line can be drawn or a string can be attached to a wall in the house in a sequence starting on the floor—red, orange, yellow, green, blue, indigo, and purple—and running to the ceiling. This is used in conjunction with the ba-gua—placed in the wealth position, it will improve finances—or in any area of a home or a business to improve luck. The seven colors also appear in Buddhist meditations, such as the Rainbow Body Meditation and the Crystal Rainbow Body Disappearing Meditation.

• The Cures Sying and Yi •

Living Color operates on two levels: sying and yi. Sying encompasses the subjective: how we emotionally, intellectually, and physically respond to color. Translated literally as "form" or "appearance," sying registers how the colors of external factors manipulate our ch'i. As Lin Yun says, " A good color can depend on your mood of the day. If you select a color that harmonizes with your ch'i, then you will flourish. If the color clashes with your mood, that color will irritate you. This theory comes from Chinese culture, but it can be applied to other cultures and traditions."

Sying also refers to how colors evoke different reactions. Some colors excite, while others bring a sense of hope. These reactions may be created by associations. Green may symbolize spring and hope, while dark brown—a color of winter—may remind us of hibernation. Sying is present in chapters on feng

Key Concept 2:
THE SIX TRUE COLORS

The Six True Colors refer to a recurring cyclical sequence starting at white and progressing to red, yellow, green, and blue, and ending in black, only to continue to white again. This sequence is thought to be a spiritually powerful color arrangement, and is primarily used in meditations and blessings.

shui—exteriors and interiors—clothing, ch'i, transportation, food (appetite), and health.

Yi, which translates as "wish," "will," or "purpose," is equally, if not more, important. Yi includes the more formulaic yet subtle ways to adjust and enhance the ch'i of plots, buildings, and people. A blessing that can be either visual or visualized, yi encompasses a variety of cures and practices that range from simple rituals to complete mystical systems. These blessings reflect the intention of each practitioner to overcome barriers to success, to heal physical illness, to balance neuroses, to deepen understanding and awareness, and to live a happier, healthier, and more positive life. Yi encompasses all that is possible when the power of the will to believe is brought to bear. Yi provides color formulas to cultivate ch'i, heighten spirituality, and ultimately turn negative energy into positive energy, bad luck or karma to good.

Among the "yi" cures are Lin Yun's Three Basic Color Concepts: the Five-Element Color Theory (which includes the creative and destructive cycles, as well as the Five-Element Ba-gua), the Six True Colors, and the Seven-Color Spectrum. They recur over and over in each chapter, and are outlined in the panels accompanying this text. Further, each of these color concepts can be applied in a static or cyclical manner.

STATIC CURES

The static cures refer to the mere presence of one or all of the five element colors. For example, a lawyer's office might be decorated with maroon-red —symbolizing the fire element—for argument. The same lawyer also could wear a maroon tie or dress. Or in another instance, someone hoping to sell something will wear all five colors to appeal to all customers' ch'i. In fact, the presence of all of the five-element colors on a building, in a room, in an outfit, or even in food presentation can adjust ch'i for balance and harmony.

CYCLICAL CURES

The cyclical aspect of the five-element colors uses two dynamic sequences: the Five-Element Creative Cycle and the Five-Element Destructive Cycle (p.23). These cycles are mystical ways to jump-start our ch'i that can be employed in all areas of our lives—the colors of our homes, offices, clothes, food, even our cars— as well as in adjusting our personalities and ch'i.

Key Concept 3:
THE SEVEN-COLOR SPECTRUM
The Seven Color Spectrum refers to the rainbow, a symbol of nature's power and beauty. The application of this sequence—red, orange, yellow, green, blue, indigo, and purple— ranges from mundane clothing choices to mystical feng shui cures and spiritually deep meditations.

The "static" and "cyclical" categories also pertain to the other two key concepts—the Six True Colors and the Seven-Color Spectrum—but these recur less frequently in the book.

While BTB uses both sying and yi approaches, it particularly emphasizes yi and the impact of the individual's will on a place, a person's well-being, or an endeavor. Yi is a form of faith healing, a method to activate the subconscious in order to positively reinforce your intentions.

To master yi, however, requires many years of practice and meditation. Merely reading about these transcendental cures may not be enough, especially in the more esoteric and mystical applications. Because mystical information traditionally must be transmitted orally from a master in the art, the yi cures in this book lack a vital element—the activating aspect of oral transmission. Nonetheless, the information gives the reader the sense of the depth and range of the effect color has on us.

COLOR IN CHINA: HISTORICAL AND CULTURAL ROOTS OF LIN YUN'S COLOR THEORY

The roots of Chinese color theory lie deep in the beginnings of Chinese civilization and culture, when the forces of nature played a central and all-pervasive role in sustaining the very basis of life. Science, religion, and art were all informed by a shared set of observations of nature and consequent beliefs and rules derived from these observations. Many of these views evolved thousands of years ago, as the early Chinese settled the Yellow and Wei river valleys. During early agrarian times, farmers struggling to survive in a vast land were often victims and sometimes beneficiaries of the whims and cycles of the forces of heaven and earth—sunlight, wind, rain—that brought flood or drought, a fertile earth or barren fields.

• Heaven, Earth, and Man •

From farmer on up to emperor, the Chinese felt that the forces of nature determined their well-being and luck. Heaven and earth seemed to play such an

"HISTORY OF COLOR IN CHINA AND COLOR ASSOCIATIONS."

active role in the fates of mankind that both were assigned human and animistic characteristics. A mountain, for example, might be seen as an earth dragon with ridges splaying out like arms and legs, and with streams and underground springs circulating like veins and arteries. And because man and nature were so closely linked, disturbing the earth might bring disaster to an area and its residents. People had a practical motivation for living in harmony with their environment, and within the evolving cultural guidelines for doing so, color and rules for its proper application was an important parameter.

Colors played an integral role in Chinese folk customs, cures, and legends. On earth, the feng shui expert sought out an auspicious building site by identifying a spot located between four hills, symbolically conceptualized as four colorful mystical beasts. The ideal place to build a home, temple, or an ancestor's grave lay between a black tortoise to the north, a white tiger to the west, an azure dragon to the east, and a red phoenix to the south. The fifth element, earth, was in the center, where the building stood. Colors, corresponding to the five elements, played a decisive role in the orientation of buildings. Facing east (green) or south (red) was best. North and west were avoided. "If a white tiger sits facing the door, should there not be misfortune, there will be calamity."[2]

Colors played a role in ancient agrarian rituals performed by anyone from the semi-divine emperor to the local priest. The emperor made sacrifices not only to heaven and earth, but also to the sun, the moon, the earth, and the harvest to ensure a good year. At appropriate altars, he sacrificed oxen and made offerings of silk. When praying to the stars the emperor presented eleven silk offerings, seven of which were white, with the rest being green, yellow, red, and black.

The ancient Chinese looked anxiously to the sky for omens of fair weather. Comets, as well as solar and lunar eclipses were thought to wreak havoc upon the lives of men. For example, an eclipse of the sun—an imperial emblem—indicated that the emperor had lost virtue and his divine right to rule: the mandate of heaven was in question.

Colors seen in the sky were taken as omens of good or bad fortune on earth. A rainbow sighted in the east augured fine weather, while to the west it meant rain. A red sky in the morning foretold an afternoon shower, while a red sky at night meant clear skies. A halo around the moon indicated wind. Even the five planets —Mars, Venus, Mercury, Saturn, and Jupiter—symbolized the five colors of the

[2] Clifford H. Plopper, *Chinese Religion Seen Through the Proverbs* (New York: Paragon, 1969 reprint), p. 120.

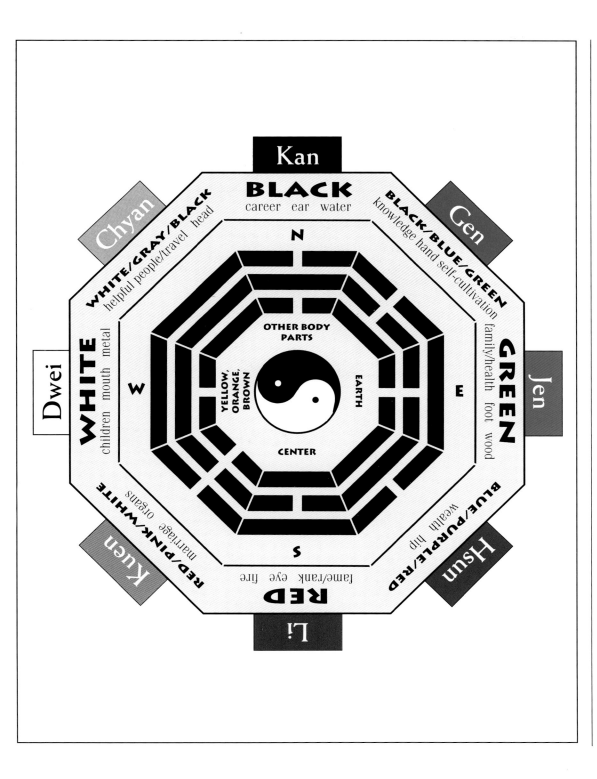

The **Five-Element Ba-gua Color Wheel**

Kan — BLACK — career ear water

Chyan — WHITE/GRAY/BLACK — helpful people/travel head

Gen — BLACK/BLUE/GREEN — knowledge hand self-cultivation

Dwei — WHITE — children mouth metal

Jen — GREEN — family/health foot wood

Kuen — RED/PINK/WHITE — marriage organs

Li — RED — fame/rank eye fire

Hsun — BLUE/PURPLE/RED — wealth hip

Inner labels: OTHER BODY PARTS · YELLOW, ORANGE, BROWN · EARTH · CENTER · N · W · E · S

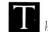

The Ba-gua Five-Element Color Wheel is fundamental to using color in feng shui. A mystical octagon incorporating the eight trigrams of the I Ching and the five-element colors, it can be applied to a plot of land, a building, a room, or a person. The octagon is a map of eight life fortunes with corresponding colors, body parts, and directions. The ninth direction—the center —is associated with the element earth, yellow, and all otherwise unaligned body parts. While the Color Wheel has infinite uses, the concept behind each use remains the same: superimpose the octagon onto a room, a body, whatever. You can enhance your fortune by applying an appropriate color in the right location.

■ ■ ■

The colors of a house or a building's facade can improve the fortunes of its inhabitants. Outdoor furniture, window boxes, and plants can further improve and enliven the effect. Avoid, however, window casements and window boxes of the same color. In this photograph of a simple home, all colors of the five elements— red, yellow, green, white, and black—create a totality: a dynamic expression of the five elements of the universe. Flowers and lawn furniture are seasonal in the north; in winter, the yellow chair can be replaced by a brown wooden bench (an earth color) and the pink and red petunias by real or artificial hollies with berries.

∎∎∎

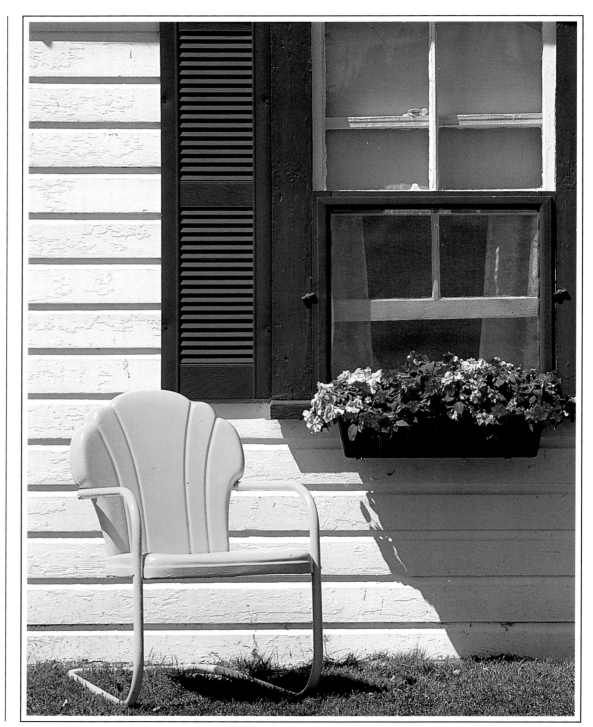

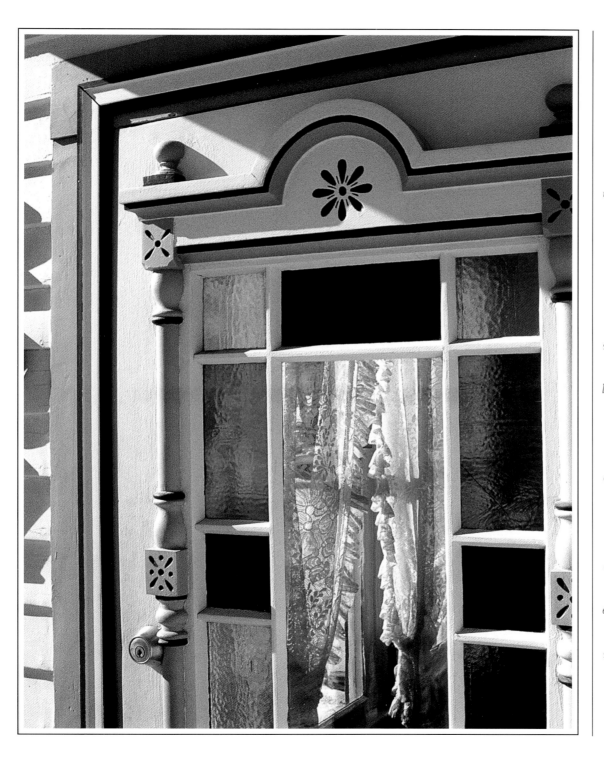

Subjective intent and impression also play a strong role in determining if a color scheme is auspicious. In this building facade, design and juxtaposition of color create a potent image. The placement of clear glass in the center of this door, surrounded by blue and yellow panes and framed by a light blue trim, creates a sense of the house as a sun radiating energy. There are subtle distinctions in choice of glass. Glass indicates sophistication and depth of character. Clear glass is pedestrian; stained glass creates a sense of further depth. Etched stained glass expresses greater sophistication. The more elaborate the stained glass, the more cultured and deep the effect.

∎∎∎

For kitchens, white is the best color. It shows off the colors of food best, like a blank canvas upon which the cook creates a meal of red tomatoes, green peppers, and yellow squash. Besides being the color of purity and cleanliness, the color white—the color of metal—is compatible with the kitchen's basic element, fire (fire overcomes metal).

■ ■ ■

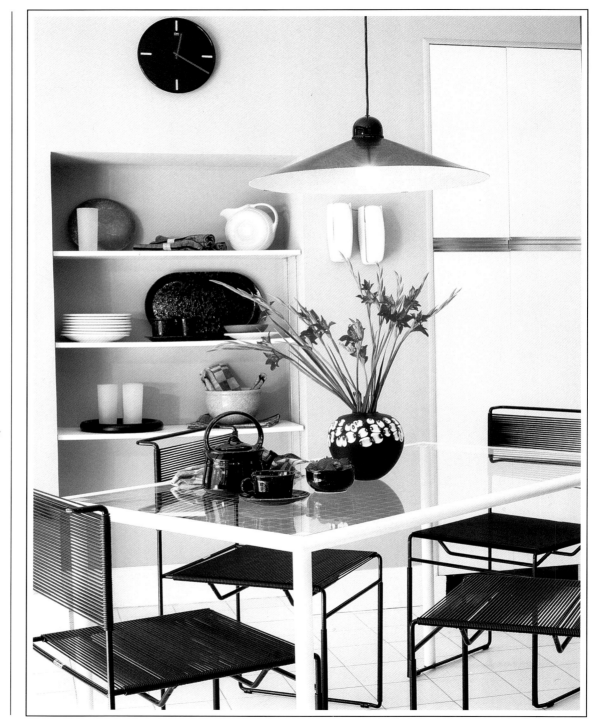

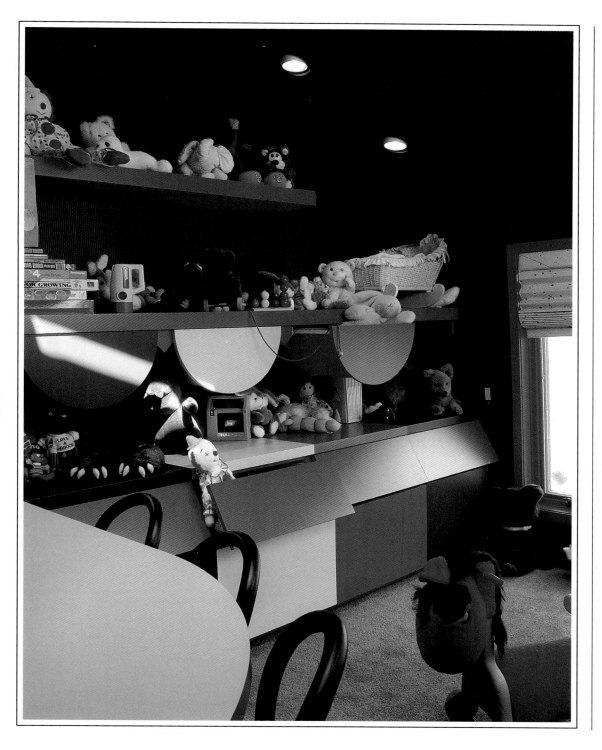

he
colors we paint our homes
and work spaces affect
our personal energies. Certain
colors energize us,
relax us, or depress us.
This children's playroom is
bright, with many
colors that stimulate young
minds and help them
grow and develop. Green is a
particularly good color
for children, making them feel
alive, blossoming with
a sense of new possibilities.

■■■

CREATIVE CYCLE COLOR SCHEMES

When applied to clothing, the Five-Element Creative Cycle and the Five-Element Destructive Cycle are two ways to symbolically raise the ch'i of the wearer. The Five-Element Creative Cycle starts at the bottom—with the shoes or hemline of pants or skirt—and progresses upward. On the right we give five different four-color Creative Cycle combinations, all of which should be read from bottom to top. The photograph illustrates the combination on the lower right: The gray socks and black shoes symbolize water, which nourishes wood, represented by blue (or green) pants, which in turn feeds fire, represented by the pink shirt. The yellow tie symbolizes earth, the element that fire creates.

■ ■ ■

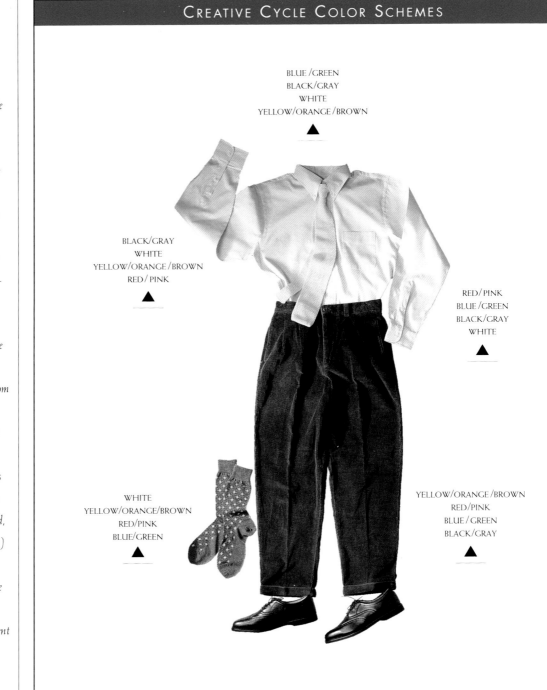

BLUE /GREEN
BLACK/GRAY
WHITE
YELLOW/ORANGE/BROWN
▲

BLACK/GRAY
WHITE
YELLOW/ORANGE/BROWN
RED / PINK
▲

RED/PINK
BLUE /GREEN
BLACK/GRAY
WHITE
▲

WHITE
YELLOW/ORANGE/BROWN
RED/PINK
BLUE/GREEN
▲

YELLOW/ORANGE /BROWN
RED/PINK
BLUE / GREEN
BLACK/GRAY
▲

DESTRUCTIVE CYCLE COLOR SCHEMES

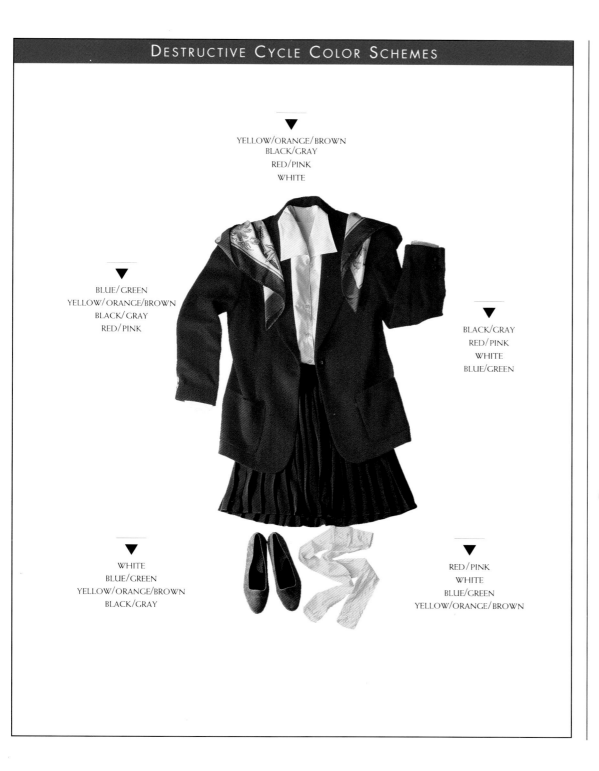

▼
YELLOW/ORANGE/BROWN
BLACK/GRAY
RED/PINK
WHITE

▼
BLUE/GREEN
YELLOW/ORANGE/BROWN
BLACK/GRAY
RED/PINK

▼
BLACK/GRAY
RED/PINK
WHITE
BLUE/GREEN

▼
WHITE
BLUE/GREEN
YELLOW/ORANGE/BROWN
BLACK/GRAY

▼
RED/PINK
WHITE
BLUE/GREEN
YELLOW/ORANGE/BROWN

D*espite its name, the Five-Element Destructive Cycle is an equally effective technique for raising the wearer's ch'i. It starts at the top of the body and progresses downward. On the left are five four-color Destructive Cycle combinations, to be read from the top down. The photograph illustrates the combination on the lower right: an outfit of a red scarf and jacket (symbolizing fire), followed by a white blouse (fire melts metal) and a blue skirt (metal chops down wood), and tan hose and brown shoes (wood uproots earth).*

W hen it comes to food, the Chinese have used color as both a healing technique and an appetite stimulant. For restaurants, the proper use of color (in serving dishes too!) can help increase business. The Five-Element Food Chart on the upper right provides both a guide to attractive food presentation and a healing aid. The photograph on the right is of not only an appealing meal but also shows a way to help wth heart problems. The red of the shrimp and peppers ties in with fire— the element aligned with the heart—and the green broccoli and tan steamer represent wood, which feeds fire, and earth, which fire creates.

∎∎∎

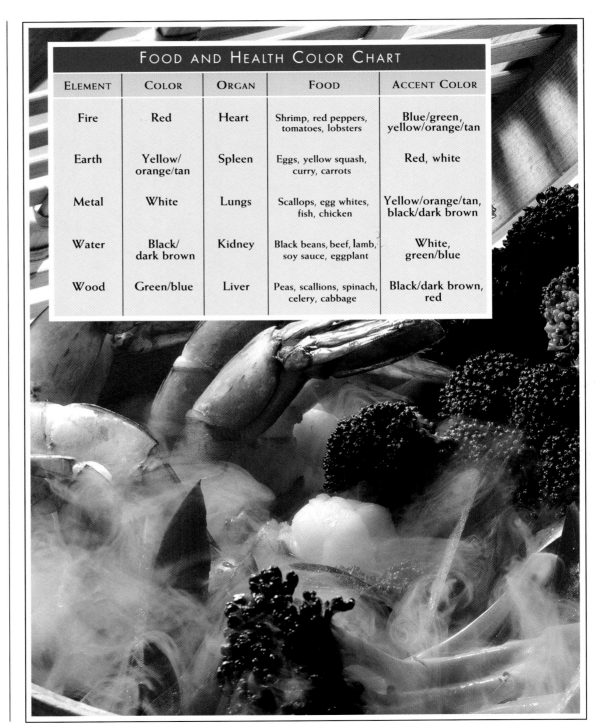

FOOD AND HEALTH COLOR CHART

ELEMENT	COLOR	ORGAN	FOOD	ACCENT COLOR
Fire	Red	Heart	Shrimp, red peppers, tomatoes, lobsters	Blue/green, yellow/orange/tan
Earth	Yellow/orange/tan	Spleen	Eggs, yellow squash, curry, carrots	Red, white
Metal	White	Lungs	Scallops, egg whites, fish, chicken	Yellow/orange/tan, black/dark brown
Water	Black/dark brown	Kidney	Black beans, beef, lamb, soy sauce, eggplant	White, green/blue
Wood	Green/blue	Liver	Peas, scallions, spinach, celery, cabbage	Black/dark brown, red

five elements. (Venus symbolizes metal and white, Mars is fire and red.) When these planets turned certain colors, Chinese astrologers would forecast the nation's fate: white and round meant mourning and drought; red meant disturbances leading to a coup d'état or military action; green foretold floods; black meant sickness and death; yellow brought prosperity. The Chinese also observed each planet separately. When Mercury, which aligns with the water element, was white, there would be drought; when Mercury was yellow, there would be dry, wizened crops; red meant military action; black meant floods, and so on.

Historically, this correspondence of color with the five elements has figured in Chinese architecture and the ornamentation of Chinese temples, pagodas, and palaces. Colors served to symbolically imitate on earth the Chinese vision of a cosmic order, and thus to ensure the stability, harmony, and good fortune of the emperor, his dynasty, and the entire nation. During the spring and autumn—times of planting and of harvest—the emperor journeyed south from Peking to worship at the altar of land, which was covered with colored soils representing the five elements. This square altar is said to have had yellow soil at the center, with blue-green, red, white, and black soils arranged around it, in a configuration whose particulars are lost to time.

The importance of color to the well-being of China and the whole universe can be traced to the legend of a fantastic and heroic character, Nu Wa. Born in the third millennium B.C., a miraculous three months after her brother Fu Hsi, emperor and creator of the ba-gua, Nu Wa possessed a number of identities: goddess of go-betweens, daughter of water spirit, spirit of wood, and snail girl, for she is described as having the body of a snail or snake topped with a human head.

Nu Wa is credited with a range of accomplishments. When Fu Hsi became emperor, Nu Wa advised him to establish a code of morality forbidding intrafamily weddings and setting standards of engagement, through go-betweens, to serve as the basis for matrimony. After succeeding her brother to the throne, she was challenged by an unsuccessful rebel, who fled to the mountain that supported the eight stone pillars holding up the canopy of heaven. Enraged by his own failure, the rebel violently shook a pillar, which, falling, brought down a corner of heaven, creating a black hole whence issued great winds and rain. To repair the damage, Nu Wa melted down stones of five colors. Then, to straighten the four edges of the world (thought to be square), she cut off the feet of the celestial tortoise—a

spiritually endowed creature gifted with strength and longevity. For centuries thereafter, carved celestial tortoises, symbolizing endurance and balance, comprised the bases of major columns of imperial buildings.

The Chinese used color to imbue the capital and emperor with sacred powers. In Peking, Tzu Chin Chueng, the "Purple Forbidden City," where the emperor mediated the country's fate, keeping peace between heaven, earth, and man, alludes to Tzu Wei, the north star. To further ensure enduring imperial power and good fortune for the nation, buildings and features of the landscape in Peking—gates, towers, hills, lakes—were sited to guarantee the balance of the five elements. Legend has it that one Ming dynasty plan for the Forbidden City was human shaped, placing important imperial halls in places analogous to the five vital organs.

Yellow, the color of the roofs of the imperial palace, signifies earth and the center, reaffirming the imperial concentration of power. There, at the center, the emperor sat, his back to the northern barbarians, ruling over his vast realm to the south.

To pray for good crops throughout the land, the emperor made periodic sacrifices and rituals at a number of altars. These altars, similar to the altar of the land, displayed colors distinct to their purpose and sacred nature. The altar of the sun was faced with red brick, the color of yang and the south. Ritual items, vessels, and vestments were also red. The altar of the moon was faced with gold, and the vessels and ritual instruments were white—the color of metal. And the altar of heaven was tiled in blue, the color of the sky, where all burnt sacrifices go.

Historically, the color red has been of great significance in China. Seen as the happiest of colors, red prevailed at weddings, whether imperial or ordinary. Pu Yi, the last emperor of China, provides this humorous description of his wedding night in his memoir *From Emperor to Citizen*: "Everything was red: red bed curtains, red pillows, a red dress, a red skirt, red flowers, and a red face."[3]

Because of its auspicious symbolism, red is present in many Chinese ceremonies, some dating back thousands of years. For example, in the *Chou Li*, an ancient Chinese architectural text, the placing or repair of the upper beam of a roof had to include not only the setting off of firecrackers—to ward off devils—but also the suspending of a piece of red cloth for happiness and a corn sieve for future good crops.

[3] Pu Yi, *From Emperor to Citizen* (Peking: 1964), p. 121.

To this day in Asia and in Western Chinatowns, emblems and requests for luck are written on red paper and posted on doors, and the bride in a traditional Chinese wedding is decked out in red.

• Color in Chinese Art •

Much insight into Chinese color theory can be gleaned from looking at Chinese art. While the vivid and ever-changing colors of nature in parks and gardens affect our hearts, minds, and souls, the colors expressed in art can be equally influential and evocative. In fact, color was one of the "six essentials" of Chinese painting, described in the *Mustard Seed Garden Manual of Painting.*

Chinese paintings were often considered visual and philosophical microcosms of nature and the universe. For centuries, Chinese painters sought to develop their own ch'i in order to express and transport the ch'i of Tao and the harmony and vitality of nature into their paintings. There were some painters who so successfully represented the life force of mountains and rivers that one art expert commented, "People nowadays enjoy looking at landscape paintings as much as at the scenery itself." He added that the scrolls were perfect for those unable to travel, since with a mere movement of their wrists they could unroll entire landscapes. The tie between nature and art is so strong that the Chinese word for landscape, *shan-shui*, translates as "mountain-water."

In the *Mustard Seed Garden Manual of Painting*, Lu Chai describes the living essence of color in Chinese painting:

> The sky has tinted clouds, glistening like brocade;
> That is the key to the color of sky.
> The earth brings forth grass and trees, all contributing ornamental touches;
> That is the key to the color of the earth.
> People have eyes and eyebrows, lips and teeth, clearly defined accents of black, red and white on specific parts of the face;
> That is the key to the color of human beings...[4]

The Chinese painted their landscapes in either monochrome ink washes or a multicolored palette. With colored paintings, artists followed detailed rules of

[4] Mai-mai Sze, trans. and ed., *Mustard Seed Garden Manual of Painting* (Princeton, N.J.: Princeton University Press, Bollingen Series, 1963), p. 34.

color application. A number of colored powders were used as pigments, many of them identical to those employed in various mystical feng shui cures for physical and psychological ills (see chapter 10). Red ground cinnabar (*ju-sha*) was used only in figure painting and never in landscapes. Yellow ocher was deemed appropriate for mountain shapes and paths through tall grasses in autumn, but orange-red realgar (*syong-huang* or "cock" yellow) was employed in depicting yellow leaves or people's clothing. The latter was also a Chinese medicine thought to foster longevity and health. Colored inks made of ground minerals and vegetable substances mixed with water or glue were often used to heighten the special effect of a painting.

Though painting with color was an art in China, monochromes were viewed as an even higher art. By using gradations of inks, washes, and brush strokes coupled with empty spaces, Chinese monochrome painting can conjure a universe of craggy mountains towering over a hermit's lean-to, or a razor-straight waterfall plunging into mists, only to reappear as a gentle stream being forded by a fisherman.

Skillful brush techniques administered from the artist's ch'i, talent, and inspiration, flowing through the body, arm, and along the brush, appear on the scroll, creating a dynamic tension between matter and emptiness—the ultimate expression of Tao. This balancing of brush strokes and ink wash fuses opposites— matter and void—to express a creative image. Chinese principles of painting are profound in that they are ultimately based in Tao, possessing the energy and vitality of ch'i and the unity and balance of complementary opposites—yin and yang. Each brush stroke expresses the nature of the artist's ch'i and that of his subject matter.

By coincidence or design, then, Chinese monochromes, with their harmony of voids and forms, are expressions of the Heart Sutra's "Color is emptiness, emptiness is color." And voids, specially rendered by ink washes or in painted surface areas, express the vastness of nature better than a realistic image of mountains and streams. These voids seem imbued with ch'i.

Similarly, the Chinese felt that ink and its subtle gradation of shades, ranging from off-white to black, could express subtleties of tone more successfully than color. As one expert said, "If you have ink you have the five colors."[5] Chinese painters used ink in different ways to create a varied sense of depth—dark ink to

5 George Rowley, *Principles of Chinese Painting* (Princeton, N.J.: Princeton University Press, 1959), p. 46.

create solid forms, lighter inks to imply distance, and ink washes to create void-like mists separating foreground from middle ground and middle from distant background. These mists acted as mysterious veils, evoking a sense of the boundlessness of nature, the universe, and the Great Void of Tao. Mists visually helped bridge the leap from finite to infinite. The act of painting and that of viewing the painting were sublime activities that linked the artist and viewer to the spiritual nature of existence and nonexistence. Chinese painters would express and reinforce the contemplative mood of a painting by writing a poem on the scroll.

From the perspective of Chinese art, black is beautiful. Whether used in a monochrome landscape, a flower study, or a calligraphy, black reinforces the contemplative nature of viewing art. Black allows the viewer to think deeply, bringing the viewer in.

Today, this theory on how color in painting affects us can be applied to other visual arts—such as television, film, animation, sculpture, theater, and ceramics.

• Mystical Color Cures •

Color played an important role in Chinese medicine. Early Chinese doctors used the five elements and their corresponding physical organs and colors to both diagnose and cure. Health was dependent on a balance of the five elements. (See chapter 7, "Food and Health.")

Color was also an element in Chinese folk cures. For centuries color or colored objects have been used as mystical antidotes to life's problems, ranging from backaches (white camphor) and burglaries (red and black fish) to bad luck (red powder) and infertility (green plants).

As a component of Lin Yun's feng shui theory, color plays an important role in both determining good and bad feng shui and also in improving the luck of a site, and therefore of residents' lives. Color, in fact, is one of the "nine basic cures" of feng shui. These consist of: (1) bright or light-refracting objects: mirrors, crystal balls, lights; (2) sounds: wind chimes, bells; (3) living objects: plants (real or man-made), bonsai, flowers, and aquariums or fishbowls; (4) moving objects: mobiles, windmills, whirligigs, fountains; (5) heavy objects: stones or statues; (6) electronically powered objects: air conditioners, stereos, television; (7) bamboo flutes; (8) colors; (9) others. When asked what cures are most

effective in our lives, Lin Yun responds, "Others," meaning the more mystical cures. Often, the "other" cures involve color.

The practice of mystical cures goes back to the third century B.C., when colored powders were employed by Chinese alchemists. Some sought to create pure gold and others to concoct the elixir of immortality. Today a number of the Black Sect mystical cures still use colored powders, such as ground cinnabar or realgar. Deemed to possess medicinal or chemical powers, they can be purchased in traditional Chinese drugstores. Realgar is primarily used to improve and strengthen ch'i. Cinnabar is more often employed to expel bad ch'i and evil forces and to bring in good fortune, such as in the Red Egg Rebirth cure (see p. 141 for both) or the Cure Against Nightmare. Often, however, the powders are interchangeable. If you substitute one for the other, it may strengthen the result of your cure. The specific goals of BTB mystical cures that employ these two powders run the gamut—altering the luck of a house (see Sealing the Door, p. 139) to changing someone's luck from bad to good or purifying a grave site.

Some cures use white objects such as rice, pearls, lotus seeds, camphor crystals, and chalk. White rice is a symbol of fertility and prosperity—thrown at weddings it is supposed to virtually plant the seeds of happiness, good fortune, and procreation—and white cures that use camphor and chalk resolve litigation and ease backaches, respectively.

White is also an element in a number of mystical cures. According to Lin Yun, white is good for curing certain heart problems. His chu-shr rationale is the following: in the five-element scheme, the heart is associated with fire. There are two kinds of heart problems: one is physical, the other psychological; they come from having too little or too much fire in our systems, respectively. Heart disease, including high blood pressure, comes from too little fire; petulance and anger (which themselves can lead to heart-related health problems) are fueled by an excess of fire. This excess can be balanced by white, the color of metal. "Fire, the color of the heart, destroys metal. So if a person is vituperative, he has too much red, too much fire. If we use white in the form of ice, the red fire will burn the ice cubes so that the fire will eventually subside." Black, the color of water, also brings a rapid-fire personality into balance, as water quenches fire. Heart disease, which comes from a fire deficiency, can be remedied with red—the color of fire—and its mutually creative colors, yellow and orange, as well as

the brown of earth and the green of wood. In this way, one's bodily fire is brought into balance.

Most green cures use plants—one of the nine basic cures of feng shui—to symbolize hope, spring, and growth. As a result, green cures often are used to improve health, wealth, and fertility.

Other mystical cures use orange or lemon peels, or colored strings to tap into the powers above.

RED ENVELOPES

Before a feng shui expert imparts any mystical cure or sacred wisdom—be it for the home, one's health, or ch'i cultivation—one or more red "lucky money" envelopes must be presented to the expert. This is an old Chinese custom. On special occasions, such as weddings or the Chinese New Year, money is exchanged in this way. If you attend a Chinese wedding, the couple's family will expect a generous donation presented in a red envelope. (Sometimes they receive more than the celebration may cost.) At the Chinese New Year, children and family retainers are presented with lucky money envelopes holding varying amounts of money.

The ritual of the red envelopes operates on a number of levels. It is one way to express your respect and sincerity toward the expert. By going to the trouble of locating or making a red envelope—any unused red envelope will do—and presenting it to a known expert, you may open your mind to the possibility that the expert can help you. In addition, the red envelopes are supposed to mystically protect the expert when they are using a great deal of knowledge, wisdom, insight, intuition, and judgment in order to help resolve your problems or achieve a desired goal. The number of red envelopes presented is determined by the number of solutions. It can range from a single envelope to multiples of nine.

• Meditation •

While the visual realm of color was crucial in Chinese life and culture, the visualized realm of color exists in meditations. Sometimes the mental images used in meditation practices derive from religious figures such as Buddhas and bodhisattvas. These images and their colors are envisioned in these internal exercises to invoke their special and specific qualities, abilities, and powers. Lin Yun encourages practitioners to envision the deity of their choice, be it Buddha,

Jesus Christ, Allah, or whoever. Other meditations use natural images or forces such as the sun, the moon, fire, or rainbows.

The practice of Buddhist meditation is not indigenous to China. It originated in India and arrived in China via both the Silk Route and Tibet as part of a wave of Buddhism that swept China in the first millennium B.C. Meditation is one way to elevate consciousness and transcend mundane life. On a spiritual level, it presents a means of achieving a state of selflessness, compassion, and supreme wisdom. On a more practical level, meditations are used to improve physical and emotional health, to restore one's perspective, and to send blessings to loved ones. In this way, life is made smoother, and suffering easier to handle. Meditation is also an aspect of yi. Meditation is an internal process to improve our personal ch'i, and either cleanse or empower the soul. (Instructions for specific meditations appear in chapter 11.)

Each meditation uses an appropriate color to accomplish its goal, and each color according to Lin Yun has a different emphasis. If you want to be very compassionate and save others from suffering, or escape from the suffering of this world, you might envision Bai Du Mu, the White Tara, or literally the white-clothed mother. In this meditation, you visualize your body becoming completely white.

"In different meditations," Lin Yun explains, "you use different colors to achieve different effects. If you want to save people from life's tough problems or restore good health, then use the Lu Du Mu—the Green Tara Meditation. Green is the color of hope and recovery. If you want to raise an individual's spiritual wisdom or help a deceased loved one achieve nirvana, then envision a gold or yellow color—the color of the Buddha. Or, if you have a troubling nightmare or go to a funeral, you can use the color red to get rid of the bad karma or luck. In this meditation, you can visualize a red sunlight filling your entire body." Here red is a component in expelling the ch'i of death and evil.

When you visualize color, you are seeing color in the mind's eye. This affects your optic nerve, your brain, and your nervous system. As a result, the visualization of color can influence our moods, behavior, physical movements, language, and business. The result is a physical and emotional chain reaction. Regarding the use of the Heart Sutra Meditation, Lin Yun notes: "Through visualization, you will concentrate, so your blood circulation is smooth. Your breath will be steady, so

ultimately your health will improve, wisdom increase—and you will attain greater spiritual depth. The white ball or light of this meditation is important in this process."

• Sun-Moon Dharma Wheel •

Another meditation, the Sun-Moon Dharma Wheel, a variation of the Heart Sutra Meditation, employs the images of white (sun) and red (moon) light to improve physical and mental health and to advance spirituality.

• Great Sunshine Buddha Meditation •

The Great Sunshine Buddha Meditation is a BTB exercise to heal bodily ills. It invokes the creative power of the sun and its light, colors, and heat in the form of a white glowing ball to cleanse the body of physical disorders and pain.

• Om-Ah-Hum Purification Practice •

Color is also a vehicle in a spiritual purification meditation—the Om-Ah-Hum meditation. In this exercise, a ball ascends to the middle of the body and changes hues from red to orange to yellow, all the way through the spectrum until the ball returns to red and literally becomes the vehicle—like a magic carpet —that carries the meditator's ch'i into the presence of the Buddha.

This meditation can be performed as a practice unto itself to perfect our karma or as part of another meditation such as the Heart Sutra or Sun-Moon Dharma Wheel Meditation. This is a purification method, a chance to perfect our karma and cultivate our ch'i. It is used to expel the negative karma that you may have accumulated during your three lifetimes—your past existence, this lifetime, and the next life. This ritual not only seeks to rid you of the bad karma and the ill effect of your wrongdoings of these three existences, but also focuses on the evil acts performed by your own speech, body, and mind and then purges them and the resulting bad karma. The syllable "om" refers to the body, "ah" connotes speech, and "hum" represents the mind. There is an additional syllable, "sha," which expresses the hope that all your wishes and intentions be granted or carried out with successful results. The four-syllable phrase is uttered three times, each addressing the ills of one of your three lifetimes.

• Green Tara Meditation •

This meditation uses the color green as a form of ch'i cultivation and one method of solving mental and physical health problems and relieving the suffering of others. Regular practice is said also to help develop spiritual power and wisdom and increase patience and compassion.

The name, not surprisingly, comes from a bodhisattva, Tara, known for her compassion. Tara usually appears in pretty green robes and resplendent green jewelry. The most distinct aspect of her appearance is her headdress. She is wearing a dharma cap on which sit the Buddhas of the five directions. Four Buddhas face north, south, east, and west, and the fifth Buddha, Amitabha, sits in the center of the cap. Green Tara is known for curing sickness—cancer, tumors, and unexpected evil occurrences.

Green Tara is best known for helping Sakyamuni reach Buddhahood. Along the way to nirvana or enlightenment, Sakyamuni encountered various temptations, obstacles, and evils that might have diverted him from his path. As he reached his final destination, Green Tara appeared to protect him, driving away all evil forces and obstacles. The Chinese call her Lu Du Fwo Mu, the Green-Colored Mother of the Buddha.

• Rainbow Body Meditation •

The Rainbow Body Meditation, using all colors of the spectrum, is one of the most sacred meditations. It is also the meditation most closely and completely associated with color. It is practiced to improve your physical health, your spirituality and spiritual powers, your wisdom and judgment, and to increase your personal virtues—patience, open-mindedness, compassion. The Rainbow Body Meditation can also be practiced to prepare us emotionally for death: to face death with greater universal understanding and to reach it with a feeling of peace and harmony.

The Rainbow Body refers to a Buddhist tale of a Tibetan Tantric Buddhist high lama who lived in the eighth century. When this extraordinary man died, he was so holy that his body turned into a rainbow. The rainbow also alludes to the natural power of the sun, the ultimate source of the spectrum. Each color of the Seven-

Color Spectrum is used in sequence. The meditation can be enhanced by your own color associations and understanding. For example, when practicing the "red" stage, you can associate red with auspiciousness, power, energy, and even getting rid of the ill effects of bad dreams and bad luck—an allusion to the Red Sunlight Meditation. The "yellow" stage might symbolize the Buddha's golden light. The "green" phase may invoke the Green Tara, and so on.

Note that the importance of the Seven-Color Spectrum lies in both its application to meditation and the significance of its philosophical roots. Lin Yun describes the system's origins. "Within the universe, you cannot discern anything. However, when light—energy—passes through a prism, then you can see the rainbow colors. Without the prism, only light exists, which is invisible." Thus, the spectrum illustrates that "color is emptiness." Lin Yun explains that the Seven-Color Spectrum is a meditation tool for Tibetan lamas of the Black and Red sects. "When they meditate at the highest level, they focus on the seven colors, which disappear and convert to light. Their bodies ultimately disappear to reach nirvana. When they reach this ultimate stage, they first become the spectrum and then the light."

· Chinese Color Associations ·

Colors affect our moods and feelings. Some colors have a universal appeal. For example, primary and bright colors tend to make us feel more cheerful. Dark colors can be sobering. The impact of other colors is more culturally determined. For example, white in the West represents purity, so a bride wears a white gown on her wedding day. In China, white represents winter, a dead or dormant state, so traditional Chinese mourners wear white muslin robes to the funeral and the corpse is covered in a white shroud. In a Chinese wedding if a bride wears white, which some modern Chinese brides now do, according to Lin Yun she is also, in a sense, in mourning—meaning there will be an unhappy end to the wedding. The Chinese likewise avoid sleeping under a white blanket, which is reminiscent of the burial shroud, thus signifying that sleep may turn into death. (White sheets are fine.)

Here is a basic breakdown of what colors symbolize, according to Lin Yun:

RED

Red is considered a particularly auspicious color. It connotes happiness, warmth or fire, strength, and fame. As a result, a traditional Chinese bride will

wear a scarlet cheongsam, a father of a newborn son hands out red eggs, and Chinese New Year's tips are dispensed in red "lucky money" envelopes. According to Lin Yun, red is like "a red sun rising from the East." When it first emerges over the horizon, it is red hot. He likens red to the source of energy of the universe. Red is a very powerful color. It is (1) an energy source; (2) a stimulator; and (3) a way of expelling bad ch'i. Some followers of Lin Yun wear red ribbons or strings to channel and retain their ch'i.

PURPLE

Purple, deep red, or plum is an equally auspicious color. It is said to inspire respect. Some say it is luckier than red. An old Chinese saying goes, "It is so red, it is purple," meaning that something is "out of this world," the best that it can be. If someone has "purple ch'i," this means a high nobility, a powerful, rich, and fortunate individual.

YELLOW

Yellow or gold stands for power, so the emperor enveloped himself in it by donning gold robes embroidered with a gold dragon—the imperial emblem. Yellow gives a sense of tolerance, patience, and wisdom gained from past experiences. An old Chinese saying goes, "With great tolerance, you will be able to attain the highest esteem (position)."

GREEN

Green represents tranquility, hope, and freshness. A color of the wood element, green also symbolizes spring growth. In plants and vegetation, green indicates good, healthy earth ch'i. This is the green of emeralds and lotus leaves.

BLUE

Blue or indigo has dual meanings. On the one hand, blue is a color associated with wood. Therefore it can symbolize spring, new growth, and hope. However, blue is also a cold secondary mourning color to the Chinese. Some Chinese developers are known to avoid blue in building projects.

BLUE-GREEN

Blue-green, mint, or aqua are more auspicious than indigo, as they are more closely aligned with the colors of nature and spring. The Chinese word for this

color is *ch'ing*, which can mean either blue or green. It can describe the blue of the sky or lapis lazuli, as well as the green of bamboo, frogs, or copper patina. In general, ch'ing represents verdant youth.

Black

On the positive side, black—or any dark color—gives a feeling of depth, both in mood and perspective. For example, the black ink of Chinese mono-chrome paintings helps create a beautiful contemplative setting, allowing the viewer to think deeply. Yet black indicates a lack of hope, and it may make us feel "dark"—low and depressed.

Gray

Gray is an ambiguous color—or a gray area. Its impact depends on an individual's association. To some, gray, like a dismal cloudy day, connotes frustration and hopelessness. To others, it is positive—a marriage of opposites: black and white. Gray in this instance signifies balance and the resolution of conflict.

Brown

Brown gives us a heavy feeling. The color can be used to create a stable, established impression. It symbolizes the depth and roots of wood. The use of brown in old European homes, for example, gives us a feeling that something has existed for a long time and will continue to exist in the future. Older people tend to prefer it. Brown can be quite elegant. Another related impression of brown is the sense of the passage of time. Brown can remind us of autumn, when leaves turn to brown and fall.

Tan

Tan or café au lait represents a new, successful beginning. Out of seeming hopelessness, a new possibility arises.

Orange

Orange, as a mixture of red and yellow, is auspicious and is imbued with the characteristics of these colors—happiness and power.

Pink

Pink represents love and pure feelings, joy, happiness, and romance.

PEACH

Peach is a double-edged color. It is the color representing attraction and love. In general, this is a good color for single people, but it is a destructive color for married couples. This perspective comes from the Chinese phrase "peach blossom luck," which refers to those who are particularly attractive to the opposite sex. A single person with peach blossom luck will be sociable and will make lots of friends and have lots of admirers. Although many of the relationships will not last, no one will be deeply hurt. For a married person, peach blossom luck will lead to adultery.

According to Lin Yun, there are three categories of peach blossom luck that are degrees of being alluring and resulting consequences. The first stage is the sociable person. Whether male or female, at work or socially, this person is found by others to be affable, easy to trust, helpful, and dependable. People enjoy seeking out this person's company. Others happily help him or her and enjoy the company of this person in dining or conversation, as well as simply being in this person's presence. This person is popular and has a quality that particularly attracts the opposite sex. This is normal and does not affect a household. (Someone completely devoid of peach blossom luck will be uncomfortable with the opposite sex and will only deal with their own gender.)

The second phase of peach blossom luck is the development from the friendship stage to a love affair. This is called peach blossom entanglement, and it affects the household. It is destructive to the family and the marriage. Even though the other spouse may not know yet, the potential of great hurt exists.

The third stage is peach blossom death. This is the tragedy: the spouse finds out, leading to family fights and, perhaps, divorce. The quarrels will be violent and threatening and may result in a crime of passion or a serious illness in the family.

Chapter Four:

FENG SHUI OUTDOORS: THE LANDSCAPE OF COLOR IN COUNTRY AND CITY

"FENG SHUI EXTERIORS."

T he colors of nature and the landscape figure prominently in the art of feng shui, the Chinese system of harmonizing with the environment. From the moment we leave home, we are confronted by color. Our eyes take in the tones of the sky, the earth, the garden, the plantings in city window boxes. The colors of sights seen on our daily trek to school or office directly affect us, as do those of the scenic drive we may take while on vacation. These colors can be restful, stimulating, or disturbing. The colors of man-made structures—our homes, neighboring buildings, swimming pools, even the cars we drive—also influence our ch'i and luck. While the style and form of roads, bridges, pools, and fountains may be crucial, color is the primary means by which we apprehend these structures. It is the skin of things. We react to it instinctively, and we can use it to modify our living environment, be it rural, suburban, or urban.

The main focus of this chapter is upon how color in the landscape can improve our own ch'i, whether this landscape is that of our own backyard or of nature at

large. In addition to examining the color implications of natural features such as mountains and water, trees and flowers, this chapter also focuses upon how the colors of the man-made landscape affect us. As we shall see, there are myriad ways of employing color outdoors to improve our ch'i and luck. Throughout this chapter, the key concepts of the five-element colors, the Creative and Destructive Color Cycles, the Six True Colors, and the Five-Element Ba-gua Color Scheme are frequently employed.

• The History of Color in the Landscape •

To fully appreciate Lin Yun's theory of color as it applies to the landscape, one must first grasp the agrarian, architectural, and artistic basis of this theory and practice. For millennia, the Chinese have believed that a vital, life-giving force—ch'i—flows within the earth. This ch'i circulates in subterranean areas, causing underground streams and magma to flow. Where ch'i flows close to the earth's crust, the soil is fertile, loose, and moist, so that crops such as wheat and rice thrive. When in ancient times Chinese farmers planted fruits and vegetables in such places, they were able to reap a rich harvest. Thus they viewed areas most suitable for human life and habitation as being well endowed with nurturing ch'i. And these fruitful environments, full of ch'i, were verdant and lush and were perceived as having good feng shui. The Chinese have always been keen observers of nature. Early on, they discovered that if they built a house halfway up a hill facing the sea, they could create a safe and comfortable home. An old Chinese saying describes the perfect spot to live: "The water is clear, the trees are lush, the wind is mild, and the sun is bright." Small villages and large cities were founded in accordance with this principle, for a place conducive to human habitation—a place with good feng shui—will inevitably attract an increasing number of residents.

The Chinese emphasize their surroundings and pay strict attention to the feng shui of an area. Within this consideration, color nearly always comes into play. The greenery of trees and shrubs, the arrangement of brilliant red, gold, and blue flowers, the particular shade of your home and that of your neighbor—all these colors affect you. Understanding the impact of color may help to guide your choices in landscaping and house painting.

· The Regenerative Power of Nature's Colors ·

From ancient times to the present, the colors of nature have provided a calming and invigorating stimulus to our bodies and minds, enhancing our emotions, speech, and nervous system. The reds, blues, greens, yellows, and whites of trees, flowers, and earth help to inspire and regenerate our ch'i.

According to Confucius, "The virtuous gravitate to the mountains, while the wise are attracted to water." In other words, the virtuous prefer the tranquil stability and solidity of mountains, and the wise are inspired by water's dynamic activity. We also can understand this saying from a perspective of ch'i and color. The virtuous who gaze upon the mountains see trees, shrubs, and an array of wildflowers, all of which are full of life force—ch'i. The lushness of the forest and the white, yellow, blue, and red of the flowers give a sense of peace and stability. In ancient China, hermit-sages took to the mountains, seeking refuge from political unrest and social pressure. They could enjoy the quietude and watch the changing of the seasons, the cycle of colors from green to yellow, red to brown. Feeling the stability and peace of the mountain, a microcosm of the balance of nature, the sages had need of nothing else, neither official position nor society. Color and love are intrinsically related. The sages loved nature and its array of colors. As a result, they were content.

The Ch'i of the Earth: When ch'i circulates in the earth near the surface the result is lush greenery— good feng shui. Brown, withered plants signal ch'i spiraling away from the surface— bad feng shui.

∎∎∎

While mountains relax our minds, water in all its forms and shades pleases us. The sea's movement and color stimulate yet calm the mind, deepening our thoughts. Gazing upon a green sea lifts our spirits. Looking upon a blue sea affects our mood, and happiness settles over us.

All colors of nature are highly evocative. To depict the warming of the spring, a Chinese poet once wrote, "The spring breeze blows on the south bank of the river." Another poet improved upon the line, changing it to: "The spring breeze greens the south bank of the river." This phrase has more life force, more ch'i. It helps our minds envision not only the mild and warm breeze, but also the green grass moving and the flowers blooming.

Today, life is complicated and confusing, and our minds can become unsettled and weighed down by work, daily activities, and struggles. We work long hours and become exhausted. So we take vacations each year to rest and travel, to go to the mountains or seashore to regenerate ourselves. We need to see colors we do not normally see in order to bring balance to our minds and bodies, and to stimulate our energy. This colorful change is, in a sense, enjoyment.

Since particular color arrangements are more restful and pleasant than others, the colors of public spaces—parks, mountains, parkways, rest areas, and gardens—should be both lively and vibrant and arranged in ways we do not normally see. This enlivens and relaxes our ch'i, increasing our happiness and pleasure. No matter where a person wants to relax—in a park, a garden, a schoolyard, at home, or near a nursing home—one should seek out colors that symbolize peace and serenity, such as green and blue. Green represents the calm of the mountains, blue the quality of the sky and the sea. In addition to using green as a restful and relaxing color, red accents can further improve a park's appeal. As an old Chinese saying goes, "There is only one red dot in a field of green." This means that a person, place, or thing stands out. It is one in a million.

· Urban Colors ·

While green—evoking spring, new beginnings, and peacefulness—is the most important color for country, suburbs, and city, other colors can further enhance the urban landscape. City life requires a rich variety of hues to vitalize the area. Through the application of appropriate colors to large

metropolitan centers such as New York, Tokyo, or Washington, DC, a country's ch'i can be vastly improved.

In general, the best color choices for a large building such as a skyscraper are white or coffee, gold or yellow, or earth colored. If the building is one in a busy skyline, color may be used to help it stand out. One may apply a special BTB cure: the lower levels and base of the building can be brown or red, symbolizing the trunk of a tree, while the top floors can be green with red accents, suggesting the upper reaches of a tree laden with fruit, its good luck and prosperity.

The emphasis in Chinese color theory tends toward such accents, in the spirit of variety being the spice of life. As Lin Yun states: "If a city is all green, this is not good. You need accent colors, such as red, black, or white. . . . Look at Tokyo. Why is it so prosperous? At night you have neon lights of all colors—green, yellow, white, red—all blinking, and it is all very lively. In contrast, Peking's ch'i is low. After 9 P.M., there is no color or lights. The city seems dead. Also, the house exteriors are mostly gray, and a predominance of this color cannot attract people. In Shanghai, on the other hand, there are more colors, more lights, more store signs. Therefore, the ch'i of Shanghai is improving, and this ch'i will eventually influence and enliven the ch'i of Peking. Already, most of the high officials in the Peking government are actually from Shanghai. In fact, according to Chinese political circles, the ch'i of Shanghai is rising. Canton's ch'i is also strong, although Hong Kong's ch'i is even stronger. This is because of Hong Kong's very colorful neon lights and signs. The blinking lights of all colors, plus the high level of activity, bring up the ch'i of that city."

Today, in New York, the ch'i is improving, and the lights of Broadway and large buildings help enliven the atmosphere. On a walking tour of Wall Street, Lin Yun commented that the economy of the United States could be improved by installing four spotlights, each aimed at a corner of the roof of the old Federal Building. He also observed that the soot-black color of the New York Stock Exchange and the black grating on the windows were better than white in undoing insider trading.

In Washington, DC, just as much as in the Forbidden City of ancient China, building color determines the strength of the ruler. Yellow, the color of the center position, was said to reinforce the emperor's central authority, his power, righteousness, and control over the realm. Chinese palace interiors and exteriors

were a golden yellow, the color reserved for the emperor. Closer to home, the White House would be disastrous for the fortunes of the United States without the yellow flower beds that grace the lawn. White, the Chinese shade of mourning, must generally be avoided in large doses. Sensitivity to possible negative connotations of color extends to blue; a construction company in Hong Kong ruled out blue as an exterior color because it traditionally is a secondary color of mourning.

Where color does intentionally lend weight and solemnity, accents may help to brighten or lighten the atmosphere while maintaining proper respect and decorum. According to Professor Lin, the starkly beautiful Vietnam Memorial in Washington, DC, could use some color. "Though the stone and names are quite beautiful, the memorial is too death oriented, the ch'i of the dead souls is too strong and may cause some unfortunate occurrences." To offset this, he suggests adding lively colors, such as red flowers and green plants, commenting, "Too much grief is not good for a nation's luck."

If the accents are extremely dominant, as in the case of a building that is gilded, the best primary color for the facade is black. Gray is also fine. Thus balance is achieved.

ROADS

Roads and roadside colors are also important. Highways should ideally have shoulders and dividers with abundant greenery and flowers to keep the drivers' minds stimulated and awake and to generally inspire.

The best color for road paving is green, symbolizing a hopeful course, full of life force. Gray or black surfaces are also fine. In the city, surface color should complement the color of the buildings. Here the Five-Element Creative Cycle Color Scheme should be used. For example, if the buildings are mostly red brick, green paving is best because wood (green) feeds fire (red). Conversely, if a factory is black, a tan or white road is best, because metal (white) creates water (black).

A special situation occurs when the shape of a building or buildings creates a recognizable form. In such a case, the road's color must animate the building's shape. For example, if a building is a cylinder and is gray or green, and roads radiate out like crab's legs, then the roads should be gray or green or be lit by green lights, to reinforce the image of live shellfish. A red road would create the impression

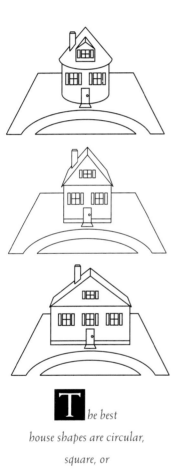

The best house shapes are circular, square, or rectangular. As resolved shapes, they give a sense of wholeness.

■ ■ ■

of a dead crab, and the luck of the people dwelling or working in the building would be "cooked"—dead.

BRIDGES

The color of a bridge—no matter what its size—can be important in raising the ch'i of the area and creating harmony between the areas of land that it links. If it links terrain of the same color, a black, gray, green, or red bridge is fine. If, however, it connects areas differing in color, the Five-Element Creative Cycle Color Scheme is important. For example, if the areas in question are green and brown, the bridge should be red, because green and brown are destructive colors, but the sequence of green, red, and brown—wood feeds fire, which creates earth—is creative and good for the area. Similarly, a small garden bridge should harmonize with the colors in the garden, creating visual balance when it links one flower bed or lawn to another. If it does not, then add different objects—a flagpole, a flower pot, a wind chime—so that all five-element colors are present.

SCHOOLS AND BUSINESSES

For schools, businesses, and stores the best colors are lively—green for spring, yellow for early autumn, and red for summer. Avoid the colors associated with winter—dark brown or black—when life is in hibernation. Dark brown or black have the danger of signaling dormant minds or businesses. If, on the other hand, the exterior color of a school or workplace is full of life, students and workers will see that color and feel comfortable. Colors full of life force—green, blue, bluish purple, reddish purple—stimulate the brain, providing access to all of one's energy. Such colors help those who see them to work hard and concentrate. The facade of a business may also be painted according to the Five-Element Creative Cycle (see our discussion of house colors, p. 66).

■■■

The Chinese traditionally avoid white doors, as being gateways to sadness. Black, green, blue, or red are more auspicious colors for entrances. The Four Winds, a Japanese restaurant in New York, installed a green-gray gate at its entrance, in hopes of enhancing its new business. It now serves lunch to a packed crowd. Literal symbolism also applies to the exterior color of buildings. For example, a seafood restaurant should not be painted red, the color of

cooked—dead—shellfish, or business will die. Paint it green, the color of live shrimp and lobsters. Similarly, if a building, be it a business or a home, is shrimp- or crab-shaped, it should be green, not red.

Exteriors: Business-by-Business Colors

AGENT'S OFFICE

Because agents must be articulate and have a good, clear mind to negotiate, red, pink, or white—the colors of fire and metal—will help them be convincing. Also, white is the color of the mouth, so their oral skills will persuade others.

ART GALLERY

The success of an art gallery relies on "word of mouth" regarding the reputation of its artists, as well as on the verbal abilities of its staff and on convincing presentation in general. Therefore, an art gallery should be white, red, or pink. White stands for the mouth, and red or pink for reason.

ARTIST'S STUDIO

The facade of an artist's studio should be mysterious, so either black, dark green, or purple—symbolizing fame—are best.

BAKERY

A bakery should either be all white—for cleanliness—or multicolored.

BEAUTY SALON

A beauty salon should be a combination of red, white, and blue.

CAR WASH

A car wash can be black or brown. *General note:* Parking lots must be light—white, gray, light green, or light blue. Avoid dark colors such as dark green or dark brown.

CARD AND STATIONERY SHOP

A card and stationery shop can be light brown, yellow, or white. Avoid black, as it is too serious.

COMPUTER OR SOFTWARE COMPANY

A computer or software company should radiate stability, intelligence, and importance, so it should have a dark facade of black, dark brown, or dark green.

Construction Firm

Because its main purpose is to construct buildings on the ground (earth equals yellow), the company should be white on the outside (earth creates metal, which is white) or green (according to the Five-Element Destructive Cycle, green overpowers yellow).

Executive Offices in Creative Fields

An executive office in a creative field can be purplish red, white, or light or dark green. Avoid black or dark brown.

Film, Recording, or Television Studios

A film, recording, or television studio should be light blue, dark green, reddish purple, or multicolored.

Funeral Parlor

A funeral parlor should be a monotone of black, white, or dark blue. An all-white facade symbolizes something that is passed, vanished, clean. All-black creates a sense of seriousness. All-blue symbolizes the ascent to heaven.

Grocery Store

A family-oriented grocery store should be light green, light blue, or light yellow—all hopeful colors.

Library

The facade of a library should be one color and dark—black, dark brown, red, purple, gray, or dark green.

Lighting Store

A lighting store should be red or purple.

Music Shop

A music shop should be black, gray, or dark brown.

Pharmacy

A pharmacy should be a light color—white, pink, light green, or light blue. It also can be purple, meaning that it is so red-hot it becomes purple, i.e., that the ability of its medicines to save lives will become well known and well regarded. Avoid black, for it is too heavy a color.

ADVANTAGEOUS COLORS FOR BUSINESSES' EXTERIORS

BUSINESS \ COLOR	BLUE	GREEN	PINK	RED	WHITE	BLACK/ GRAY	YELLOW/ BEIGE	PURPLE	OTHER OPTIONS
Agent's Office			YES	YES	YES				
Art Gallery			YES	YES	YES				
Artist's Studio		YES dark green				YES black		YES	
Bakery					YES				Multicolored
Beauty Salon									White & blue combination
Car Wash						YES black	YES		
Card & Stationery Shop					YES	NO black	YES		
Computer or Software Co.		YES dark green				YES	YES		
Contruction Firm		YES			YES				
Executive Offices in Creative Fields		YES light or dark		YES purplish	YES	NO	NO dark brown		
Film, Recording or TV Studio	YES light blue	YES dark green						YES reddish	Multicolored
Funeral Parlor	YES all blue				YES all white	YES all black			
Grocery Store	YES light blue	YES light green					YES		
Library		YES		YES		YES black & gray	YES dark brown	YES	
Lighting Store				YES				YES	
Music Shop		YES				YES all black or all gray	YES all dark brown		
Parking Lot	YES light blue	YES light green			YES	YES			
Pharmacy	YES light blue	YES light green	YES		YES				
Psychic's Salon		YES dark green		YES		YES black		YES entirely	
Psychologist's Office		YES dark green		YES		YES black		YES	
Real Estate Office		YES dark or light green			YES		YES yellow or brown		Multicolored
Supermarket	YES light blue	YES						YES	
Toy Store					YES				Multicolored
Video Store									Multicolored
Wine Store		YES	YES	NO	YES	YES	YES	NO	Anything other than red or purple

PSYCHIC

The exterior of a psychic's parlor should be all-white, all-red, or all-purple. These colors enhance spirituality.

PSYCHOLOGIST'S OFFICE

The exterior of a psychologist's office should be dark green, red, purple, or black—the color of water—to symbolize clarity of mind.

REAL ESTATE OFFICE

Because the real estate business is affected by the economy, an office should be yellow, brown, white, or dark or light green, to bring in business and sell real estate.

SUPERMARKET

A supermarket should have lively, bright colors—dark or light green, light blue, pink, or purple.

TOY STORE

A toy store should be either white or multicolored.

VIDEO STORE

A video store should be multicolored. It is best to have all the colors of the five elements.

WINE STORE

A wine store can be any color but red or purple, because red and purple are too expected and "rational."

· Colors in Landscaping ·

Whether on residential property or a business site, the colors of the landscape can indicate the ch'i of the area, thus affecting inhabitants. Prospective buyers of property should pay close attention to the colors of the land and vegetation. If the grass is gray or brown or trees are dying, this may augur receding life force and, ultimately, failure for residents.

Conversely, where a plant thrives, so will the inhabitants. The choice of particular plants can be evocative and can help determine residents' destiny. Indeed, the

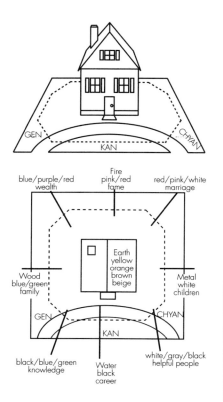

blue/purple/red
wealth

Fire
pink/red
fame

red/pink/white
marriage

Wood
blue/green
family

Earth
yellow
orange
brown
beige

Metal
white
children

GEN

KAN

CHYAN

black/blue/green
knowledge

Water
black
career

white/gray/black
helpful people

he

Five-Element Ba-gua can

be superimposed on

a land plot by aligning "kan"

with the center of the

entrance side. Areas of residents'

lives can be enhanced

by installing

appropriate colors in the

corresponding area of the lot.

■■■

Chinese ascribe special symbolism to certain plants. For example, the tree peony represents spring, love, and affection for beauty. From ancient times, the peony has been regarded as foretelling luck, prosperity, and elevated social status. Lush flowers and green leaves announce good fortune, while if the plant is dry and has an unpleasant color, the owner and family suffer poverty and disaster. The lotus symbolizes summer and spiritual purity. Rising out of the mud, it is clean and white. So the Buddha is often depicted sitting on a lotus, rising above and transcending turbid, mundane existence. Red persimmons stand for joy, prosperity in business, and auspicious beginnings for a new endeavor. Apples symbolize safety, and oranges represent good luck. Evergreens and bamboo are emblems of longevity.

Plant color has long been a signal to feng shui experts of good, nourishing ch'i, and thus of a site's auspiciousness. The greenery of trees and bushes indicates the existence of good ch'i and can also further improve the ch'i of a site and its residents. Spring green is the best shade, a sign of new healthy leaves and healthy ch'i. One should also be aware of the leaf shape, and avoid having sharp, prickly plants near pathways and entrances.

There are also many variations in any particular landscape. If you look at a meadow it may appear lush and green, but on closer inspection you will see it is not uniform. In one place, the trees and plants are greener, while in another they may be drier and more yellow. If you look at the lawn, you may find some patches that are greener than others. Even if you look at the potted plants in front of a house, you may find some plants that are lush, while the ones next door may be scraggly. Plant colors can thus signal the ch'i of the earth.

Sometimes, however, the human hand can harm the color and therefore the feng shui of a site. In the 1960s in Hong Kong's New Territories, construction on a mountainside caused great concern among residents of the area. Digging into the earth revealed a red soil, which when rained upon became a blood-colored mud gushing out of the hill like a bleeding wound. Disturbed local citizens claimed that the earth's flesh had been cut open. To appease them, developers constructed a 100-by-200-foot fence to bandage the gory sight.

The color and health of local animals is another way feng shui experts determine the ch'i of a site. (During ancient times, diviners would examine the internal organs of local animals to help determine the auspiciousness of a site.) Some places have beautiful birds with colorful plumage flying around and singing

bright and clear songs that uplift our spirits. Nearby, the low hoarse caws of black crows may lower our ch'i and depress our moods. Likewise, attention should be paid to the fortunes of neighbors, the luck and tragedies of their lives—such as divorce or bankruptcy. "Occult" events—such as dead birds, cockroaches, or a light bulb blowing— are other meaningful considerations in evaluating the ch'i of an area.

• Enhancing the Landscape with Color •

When a modern feng shui expert looks at a suburban home, what is taken into consideration is not only the landscaping but also the plot and house shapes, the colors of the driveway, house, pool, plantings, and even the neighboring homes. The ideal site is lush and green, accented with brightly colored flowers and shrubs. The plot and home should be "regular" in shape—square, rectangular, or circular—and building colors should be harmonious (see pp. 63, 66). If, however, problems exist, strategic use of color through landscaping can improve the luck of a property and the ch'i of residents.

Placed on either side of an entrance, plants attract and create good ch'i. In the case of a business, restaurant, or store, plants are a subtle sort of advertising, drawing in customers and money.

Plants can also remedy bad ch'i. Large trees can help convert a disturbing view of a graveyard, church, or fast highway into a vista of a pleasant grove, keeping down noise at the same time.

FIVE-ELEMENT BA-GUA COLOR SCHEME

One way to enhance a site's ch'i is to apply the Five-Element Ba-gua Color Scheme to both the land and buildings. The Five-Element Ba-gua Color Scheme can apply to many aspects of a suburban plot: plot and house shapes, as well as the color selection of plantings, pools, and fountains. The Five-Element Ba-gua Color Scheme takes a plot of land or a house and overlays a mystical octagon that is divided into eight aspects of life: wealth, fame, marriage, children, helpful people, career, knowledge, and family. Upon this octagon five elements are superimposed—earth, fire, metal, water, wood—each having a corresponding color.

An auspiciously colored plant sited in an appropriate place can enhance a particular area of residents' lives. For example, a blue spruce planted in the "wealth" area of the lot may improve family finances. A white garden planted in the

Residents seeking to improve their finances can plant red flowers or bushes in the "wealth" area of their garden (above). By installing white flowers or bushes in the "children" area of your garden, you may enhance your fertility and the good luck of your children (below).

■■■

he best plot shapes are square and rectangular (above), which give a sense of wholeness to the property. An irregularly shaped plot missing the "knowledge" area can be rectified by planting blue or purple flowers in the adjacent area; a plot missing the "marriage" area can be resolved by adjacent plantings of red, pink, or white flowers (below).

blue or purple

red, pink or white

■ ■ ■

"children" area may increase one's chances of producing children and will enhance their prospects. Such a garden can be full of white roses, lilies, and jasmine—like the garden at Sissinghurst, the home of Sir Harold Nicholson and Vita Sackville-West.

In one case, a two-career couple in the Northeast, who one autumn had problems finding adequate childcare for their young children, planted white chrysanthemums around the "helpful people" corner of their house. They reinforced the flowers by planting white tulips, narcissus, and snowdrop bulbs to bloom in the spring. Things improved almost immediately, but soured soon after, when they had to fire yet another nanny, who they discovered preferred watching soap operas to watching children. On investigating the plantings, they noticed that the snowdrop bulbs had been dug up by squirrels preparing for winter. They planted white daffodil bulbs and shortly thereafter hired appropriate help.

LAND PLOTS

To apply the Five-Element Ba-gua Color Scheme to a plot of land, one must first identify the driveway entrance to the property. This is the *ch'i kou*, or mouth of ch'i, which will either be at *gen*, *kan*, or *chyan* ("knowledge," "career," or "helpful people," respectively—see p. 60). These three positions are always the starting points when reading how one superimposes the ba-gua onto a plot of land. Each area of the yard associated with the five elements and ba-gua has an ascribed color that can enhance the corresponding area of residents' lives. For example, if you want to improve your finances, locate the far left corner of the yard: the *hsun* or "wealth" position. Sited between "family"—the life situation associated with wood, and thus with the color green or blue—and "fame"—the position aligned with fire and the color red—the "wealth" area can be enhanced by adding red, purple, green, or blue plants or flowers (see p. 60). If you are concerned about your children's well-being, identify the middle portion of the right side of the yard. This is the "children" area. The best color here is white, because this area is associated with the metal element. One infertile New York couple planted an entirely white garden in their home's "children" area and had two children in short order (see p. 60).

It should be noted that some Chinese avoid any white flowers in their gardens, since white forebodes and reminds them of death. In fact one Western landscape architect complained that when he installed some white impatiens in a border, his

Chinese client became very upset and made him replace the border with brighter colors. Depending on your personal association, white can be positive. To some, white is a symbol of purity. On moonlit spring nights white apple blossoms, tulips, and azaleas seem to radiate an almost iridescent glow.

PLOT AND HOUSE SHAPES

The shape of a plot of land or a house may be complete, may have an area missing, or, on the contrary, may possess an addition that creates an asset in inhabitants' lives. The best yard shape is square or rectangular. The Five-Element Ba-gua Color Scheme can be superimposed on an awkwardly shaped plot of land to help bring balance to the shape. For example, if a yard is missing the "knowledge" area, on the left side of the front yard, the planting of purple, blue, or green flowers or shrubs can harmonize the plot shape. If the yard is missing the "marriage" area, in the far right corner of the plot, install red, pink, or white plants to resolve this shape.

Lighting can also be used to remedy poor shapes. A lamp or floodlight, for example, can square off a missing corner of an L-shaped house. Installed at the lowest point of a hill, it can keep ch'i and money from rolling off of a sloped plot.

Landscaping using the Five-Element Ba-gua Color Scheme can also help resolve an unfortunately shaped house. As previously mentioned, the Chinese prefer regular shapes—the square, rectangle, circle. When applying the Five-Element Ba-gua Color Scheme to resolve an awkwardly shaped house or building, use the structure's front door as the ch'i kou to determine where colors should be placed. In feng shui, to apply the ba-gua, one must determine whether the ell of the house is a positive or negative configuration, that is, whether the ell is an addition or instead creates a house shape with an area or areas missing. If the ell is narrower than half the width or length of the house, it is considered an addition to the house and the residents' lives. For example, if a house has an addition in the "wealth" area, residents will enjoy financial rewards. If the addition is in the "helpful people" area, the family will enjoy support from friends, compliance from employees, and patronage from their bosses. If, however, the ell is wider than half the length or width of the house, it creates a missing area. For instance, a house missing a corner on the far right of the house will have marital problems, something missing from the relationship. A breadwinner living in a house with a recessed entry in the center of the house's facade may have career upsets and disappointments.

A *building ell can either create a sense of a missing area or be considered an addition. If the ell is less than half the width or length of the house, it is an addition (above). If the ell is more than half the width or length, it creates a missing area (below).*

∎∎∎

63

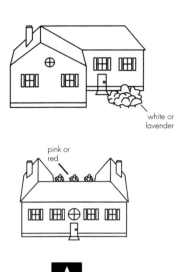

white or
lavender

pink or
red

Awkward
house shapes can be resolved
and enhanced by plants.
An L-shaped house missing the
"helpful people" area can be
resolved by installing white or
lavender flowers (above).
A U-shaped house missing the
"fame" area can be corrected
with a line of pink or
red flowers or bushes (below).

■ ■ ■

Landscaping is one way to resolve unfortunate, unbalanced house shapes. Regardless of the particular color of a flowering plant, any tree or bush may be used as a "green" cure, which when planted outside a missing corner of your home will bring balance to the corresponding areas of your life. The cure may also be more color-specific; for instance, in the case of the house with marital strife, one might plant a pink rhododendron or red and white flowers in order to create an attractive addition in the missing "marriage" corner of the house. The planting symbolically extends the boundaries of the building. If the house is an upside-down L-shape and missing the "helpful people" area and part of the "career" area, white or lavender flowers or a tree will serve to square off the shape. If the house is U-shaped and missing the "fame" area, red flowers can remedy this problem.

POOLS

The color of a swimming pool can also affect the luck of a family. The value of this landscape feature can be traced back to ancient China, where it was regarded as a crucial element. The Chinese word for landscape is *shan-shui*, which translates as "mountain-water." Because accessibility to water is so essential to the cultivation of rice and other crops, water is thought to bring good fortune and wealth to those who enjoy a view of it from their homes and offices. Along with the practical use of water and its resulting monetary symbolism, water also has a meditative aspect within Chinese gardens and landscape paintings. In most landscapes, which tend to be monochromatic, water is a shade of black and is thought of as a vital yet restful quality within a landscape. (Black itself is the designated color of water in the Five-Element Ba-gua Color Scheme. The deeper the water is, the darker it gets.) Among the five elements, water is associated with wisdom, representing clarity of mind and depth of thought.

Within the modern landscape, water is more of a decorative or recreational element when used in fountains or pools. Yet water still retains the symbolism of promised wealth, and color choice of a pool or a fountain can, according to the Five-Element Ba-gua Color Scheme, improve residents' finances. If a pool sits in the "wealth" area—between the fire and wood elements—it should be painted green or blue for wood, or pink or red for fire. If the pool is located in another area of the property, it will both bring in money and enhance the corresponding area of residents' lives, especially if the pool is the correct color. For example, a pool

sited in the "children" area of a yard should be in a tone associated with metal—the element of children—or earth—the element that creates metal—or water—the element that is created by metal. Therefore, a pool located in the "children" area could be either white, beige, yellow, gray, or black.

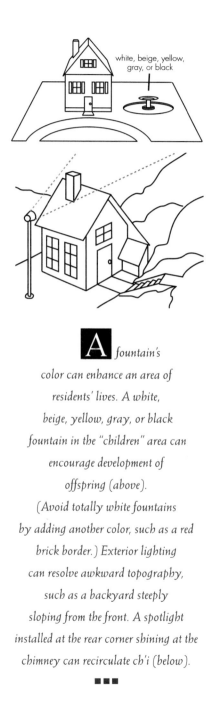

FOUNTAINS

Fountains—one of the nine basic cures of feng shui—can raise the ch'i of a plot of land and enhance specific areas of the lot's ba-gua. If the fountain is lit, it will further enhance residents' fortunes. White or one-color lighting is fine, but the more colors the better. The best color schemes are either the five-element colors or the seven colors of the rainbow. Fountains can be negative if they are a dead white, or if the shape of the pedestal or the pool resembles a coffin. If it does, use "happy" colors, such as red or green. If the fountain is a pure, hospital white, add red bricks or flowers to enliven the monotony.

EXTERIOR LIGHTING

Lighting can improve the ch'i of a site and also resolve specific feng shui problems. One example is when a house sits below street level, which can bring about a state of bad ch'i, affecting your career, marriage, and health. A spotlight can be placed at the rear of the property shining towards the highest point of the house (including television antenna and chimney). The spotlight can be set on the ground or mounted on a pole.

Another use of exterior lighting is when spotlights are installed at four corners of the roof, shining upward. On a house or an office, the four spotlights should converge toward one focal point high above the building—business will successfully develop worldwide, and there will be no limit to career development. The spotlights shining above a house can radiate outward, but this angling should certainly not be used for an office—the business may win international acclaim, but it will also run the risk of bankruptcy.

DRIVEWAYS

The color of the driveway also can affect the luck of residents and the ch'i of a property. Paving should complement the main color of the house. To discern a good color, apply the Five-Element Creative Cycle. Whatever the driveway color is, paint the house in the color of the element the driveway color creates.

A fountain's color can enhance an area of residents' lives. A white, beige, yellow, gray, or black fountain in the "children" area can encourage development of offspring (above). (Avoid totally white fountains by adding another color, such as a red brick border.) Exterior lighting can resolve awkward topography, such as a backyard steeply sloping from the front. A spotlight installed at the rear corner shining at the chimney can recirculate ch'i (below).

∎∎∎

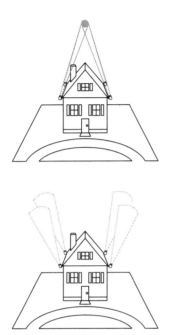

T he ch'i of
a house or office can be elevated
by installing exterior
lights that shine out from each roof
corner to point inward and
upward, converging above the
house (above). The ch'i of
a house can also be elevated by
installing exterior lights
that shine out from each roof corner
and diverge (below).

For example, if the driveway is paved in black asphalt, the best house color is green: black is the color associated with the water element, and green is associated with wood, which is fed by water. If the driveway is paved in rose gravel, then the house should be a shade of beige: beige, a color linked with earth, is created by red, the color of fire. Be sure not to paint a house a destructive color in relation to the driveway: negative consequences would result. If a road aims straight at a building, this can cause negative ch'i. Installing a mirror can help deflect it.

FENCES

The best colors for fences are jade green and red. A jade green fence represents life force and growth, like the green of lush vegetation. A red fence represents girding one's family with power, strength, and nobility. On the other hand, white fences symbolize death, sickness, and failure. Since white picket fences are so common, we suggest a cure. If you cannot paint them red or green, grow red flowers or green vines near or on the fence. Alternatively, you can install red decorative objects: try tying nine red ribbons to the fence.

In the case of an unpainted wooden fence, which is lifeless, grow ivy or plant an evergreen hedge to add a sense of growth, life, and hope. If red flowers, berries, fruit, or ornaments are added to the hedge, the entire effect of the wooden fence, the greenery, and the red will be to create an image of a fruitful apple tree, symbolizing prosperity.

The Five-Element Creative Color Cycle can also be applied to fences. For example, if the property has a green lawn, a black fence is good, because water (black) feeds wood (green).

• Exterior House Colors •

Of course, the color of a house and the face it presents to the street can be uplifting or depressing. The effect of such colors upon us is immediate and intuitive. But the color and condition of a home's exterior can also affect its inhabitants. For example, an ocher house in Berkeley was affected by the heat of a nearby fire. Paint began sloughing off, and the house looked derelict. The owner began to suffer from constant illness and developed an abdominal tumor. "The color affected my health, career, and wealth," she said. At Lin Yun's suggestion, she had

the house painted purple with white trim and pink stairs, and the tumor was successfully removed. The house became a focal point, providing even neighbors who disapproved of the new color with a useful landmark to guide friends to their homes.

Likewise, when a Chinese restaurant opened in a gray and formerly neglected site in San Francisco, the owners painted the building bright green, and almost immediately business improved.

USING THE FIVE-ELEMENT COLOR CYCLES

The choice of your house color can help create a smooth household if you opt to apply the color schemes from the Five-Element Color Cycles. This color sequence can begin with the driveway or at the ground level of your house. If you have a driveway and choose to consider its color, follow the creative sequence: start the color scheme with the driveway, then continue to the walls, then to the shutters and trim, and then to the roof. For example, if the driveway is tan gravel, the color associated with earth, and no bottom trim is being considered, the exterior walls of the house should be white—earth creates metal, the element linked with white. The shutters should be gray or black, the color of water, which is produced by metal. The roof should be a shade of green or blue, the colors associated with wood, which is fed by water. If, on the other hand, you have a brick driveway that is a shade of red or pink—the colors of fire—the walls of the house should be a beige tone, for earth. The shutters and trim should be white, for metal, and the roof gray or black, for water.

If you have no driveway or choose not to use it in selecting the colors of your house exterior, you can use either the Five-Element Creative Cycle or the Five-Element Destructive Cycle to devise a color scheme. If you are using the creative cycle, start at the base trim of the house, or if this is lacking, consider the exterior walls as the first color in the creative sequence. The creative color cycle starts at the bottom and ends at the top of the house. For example, if your house is edged in brick—red for fire—the walls might be beige, because fire creates ash, or earth. The trim and shutters can be white, the color of metal which is mined from the earth. The roof can be gray or black, the color of water which metal creates. If there is neither trim nor shutters, the sequence begins at the bottom trim, proceeds to the walls, and then rises to the roof.

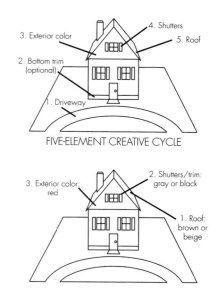

FIVE-ELEMENT CREATIVE CYCLE

When using the Five-Element Creative Cycle to improve the ch'i of one's home, the color sequence can start at the driveway and proceed to the bottom trim, the wall color, the shutters, and then to the roof (above). (Bottom trim is optional.) When using the Five-Element Destructive Cycle (shown here using three colors), the sequence should start with the roof and move down to the walls or bottom trim (below).

■ ■ ■

FIVE-ELEMENT CREATIVE CYCLE — FOUR COLORS					
Roof	pink/red (fire)	brown/yellow (earth)	white (metal)	gray/black (water)	blue/green (wood)
Shutters	blue/green (wood)	pink/red (fire)	brown/yellow (earth)	white (metal)	gray/black (water)
Walls	gray/black (water)	blue/green (wood)	pink/red (fire)	tan/brown/yellow (earth)	white (metal)
Bottom Trim ↑	white (metal)	gray/black (water)	blue/green (wood)	pink/red (fire)	tan/brown (earth)

FIVE-ELEMENT CREATIVE CYCLE — FIVE COLORS					
Roof	pink/red (fire)	brown/yellow (earth)	white (metal)	gray/black (water)	blue/green (wood)
Shutters	blue/green (wood)	pink/red (fire)	brown/yellow (earth)	white (metal)	gray/black (water)
Walls	gray/black (water)	blue/green (wood)	pink/red (fire)	tan/brown/yellow (earth)	white (metal)
Bottom Trim	white (metal)	gray/black (water)	blue/green (wood)	pink/red (fire)	tan/brown (earth)
Driveway ↑	tan/brown (earth)	white (metal)	gray/black (water)	blue/green (wood)	pink/red (fire)

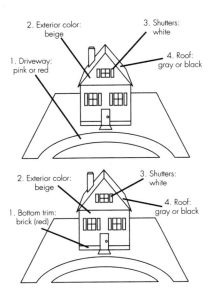

2. Exterior color: beige
3. Shutters: white
1. Driveway: pink or red
4. Roof: gray or black

2. Exterior color: beige
3. Shutters: white
1. Bottom trim: brick (red)
4. Roof: gray or black

When using four colors, the Five-Element Creative Cycle color sequence can start at the driveway and proceed to the bottom trim or wall color, the shutters, and then to the roof (above). One can also start at the bottom trim and progress upward from there, disregarding the driveway (below).

■ ■ ■

To follow the destructive cycle, start with the roof and descend to the walls or bottom trim, applying the color sequence of the mutually destructive cycle: water puts out fire; fire melts metal; metal chops down wood; wood disturbs the earth; earth thwarts water. For example, if the roof is brown, the color of earth, the trim and shutters should be gray or black, the color of water, an element that is thwarted and controlled by earth. The walls, then, should be the color of fire—red—which is doused by water.

According to Professor Lin, one particularly auspicious, transcendental cure to improve the ch'i of a house is to use all the five-element colors in a mutually destructive color sequence. This is a particularly dynamic cure that symbolizes the complete recycling of energy and thus invigorates the house and the ch'i of its residents. One of these special sequences is the following: Tile the roof black or gray (for water); paint the facade a shade of red (for fire); and paint the lower edge white (for metal). Plant green shrubs around the base of the house (for wood) and make the chimney orange or tan brick (for earth). Whether it goes with your taste

FIVE-ELEMENT DESTRUCTIVE CYCLE — FOUR COLORS					
Roof ↓	tan/brown (earth)	gray/black (water)	pink/red (fire)	white (metal)	blue/green (wood)
Shutters	gray/black (water)	pink/red (fire)	white (metal)	blue/green (wood)	tan/brown/yellow (earth)
Walls	pink/red (fire)	white (metal)	blue/green (wood)	tan/brown/yellow (earth)	gray/black (water)
Driveway	white (metal)	blue/green (wood)	tan/brown (earth)	gray/black (water)	pink/red (fire)

FIVE-ELEMENT DESTRUCTIVE CYCLE — FIVE COLORS					
Roof ↓	brown/yellow (earth)	gray/black (water)	pink/red (fire)	white (metal)	blue/green (wood)
Shutters	gray/black (water)	pink/red (fire)	white (metal)	blue/green (wood)	brown/yellow (earth)
Walls	pink/red (fire)	white (metal)	blue/green (wood)	brown/yellow (earth)	gray/black (water)
Bottom Trim	white (metal)	blue/green (wood)	brown/yellow (earth)	gray/black (water)	pink/red (fire)
Driveway	blue/green (wood)	brown/yellow (earth)	gray/black (water)	pink/red (fire)	white (metal)

or not, this is a regenerative cycle of color using the mutually destructive relationship of all the five elements. A house with such a color scheme becomes an emblem both of the dynamic force of ch'i and the continual cyclical change of Tao.

• Decorative Exterior Elements •

WINDOW BOXES

Exterior color schemes need not be limited to outside walls and windows. Other extrinsic elements can be used as an inherent part of an overall color plan. The color of window boxes is another element of a building's facade that can be part of the Five-Element Color Scheme. There are two ways that the color scheme can be applied: apply it to just the window box in relation to the color of the window casement, or you can deal with the window box color as part of the building's entire facade.

The best window box color is one that has a creative relationship with the casement color. For example, if the window is green, paint the window box black or red, because wood (green) feeds red (fire) and is nourished by water (black), and

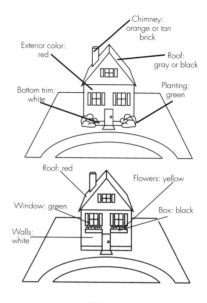

A special transcendental cure is to employ all five-element colors (above). In this case, one need not follow a sequence. Window and window box colors should "create" each other (below). Here the black (water) window box feeds the green (wood) window. (The three other colors help create a symbol of all five elements.)

■■■

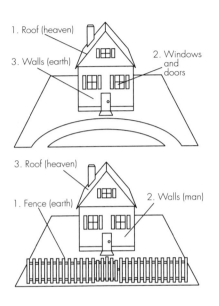

1. Roof (heaven)

3. Walls (earth)

2. Windows and doors

3. Roof (heaven)

1. Fence (earth)

2. Walls (man)

To apply

the Five-Element Destructive

Cycle to a house using

three colors in the heaven, man,

and earth sequence, start at

the roof and descend to the windows

and doors, and then consider

the walls (above).

Fences can also be part of the

Five-Element Color Cycles. When

employing the Five-Element Creative

Cycle, begin at the fence (earth),

proceed to the walls (man), and then

to the roof (heaven) (below).

∎∎∎

thus the home's ch'i will rise. The color of the box should always be different from that of the window casement. The worst color combination of window and window box, however, is the Five-Element Destructive Cycle. For example, if the window is green avoid painting the box white or yellow, because wood (green) uproots earth (yellow) and is chopped down by metal (white).

If you are considering all the colors of the building's facade, use all of the five-element colors—red, yellow, white, green, and black—or all of the Six True Colors—red, white, black, green, blue, and yellow. Here the color sequence does not matter, as long as all the colors are present. For example, if the house is white with red trim and a brown roof, then the window might be green and the window box black. Or the house might be white, the roof red, the window green, the window box black, and the flowers yellow.

WINDOW GLASS COLOR

The color of a window's glass can enhance the lives of residents. Clear glass is fine, but stained glass represents a greater depth and sophistication. The more elaborate the stained glass, whether further etched or of intricate and colorful design, the higher the level of culture and thought. Window color and its use within the overall color scheme can also raise the ch'i of a home and its inhabitants. For example, a clear center pane of a window or a door, surrounded by yellow and blue panes bordered by a blue trim, will create a sense of the house as a sun radiating energy.

PORCHES

The color of a porch can be included in a house's facade when tallying up the five elements. If the house is painted in any array of four of the five-element colors, such as red, white, gray, and tan, the porch might have a sky-blue ceiling or green columns to create the fifth-element color. In this case, with all the five elements present, the color sequence does not matter. If the house is not painted according to the five-element colors, then the porch should be the same color as the house walls or trim.

• Heaven, Man, and Earth Color Sequence •

If you apply the heaven, man, and earth sequence to an exterior, you can consider the roof as heaven, the fence as earth, and the walls and windows as

FIVE-ELEMENT CREATIVE CYCLE COLOR SCHEMES					
Roof (heaven)	tan/brown/ orange/yellow (earth)	white (metal)	gray/black (water)	blue/green (wood)	pink/red (fire)
Windows and door (man)	pink/red (fire)	tan/brown/ orange/yellow (earth)	white (metal)	gray/black (water)	blue/green (wood)
Walls ↑ (earth)	blue/green (wood)	pink/red (fire)	tan/brown/ orange/yellow (earth)	white (metal)	gray/black (water)

FIVE-ELEMENT DESTRUCTIVE CYCLE COLOR SCHEMES					
Roof ↓ (heaven)	tan/brown/ orange/yellow (earth)	gray/black (water)	pink/red (fire)	white (metal)	blue/green (wood)
Windows and doors (man)	gray/black (water)	pink/red (fire)	white (metal)	blue/green (wood)	tan/brown orange/yellow (earth)
Walls (earth)	pink/red (fire)	white (metal)	blue/green (wood)	tan/brown/ orange/yellow (earth)	gray/black (water)

FIVE-ELEMENT CREATIVE CYCLE COLOR SCHEMES					
Roof (heaven)	tan/brown/ orange/yellow (earth)	white (metal)	gray/black (water)	blue/green (wood)	pink/red (fire)
Walls (man)	pink/red (fire)	tan/brown/ orange/yellow (earth)	white (metal)	gray/black (water)	blue/green (wood)
Fence ↑ (earth)	blue/green (wood)	pink/red (fire)	tan/brown/ orange/yellow (earth)	white (metal)	gray/black (water)

FIVE-ELEMENT DESTRUCTIVE CYCLE COLOR SCHEMES					
Roof ↓ (heaven)	tan/brown/ orange/yellow (earth)	gray/black (water)	pink/red (fire)	white (metal)	blue/green (wood)
Walls (man)	gray/black (water)	pink/red (fire)	white (metal)	blue/green (wood)	tan/brown orange/yellow (earth)
Fence (earth)	pink/red (fire)	white (metal)	blue/green (wood)	tan/brown/ orange/yellow (earth)	gray/black (water)

T*he cyclical color schemes on the left follow the heaven, man, and earth sequence. As shown in the drawings opposite, consider either the walls as the earth element, with windows and doors representing man, or the fence as earth, with the walls as man.*

■ ■ ■

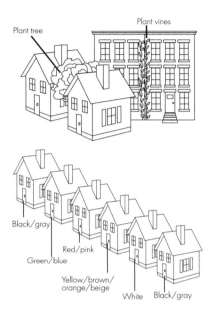

Plant tree

Plant vines

Black/gray

Red/pink

Green/blue

Yellow/brown/
orange/beige

White Black/gray

*To resolve
incompatible neighboring house
colors, place a tree in
the front yard or side area.
In the case of town houses, grow
ivy between them (above).
When neighboring
houses are the same color, their
doors should be painted
in complementary Five-Element
Creative Cycle colors (below).*

man, in the middle. Use this sequence with either the Creative or Destructive Cycle. If you applied the Five-Element Destructive Cycle, for example, the roof might be black: water (black) extinguishes fire (red), which melts metal (white). Thus the fence should be white, and the walls red (see p. 71).

A three-color sequence can also be applied to the exterior, with the roof as heaven, the walls as earth, and the doors and windows as man. For instance, in a Five-Element Creative Cycle, the walls might be beige, the doors and windows might be white, and the roof might be black—earth (beige) creates metal (white), which gives rise to water (black) (see p. 71).

• House Scale and Local Climate •

Other factors, such as home size or climate, can influence the selection of house colors. For instance, the concept of yin and yang can be employed to harmonize the scale of a building. If the house is small, paint it with bright or light colors, avoiding dark tones. If on the other hand a house is large, darker colors are fine. If you live in a hot climate, a lighter exterior color will make you feel cooler. In such an environment, avoid oppressive dark colors. An exception may be made for a large home with grand rooms, where dark tones can create a cooler feeling.

• Neighbors •

The Five-Element Color Scheme also comes to bear on the colors of neighboring houses. Whether a house-next-door has a positive or negative impact depends on whether its color "creates" or "destroys" your own house color. If the neighboring house is a destructive color in relation to your home, this may have negative consequences, bringing down the ch'i of your house. If, for example, your house is white and your neighbors paint their house red, this color juxtaposition will bring down the luck of both families, since fire destroys metal. But if the neighboring house is painted in a creative color in relation to your house, then this will enhance your property's ch'i. For instance, if your neighbor's house is dark brown, it may affect you negatively as being a depressing color you see every day when you return home. But if your house is white—the color of metal, which is created by earth, brown—then the brown house is good

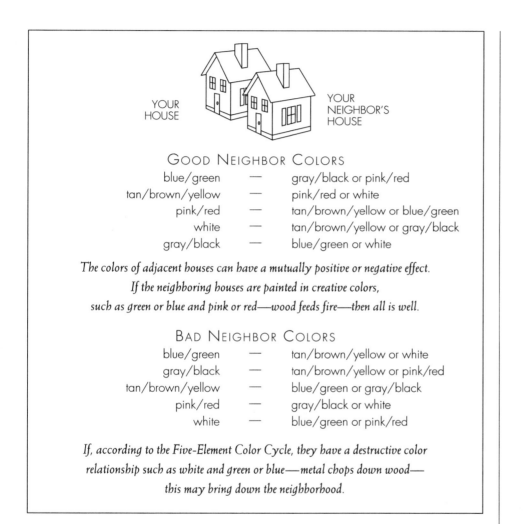

YOUR HOUSE

YOUR NEIGHBOR'S HOUSE

GOOD NEIGHBOR COLORS

blue/green	—	gray/black or pink/red
tan/brown/yellow	—	pink/red or white
pink/red	—	tan/brown/yellow or blue/green
white	—	tan/brown/yellow or gray/black
gray/black	—	blue/green or white

The colors of adjacent houses can have a mutually positive or negative effect.
If the neighboring houses are painted in creative colors,
such as green or blue and pink or red—wood feeds fire—then all is well.

BAD NEIGHBOR COLORS

blue/green	—	tan/brown/yellow or white
gray/black	—	tan/brown/yellow or pink/red
tan/brown/yellow	—	blue/green or gray/black
pink/red	—	gray/black or white
white	—	blue/green or pink/red

If, according to the Five-Element Color Cycle, they have a destructive color
relationship such as white and green or blue—metal chops down wood—
this may bring down the neighborhood.

for your luck. If your house color is a creative color in relation to your neighbor, for example, you will also enjoy good fortune. Conversely, if your house color "destroys" your neighbor's house color, your property's ch'i will be harmed. Similarly, if your house is the same color as your neighbor's, the doors should be of complementary colors.

Another cure for incompatible colors is to plant a tree in front of or between the houses, or, in the case of town houses or apartments, grow a vine up the division.

If you want to bring up the ch'i of your home because the neighborhood buildings weaken its ch'i, you must know what color to use to stand out. Here is how we cure with color: if the house next door is red and yours is white, because fire (red) destroys metal (white), you will be overcome. If you use black, you will overpower him. If you use green, you will cultivate him. If you use yellow, he cultivates you. If you use purple, that is the best. The house will be so full of ch'i and luck that it will achieve the highest level of good fortune.

Chapter Five:

FENG SHUI INDOORS: CHINESE COLOR THEORY CAN IMPROVE YOUR CH'I AND YOUR LUCK

House interior colors influence our ch'i, often to a greater extent than the colors of a house's exterior or of our clothes. This is because we spend a greater amount of time indoors, without changing the color of our bedroom wall the way we change our clothes. This is the interior realm of feng shui, the Chinese theory and practice of how the ch'i of our surroundings influences our own ch'i. In the practice of feng shui, the philosophy of color is an important consideration when painting the interior of a home or office. A feng shui expert will sometimes advise a person to use or avoid certain colors.

We will always be influenced by the colors of our environment, but the extent of this influence depends on the state of each person's ch'i, which may be good or bad. If we take the instance of two identical houses, each with bad feng shui—perhaps they have unaligned doors, narrow halls, or unfortunate colors—but each is occupied by a different couple, we may find that one

couple experiences more difficulties than the other. This is because the first couple's ch'i may be bad and the second couple's ch'i may be good. If an occupant's ch'i is good, nothing bad will happen right away. But in the case of bad personal ch'i, there may be constant fights, sickness, financial setbacks, and perhaps eventual divorce. The couple with good ch'i will also be affected by their home's feng shui, but it will take a longer time. Gradually, after five to ten years, their troubles will get worse and worse. So people with bad ch'i will suffer the effect of bad feng shui almost immediately. Feng shui affects people regardless of whether their ch'i is good or bad, but the time frame of feng shui's negative impact will be different, taking longer for those with good ch'i, and less time for those with bad ch'i.

The colors we paint our homes and work spaces affect our ch'i. Certain colors depress us, relax us, or stimulate us. The best colors for a house's interior are light blue or light green. These are relaxing colors that help the occupant shift from the stress and stimuli of work and the outside world to a more peaceful and nurturing setting. Light blue and light green are also good colors for living rooms. Color choice is a highly personal endeavor. Some colors suggested here may not agree with your own color aesthetics. If you opt not to use color as a cure to improve your feng shui and ch'i, simply choose your favorite colors, ones that make you feel comfortable and happy. (Avoid black as a predominant color—it is a sign of depression and self-destructiveness.) However, if you are seeking to improve the harmony of the house, try using Chinese color theory to help improve your ch'i and your luck.

Interior colors greatly affect us. They can be used to create a desired response. These are the hues that set the atmosphere of a home or workplace. If you choose to apply Lin Yun's color theory to your home or office, there are a number of methods from which to select an appropriate palette for a room's use or occupants' ch'i. This chapter will offer three different color methods to improve personal ch'i: analysis geared to the particular type of environment we are considering, whether room-by-room analysis in the home or, outside the domestic sphere, business-by-business; the ba-gua five-element color octagon; and the five-element color scheme. No matter what method you employ to select them, the colors of all home interiors should be restful and relaxing, to help us refuel and revitalize ourselves.

• *The Ba-gua Five-Element Color Octagon* •

The Five-Element Ba-gua Color Octagon can be applied to a house's interior or to a specific room. Readers of previous chapters will already be familiar with the ba-gua, the heart of Chinese color theory. Based on the trigrams of the *I Ching*, the ba-gua is a map of life situations that can be super-imposed on the layout of a room or a building. These life situations range from wealth to marriage, fame to career.

In order to determine the location of these areas of your room or building, stand at the threshold. Imagining the octagon to be centrally located in the room, the door can be said to be located in three possible positions—three sides of the octa-gon—left, center, or right. Align the kan, or "career" area, with the center position.

This is the three-door ba-gua. As you face the threshold, if the door is positioned on the right, it is in the chyan, or "helpful people" area, meaning people who work for you and those who can help you from above. If the door is in the middle, it is in kan, the "career" area. If you enter on the left side, the door is in the gen, or the "knowledge" position.

Overlaid on the ba-gua are the five elements. The corresponding colors or mutually creative sequence can be applied to a specific area of a house or room to activate or enhance this same area of your life. For example, if you are seeking fame and career advancement, you might want to position a painting with red in it in the "fame" area of your office. Also, green or blue, the colors of wood, which feeds fire, and yellow, tan, orange, or brown, the colors of earth, which fire creates, are colors that can enhance the "fame" area.

• *The Home: Room-by-Room Colors* •

To the Chinese, a home is similar to a human body. Each room in a home is like a separate, but interrelated, vital organ—part of the whole, but with its own functions. Room-by-room colors give us a general idea of appropriate colors to help enhance the specific room's atmosphere and uses.

FOYER

The best color for an entrance foyer, the threshold to our experience of a home, is a light or bright color. The foyer should be well lit, so that when we

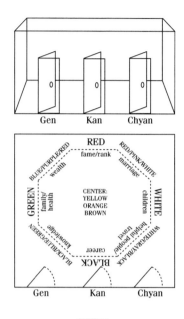

In order
to determine where the areas of
your room or building
are, stand at the threshold.
Imagining the octagon
to be centrally located in the room,
the door can be said to
be located in three possible
positions—three sides of
the octagon—left, center, or right.
Align the kan, or "career"
area, with the center position.
This is the three-door ba-gua.

■ ■ ■

ROOM-BY-ROOM WALL COLOR								
COLOR / ROOM	BLUE/ GREEN	BROWN	RED	PINK	WHITE	GRAY/ BLACK	BEIGE/ YELLOW	MULTI- COLOR
Foyer	YES light	NO		YES	YES	NO		
Kitchen			NO		YES	NO		
Master Bedroom	YES light			YES				
Child's Bedroom	YES							
Living Room	YES	YES			YES		YES	YES
Shrine Room	YES		YES			YES	YES	
Library/ Study	YES light	YES		YES				
Dining Room	YES			YES	NO	NO		
Bathroom				YES	YES	YES		

While interior colors may be selected according to taste, see the table on the right for colors that are particularly appropriate for certain rooms, and for colors that should generally be avoided.

■ ■ ■

return home, our ch'i is positively altered and we enter a pleasant realm that regenerates our energy. The best colors are light, almost off-white, shades of blue, green, or pink. These are colors of hope and welcome, drawing us into the rest of the house. Light colors are especially effective if there is no natural light source, or if the foyer is small and constrained. Avoid dark colors, unless the foyer is particularly large. Good, creative lighting can also enhance a dark foyer.

KITCHEN

In a kitchen, white is the best color. It shows off the colors of food, as if it were a blank canvas upon which the cook creates a meal of red tomatoes, green peppers, yellow squash. Besides being the color of purity and cleanliness, the color white—the color of metal—is compatible with the kitchen's basic element, fire (fire overcomes metal). Avoid all-black kitchens, because black —the water element color—destroys fire. Also avoid a red kitchen or there will be too much heat in the kitchen and the cook of the family will always be hot-tempered. Red and black as accent colors, however, are fine in a predomi-nantly white kitchen.

BEDROOM

Pink is best for the master bedroom. This is because the marriage position of the ba-gua sits between fire (red) and metal (white). Pink is also an auspicious color. Light green and light blue are also fine for bedrooms, as they are colors of hope and cultivation. If a single man or woman seeks the opportunity to get married or wants to find a girlfriend or boyfriend, paint the bedroom peach or pink. One anxious mother of four teenage daughters in Berkeley, California, painted each girl's bedroom peach.

The Chinese traditionally avoid having white blankets—the color of the shroud that covers the dead—because they fear sleep will seem like death. Plain white sheets or white sheets with flowers or colorful designs are fine. Pink or red sheets and blankets are used by those who want to get married, as well as by newlyweds desirous of ensuring marital bliss. Blue or green blankets help promote development in the young. Yellow is fine for the elderly.

The colors of the bedroom can also be used to create a powerful metaphor and cure. In one Long Island house, the master bedroom was situated over the garage. The feng shui expert noted that this situation could create instability in the couple's marriage, family, and business, because their cars were constantly moving in and out, shifting beneath them. Applying a special BTB cure, the expert suggested that the floor be brown wood or a tan carpet, symbolic of the stable trunk of an old tree. He added that the walls should be green, symbolizing the healthy leaves of the tree, with red accent colors for the walls or ceilings, suggestive of fruit or flowers growing in the tree. He explained that the red connotes flowers or fruit blooming from a nice old foundation. The leaves are lively, and the fruit brings good fortune—fruitfulness.

For young children, education is important. The colors of the knowledge area, which sits between water and wood on the ba-gua wheel, are black, blue, and green. Black is fine for furniture to encourage deep thoughts. Green is the best of these colors. These are colors that help the child apply himself or herself in school. This is especially important if the child is under twenty years old. Once a child is over twenty, he or she should select their own favorite colors. In the bedroom of an unruly child, use deep or solemn colors on the walls and for furniture, such as the desk and bureau. White, black, and brown are recommended.

LIVING ROOM

The living room should be full of many colors, shades, and patterns. As the place to entertain guests, the living room should be full of pleasant visual stimuli to keep the atmosphere and conversation lively and diverse. The best colors are yellow, beige or tan, or green or blue. Browns or yellows align the living room with the earth and the central position. The living room is the hub of the house, and earth—symbolized by brown, tan, yellow, and orange—is the element at the center (tai-chi) of the ba-gua.

MEDITATION ROOM

If there is a meditation room, an austere setting is best: solid, calm, subdued colors, with no patterns. Subtle and deep shades of blue, green, black, yellow, or red will encourage deep concentration and thoughts.

LIBRARY

The library or study should also have a quiet, meditative atmosphere but be a bit livelier than a meditation room. The best color, however, depends on the types of books that the residents like to read. If they prefer serious books, brown is an appropriate shade. For less serious readers, pale blue, light green, or pink are good.

DINING ROOM

Dining rooms, where the family eats and entertains, should be appetizingly colorful. Pinks, greens, and blues are best. Avoid black or white or a mixture of black and white. These colors are less conducive to enjoying eating. Two exceptions to avoiding blacks are when very elegant dining is desired or when residents are trying to lose weight. Black place mats or tablecloths are helpful when dieting. In general, however, light and bright colors are best for dining, stimulating the palate.

BATHROOM

Bathrooms can be black or white or a mix of black and white. Accent the black or white with brighter colored towels. Pink and other pastel colors are also good. Gray is fine.

ADVANTAGEOUS COLORS FOR BUSINESSES

BUSINESS \ COLOR	BLUE	GREEN	PINK	RED	WHITE	BLACK/GRAY	BEIGE/YELLOW	PURPLE	OTHER OPTIONS
Accounting Firm					YES		YES yellow		
Agent's Office		YES dark green		YES	YES	YES			
Architect or Designer	YES	YES							Five-element colors
Artist's Studio					YES all white	YES all black			Multicolored bright-colored
Banking & Investments	YES	YES			YES		YES		
Computer Company	YES	YES							
Construction Firm		YES			YES	YES			
Doctor	YES	YES	YES		YES			YES	
Executive Offices in Creative Fields	YES sky blue	YES		YES					Multicolored
Film, Recording, or TV Studio	YES	YES light green	YES		YES	YES			
Lawyer	YES	YES			YES	YES	YES		
Library	YES	YES		YES	YES	YES			
Police Station					YES				
Psychologist's Office					YES				Five-element colors, multi-colored
Publishing House	YES	YES						YES	
Real Estate		YES light green			YES		YES		
Software Company					YES	YES	YES		
Trading Firm		YES							
Writer		YES			YES				Many accents

Offices come in every shape and color, but some colors may be better suited than others to the work going on there.

∎∎∎

• Interiors: Business-by-Business Colors •

Color can be particularly effective in work and business. Please note that a cash register should be in a bright, lively color that has life force, such as red, green, or a wheat shade of beige.

The best stationery print or paper color is green, because it has life force. Black ink on green stationery is also auspicious. For office stationery, darker colors will encourage workers to be more stable and responsible. Lighter colors will

Color plays a key role in defining the atmosphere for any kind of retail business— either attracting or discouraging business.

■ ■ ■

ADVANTAGEOUS COLORS FOR STORE INTERIORS

STORE \ COLOR	BLUE	GREEN	PINK	RED	WHITE	BLACK/GRAY	BROWN/YELLOW	OTHER OPTIONS
Appliance Store					YES			Multicolored
Art Gallery			YES	YES	YES		YES light yellow	
Bakery					YES all white			Multicolored
Bar		YES			YES	YES		Avoid red
Beauty Salon						YES black&white		Multicolored
Bookstore	YES	YES					YES yellow	
Car Wash					YES			
Card & Stationery	YES light blue	YES light green	YES		YES			
Computer Store		YES light green		YES				Multicolored
Funeral Parlor	YES light blue			YES	YES all white			
Furniture	YES	YES		YES accents				
Grocery Store		YES light green	YES		YES			
Jewelry Store	YES			YES	YES			Avoid yellow
Lighting Store	YES light blue	YES light green	YES		YES			
Men's Clothing								Bright colors
Music Shop	YES all blue	YES all green		YES all red	YES all white	YES all black		
Parking Lot	YES light blue	YES light green			YES		YES light yellow	Bright colors
Pharmacy	YES light blue		YES					
Psychic's Salon					YES all white	YES all black		Multicolored
Restaurant	YES	YES						Multicolored, avoid red in seafood
Shoe Store				YES	YES	YES gray	YES brown	Avoid black with white
Supermarket					YES	YES gray	YES light yellow	Multicolored
Toy Store		YES light green	YES		YES		YES light yellow	Multicolored
Video Store	YES light blue	YES light green	YES light pink		YES all white		YES light yellow	
Wine Store	YES light blue	YES light green	YES					
Women's Clothing	YES	YES						Bright colors

encourage more mental and physical activity in the office. The same goes for business cards. For a new business, use green. It symbolizes spring, hope, and the East, where the sun rises and auspicious beginnings appear.

ACCOUNTING FIRM

Accounting firms should be either white or yellow—not too colorful—so the accountants can calculate clearly, quickly, and accurately.

AGENT'S OFFICE

Because an agent needs to think of many angles to sell a book or a movie, the agent must have a clear mind. The chyan and kan areas of the ba-gua represent the head and ears and are aligned with the colors gray, black, and dark green. Therefore, these colors are good; in addition, try white or red, or install black-and-green striped wallpaper.

APPLIANCE STORE AND SUPERMARKET

Appliance stores should be white or colorful. Supermarkets should also be colorful.

ARCHITECT'S OR DESIGNER'S OFFICE

If an architect or designer is hoping to develop long-term building relationships, their offices should be green or blue or have all the colors of the five elements. With these colors, their brains function well and quickly, their minds are open to ideas and their clients' needs, and they are ready to help others with their designs.

One New York interior designer who uses a feng shui consultant in most of her projects designed her offices using all the colors of the five elements to increase business and to improve design output and interoffice relationships. For the floors, she used a green stain. She washed the walls with ocher, and the ceiling was white-washed brick. The windows were painted a terra-cotta red, and the furniture was black.

ART GALLERY

The interior of an art gallery can be white, red, pink, or light yellow for credibility and credit.

ARTIST'S STUDIO

For paintings to stand out, an artist's studio can be all-white, all-black, bright-colored, or multicolored.

BAKERY

A bakery should create a sense of cleanliness, with all white interiors or multicolored walls.

BANK

Banks and investment businesses should be white, symbolizing incorruptibility, with green and blue accents to represent security and reassurance.

The general manager of a bank in San Francisco described the effect of changing the interior color of one wall of the branch office. Originally, a painting portraying autumn scenery hung on yellow walls. The drapes were yellow and brown as well. This created a heavy, dull feeling; both staff and customers tended to be argumentative, temperamental, and irrational. After she had a wall painted green, the branch became incredibly busy; the customers are now easier to reason with, calmer, and more open to different opinions. The staff also get along better.

BEAUTY SALON

There should be beautiful colors in a beauty salon, so black-and-white or multi-color are good choices. They encourage creativity and the successful search for enhancing the best physical traits of each customer.

BOOKSTORE

Bookstores should be green, blue, or yellow.

CAR WASH

A car wash should be white, giving customers a clean impression.

CARD AND STATIONERY SHOP

To enable salespeople to have clear minds, the shop can be white, pink, light green, light blue, or beige.

CLOTHING STORE

Interiors of men's clothing stores should be bright. Women's clothing stores should either be bright or have green or blue colors.

COMPUTER COMPANY

To increase optimism and intellectual and creative activity, use many colors, or light blue, or green.

COMPUTER STORE

In a computer store, a variety of colors will allow salespeople to be clever and have clear minds. Red or light green are also good colors.

CONSTRUCTION FIRM

To increase intelligence, the construction office should either be a bright color, green, or white and black.

DOCTOR'S OFFICE

Doctor's offices should be primarily white, a color of cleanliness and purity. A doctor's office should give patients a sense of hope and life with light off-white tones—apple green, light blue, or off white with a pink hue.

EXECUTIVE OFFICES IN CREATIVE FIELDS

Use sky blue, green, purple, red, or multicolors.

FILM, RECORDING, OR TELEVISION STUDIO

A film, recording, or television studio should be all-white, all-black, light green, pink, or sky blue.

FUNERAL PARLOR

A funeral parlor should be either all white to symbolize peace and calm, light blue to represent the rise to heaven, or red to purge any evilness and to thwart any "strange events."

FURNITURE STORE

The best color for a furniture store is green, the color of wood, the material of fine furniture. Another auspicious color scheme is based on a fruit tree, with green for leaves and red for fruit.

GROCERY STORE

A mom-and-pop grocery store should be light green, pink, or white, to encourage the harmony of workers and to symbolize cleanliness.

IMPORT-EXPORT OFFICE

Trading firms, merchants, or businesses should have tones of green or blue to increase revenues.

JEWELRY STORE

Avoid yellow in jewelry stores.

LAWYER'S OFFICE

A lawyer's office should be black and white or yellow and white to fan the flames of eloquence in court disputes. Black stands for the water element, associated with wisdom. White is the color of metal, the element that refers to eloquence, justice, and righteousness. A lawyer's office can also be green or blue—the color of the wood element. In general, conference rooms, lawyers' offices, and legal courts should be dark and solemn, employing black, white, beige, maroon, dark green, or blue. The last three colors all feed the fire element, which can represent argument.

LIBRARY

To encourage deep thoughts and questions in readers so that they can clearly research all angles of a subject, a library should be all-white, all-black, light green, light blue, or red.

LIGHTING STORE

To create the appropriate atmosphere for selling lighting fixtures, white, pink, light green, and light blue each give an air of romance, hope, and harmony. Keeping the lights on will further help sales.

MUSIC SHOP

A music shop can be all-white, all-red, all-black, all-blue, or all-green.

PARKING LOT

The inside of a parking lot or garage must be bright so that workers and customers can be hopeful, and so that criminal activity is discouraged. Here the best colors are white, light green, blue, or yellow.

PHARMACY

The impression of a pharmacy should be clean and pure. Light blue will give clients hope, and pink symbolizes the progression from illness to happiness.

POLICE STATION

Police stations should be primarily white, a symbol of purity and incorruptibility. Avoid having bright accent colors.

PSYCHIC

A psychic's parlor should be either all-white, all-black, or multicolored.

PSYCHOLOGIST'S OFFICE

A psychologist's office can be white for cleanliness. Alternatively, it can be multicolored with a balance of all five element colors, so that the therapist remains rational and maintains his or her own balance.

PUBLISHING HOUSE

The best color for a publishing house is purple, referring to the Chinese saying that purple is the superior color and that good things will develop from purple. Green and blue are also positive literary colors, as wood is the source of paper.

REAL ESTATE OFFICE

Because a real estate agent deals with land sales, light yellow—an earth color—is good for the office, as is white—the color of metal, the element earth creates. Light green also is fine, because wood (green) overpowers earth.

RESTAURANT

Restaurants may be multicolored or should have colors that create a feeling of contentment and hope, such as green or blue. Avoid red in seafood restaurants. Red is the color of cooked—dead—shellfish, thus portending that the business will fail. Green, the color of live shellfish, is good. A bar should not be red, a color that can inspire brawls. White, black, and green are better colors. Lin Yun also recommends bright colors outside. Alternatively, the restaurant's name can be created from brightly colored or sparkling beads that glisten in the sunlight and lure in business. Interiors of restaurants should encourage hearty appetites by stimulating our ch'i. "When you enter a restaurant and something like a wall blocks your way, by the time you get to the table you may already be fed up. So you lose your appetite and don't feel inclined to eat." Colors that stimulate the eyes and thus the taste buds are the best choice, creating a feeling of contentment. Red and green are best and should be used with other lively accent colors, so that when diners enter the restaurant they will have a comfortable, "special" feeling.

SHOE STORE

Shoe stores can use shades of black (gray) or brown. Avoid combining black with white, the colors of mourning. A combination of white and red is good for a shoe store.

SOFTWARE COMPANY

To create an environment suitable for clear thinking and quick work, white, beige, or gray will sharpen and wake up workers' minds and increase intelligence and intellectuality.

SUPERMARKET

A supermarket can promote harmony and cleanliness with light yellow, gray, or white. It should be well lit.

TOY STORE

A toy store can be white, pink, light green, light yellow, or multicolored.

VIDEO STORE

All-white, all-pink, light-blue, light green, or light yellow are good colors for video stores.

WINE STORE

Wine stores should use color to embody the "enjoyable" image of wine. Light green and light blue are fine for this purpose. Pink symbolizes the romantic and represents enjoying "the good life."

WRITER'S STUDY

A writer's study should be a peaceful shade of green or white, with lots of accent colors to stimulate thoughts, ideas, and creativity.

• The Five-Element Color Scheme in Business Interiors •

The Five-Element Color Scheme can be applied to businesses. For example, when a young woman opened a gourmet coffee and tea shop in 1988 in San Francisco, she applied the Five-Element Creative Cycle to the walls. She painted the lower part of the wall black for water, the middle part green for wood, and the upper part red for fire—thus creating a sequence of water nourishing wood and wood feeding fire. By all accounts, her business has grown steadily and is now an attraction in the financial district.

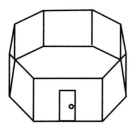

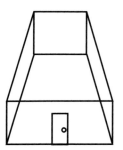

The best shapes for rooms are octagonal, rectangular, circular, or square.

■ ■ ■

•Education: Schools •

School colors should never be dull or monotonous, lest the student become bored. The most important learning environment is the classroom: teachers and architects who design schools need to pay special attention to interior colors. For example, if all the desks and chairs are brown, the child's education may be wooden. In the classrooms, this all-brown effect can be balanced by painting the walls with more colorful tones.

When choosing classroom colors, however, the particular needs of the students must first be identified. Different colors bring out the best and cultivate the minds of different types of children. If the school is for normal children, use both a solemn, peaceful wall color and off-white; mix this scheme with accents of livelier colors. This arrangement will create stability in the classroom while encouraging some lively and creative ideas. If the school is for students with special needs, such as physically handicapped or mentally disabled children, brighter colors are best. These influence such children by stimulating the brain and thus slowly improving their mental and physical activity. Green is a particularly good color in a classroom for children with special needs, for green brings thoughts of spring—it is the color of new growth. "Children love green, because it enters their eyes and progresses through the brain, and they will think of spring. They will feel alive, blossoming with a sense of new possibilities." Bright colors are recommended for children with Down's syndrome or mental disabilities. Red is a particularly stimulating color. However, be sure not to use too much red with a normal child, or the child may become anxious and driven to argue and fight. For the unruly child, dark colors, such as dark green or blue, are recommended. Alternatively pastels, such as light green, pale blue, or gray, may softly influence such a child. Avoid bright colors, such as red.

• Room and House Shapes •

Color can also be used to resolve the problem of an awkwardly shaped house or room. According to the Chinese, regular shapes—octagonal, square, rectangular, or circular—are fine, but if a building or room is "missing" an area, then the corresponding area of the ba-gua will be lacking in the occupants' lives.

These regular shapes give the occupant of the room a sense of wholeness.

■■■

To determine if the shape has an addition or a deficit, first look at the L of the structure. If the L is less than half as wide or long as the room or house, it is considered an addition, which will create an asset in the inhabitants' lives. If it is larger than half the width or length it creates a negative shape. As with plot shapes (see p. 62), the Five-Element Ba-gua Color Scheme can be superimposed on the shape to help bring balance to an odd-shaped room or house. For example, if a master bedroom is missing the far right corner, the "marriage" area, the couple may find their marriage lacking (see p. 91). This problem can be rectified by applying color to the room. In this case, the addition of something red or pink will enhance the marriage area and thus bring harmony to the relationship. One New York woman hoping to enhance her social life hung a red ribbon in the marriage area of her bedroom, which was missing a corner, and started dating a young man on a regular basis.

Octagons and hexagons are lucky shapes. The hexagon can be further enhanced if either plants or a sequence of six colored objects—white, red, yellow, green, blue, and black—are placed in each corner (see p. 93).

· The Five-Element Color Scheme ·

The Five-Element Color Scheme is a vertical color sequence that can be applied in any room in order to enhance the ch'i or feng shui. The ten possible auspicious color schemes are based on the Five-Element Creative Cycle and the Five-Element Destructive Cycle. These cycles are applied to the vertical plan of a house or room. Despite the negative implications of its name, the destructive color scheme is just as positive as the creative color scheme. They both symbolize the natural process of constant cyclical change and thus serve to incorporate us symbolically within it. As an outgrowth of the interplay between yin and yang, the two physical processes of destruction and creation symbolize different manifestations of ch'i and the concept of eternal recurrence. A room containing the Five-Element Color Cycle—be it creative or destructive—becomes a symbol-ically charged microcosm of the cyclical progress and process of the universe.

When applying
the Five-Element Ba-gua to an
irregular room shape,
an area smaller than the room's
width or length is
considered an addition (above),
while a larger area
creates a deficit (opposite).

■ ■ ■

FIVE-ELEMENT CREATIVE CYCLE — THREE COLORS					
Ceiling	gray/black (water)	blue/green (wood)	white (metal)	red/pink (fire)	beige/yellow (earth)
Walls	white (metal)	gray/black (water)	beige/yellow (earth)	blue/green (wood)	red/pink (fire)
Floor ↑	brown/beige (earth)	white (metal)	red/pink (fire)	gray/black (water)	blue/green (wood)

FIVE-ELEMENT CREATIVE CYCLE — FIVE COLORS					
Ceiling	pink/red (fire)	tan/brown/ orange/yellow (earth)	white (metal)	gray/black (water)	blue/green (wood)
Curtains	blue/green (wood)	pink/red (fire)	tan/brown/ orange/yellow (earth)	white (metal)	gray/black (water)
Walls	gray/black (water)	blue/green (wood)	pink/red (fire)	tan/brown orange/yellow (earth)	white (metal)
Furniture	white (metal)	gray/black (water)	blue/green (wood)	pink/red (fire)	tan/brown orange/yellow (earth)
Floor ↑	tan/brown/ orange/yellow (earth)	white (metal)	gray/black (water)	blue/green (wood)	pink/red (fire)

THE CREATIVE CYCLE

If you want to use the Five-Element Creative Cycle Color Scheme, begin at the floor level. Choose any color you like for the color of the floor, rug, or carpet. Let us illustrate, assuming that you have selected the color red. Since red is aligned with the element fire, the next color will be aligned with the element that fire creates—earth. Thus the wall (moving up) can be yellow or beige. The ceiling should then be painted a color aligned with the element earth creates—metal. It will thus be white. Now the room symbolizes fire creating earth, which holds metal. The other creative color schemes are illustrated in the tables.

When applying either the creative or the destructive colors, feel free to use the shade and tones that you prefer and that aesthetically complement one another.

One Five-Element Creative Cycle Color Scheme for a bedroom might be a green rug, pink wallpaper, and a beige ceiling. Another might be a wheat-colored carpet, white walls, and pale gray ceiling. If the ceiling is low, add a mirror to the wall.

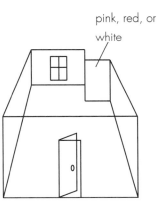

pink, red, or white

Color can cure a missing area: a room missing the marriage area can be resolved with the addition of something pink, red, or white.

FIVE-ELEMENT DESTRUCTIVE CYCLE — THREE COLORS					
Ceiling ↓	white (metal)	blue/green (wood)	beige/yellow (earth)	gray/black (water)	red/pink (fire)
Walls	blue/green (wood)	beige/yellow (earth)	gray/black (water)	red/pink (fire)	white (metal)
Floor	brown/tan (earth)	gray/black (waterl)	red/pink (fire)	white (metal)	blue/green (wood)

FIVE-ELEMENT DESTRUCTIVE CYCLE — FIVE COLORS					
Ceiling ↓	tan/brown/ orange/yellow (earth)	gray/black (water)	pink/red (fire)	white (metal)	blue/green (wood)
Curtains	gray/black (water)	pink/red (fire)	white (metal)	blue/green (wood)	tan/brown/ orange/yellow (earth)
Walls	pink/red (fire)	white (metal)	blue/green (wood)	tan/brown orange/yellow (earth)	gray/black (water)
Furniture	white (metal)	blue/green (wood)	tan/brown orange/yellow (earth)	gray/black (water)	pink/red (fire)
Floor	blue/green (wood)	tan/brown/ orange/yellow (earth)	gray/black (water)	pink/red (fire)	white (metal)

The Creative and Destructive Cycle Color Schemes on this and the previous page are vertical symbols of the dynamic interplay between heaven, earth, and man, and can be used to energize any room.

■ ■ ■

THE DESTRUCTIVE CYCLE

If you want to employ the Five-Element Destructive Cycle Color Scheme, you should start at the top—the ceiling—and select a color—for instance, white—then apply to the wall the color that white, or metal, overcomes. That color is green or blue, for wood. Then install a carpet or rug (or stain the floor) the color wood overcomes, which is brown or tan, the color of earth. The other destructive sequences are illustrated in the tables provided here.

• Furniture and Window Treatments •

There are a number of ways to select the colors here: you can use the Heaven, Man, and Earth sequence; use the Five-Element Color Scheme, or use colors that adjust the ch'i of the inhabitants. Exploring the first method, the ceiling symbolizes heaven and the floor represents earth. Walls, window treatments, and furniture are then viewed as the domain of people,

and thus match the color family of the walls. For example, if the wall is yellow, for earth, then the furniture or curtains can be brown or orange. Yet furniture also can be associated with "earth," because it sits on the floor. In such case, if the floor is red, then the furniture can be a pink or reddish purple, or any color in the red family.

Drapes and shades should match the color of the ceiling, wall, or floor, depending on whether you want to associate them with heaven, man, or earth.

Using the Five-Element Color Scheme to select the color of furnishings and window treatments is another way to further enhance and enliven a room. Curtains and furniture can be considered as separate parts in the Five-Element Color Scheme. The sequence goes as follows: floor, furniture, walls, curtains, and ceiling, or the other way around. Note that if the furniture is creating a color within such a scheme, it should be monochromatic.

If the room is not following the five-element order, then choose colors to adjust the ch'i of occupants. If residents have suffered from a streak of bad luck or serious health problems, then decorate with bright colors. If they or their lives are unstable and unsettled, darker colors will stabilize their environment and lives.

• Mystical Cures to Restore and Enhance Good Luck Within the Home •

Color may also be used in the form of mystical cures for the purposes of restoring or enhancing good luck within the home. The Chinese view the luck of a house as somewhat continuous, and for this reason when house hunting you should try to locate a place where prior residents prospered, were happy, and consequently moved on to an even better place. The Chinese avoid "bad luck" houses, as they fear they may be stepping into the previous tenant's shoes and will suffer the same fate. So beware of bargains. If a house or shop seems like a good buy, you should investigate its history. Misfortune might account for the low price.

But perhaps you are already about to move into a home whose former tenant suffered ill fortunes: death, an accident, financial losses, problems of employment, bankruptcy, or divorce. You can mystically cure a house with an unfortunate history by using the Sealing the Door cure (p.139). This cure can

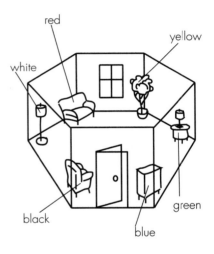

The Six True Colors can enhance a hexagonal room: place white, red, yellow, green, blue, and black objects in sequence in each corner.

■ ■ ■

also be used to avoid robberies or to purge the unsettling atmosphere after a burglary has occurred. It can be applied to a room as well.

No matter what the fortunes of a house have been, the Chinese custom is for each new occupant to perform a mystical housewarming ritual to establish ownership (see p. 140). This housewarming in Chinese communities might range from an elaborate feast and lion dance to celebrate the opening of a bank to the setting off of firecrackers for the opening of a store or restaurant. The latter custom serves the purpose of curing a place of misfortune while at the same time it draws attention, drumming up business.

The "green cures" of plants are often used in interior decoration to ameliorate health problems, as well as for feng shui solutions. Plants are thought to conduct good nourishing ch'i throughout a place. The green of leaves evokes spring, life, and growth, even if the person installing the cure chooses to use artificial plants made of silk or plastic. When installed inside a home, office, business, or hospital, green plants evoke the serenity and restorative powers of nature.

The particular placement of plants is important. They can be used to obscure or soften a sharp-angled column or corner that blights a room. To recirculate ch'i when an odd-shaped room has an acute angle, place the plant within the angle. To disperse fast-flowing ch'i, for instance when a window lines up with two doorways to create a tunnel effect, place a plant in the window or in between the door and window to help redirect and circulate the energy flow.

Placement of plants can also be determined in reference to the ba-gua; plants can be installed to resolve a missing area of the ba-gua or to enhance a particular area. For example, if you seek to improve your finances, you may wish to place a healthy plant in the wealth area of your home or office.

Specific "green cures" harnessing the energy and vitality of plants can be found in chapter 10, which is devoted to "Mystical Cures and Healing Practices."

Bright or light-refracting objects, such as mirrors, crystal balls, and lights, are often used to resolve a multitude of feng shui problems. Inside a house or an office, mirrors can draw in good views of gardens or water, improving ch'i and interior lighting. They can balance odd-shaped rooms.

Faceted crystal balls hung in an area that receives sunlight transform the light with their prismatic power into a rainbow of refracted colors. They are symbolically used to improve the flow of ch'i in a home and thus the lives of residents.

These objects are used to enliven dead spaces and to convert strong threatening ch'i into positive nurturing energy.

Lighting can further improve the ch'i of an interior; light is one of the nine basic cures of feng shui. The basic principle is that any color or type of light can be used in any position of the home or office, as long as inhabitants are comfortable. Interior lamps are symbolic of the sun and its energy and enrich interior ch'i. One special cure is the Five-Element Ba-gua lighting, used to strengthen a given area of life correlating with the ba-gua. Lights need to be very bright, although not on all the time. Colored light bulbs can be used to reinforce the cure. One example would be red lighting used in the "fame" area to increase fame.

When combined, all these ways of using color to ensure health, success, and prosperity will reinforce one another and create an abundant living and working environment full of life force that flows unobstructed. An ophthalmologist in La Jolla, California, demonstrated the power of using the five-element colors to coordinate his color scheme. Business was slow, and on the advice of a friend he added nine green plants to his waiting room—to bring in life and vitality— and hung up a large crystal that refracted red, orange, yellow, green, indigo, blue, and purple throughout the office. His business soon prospered, and he opened a second office in San Diego, which was painted in colors inspired by both the Five-Element Ba-gua and the Five-Element Creative Cycle. First he identified the color and element associated with the eye on the ba-gua—red and fire. Then, peach—a pastel hue of red—was applied to the walls. A green carpet was installed—wood (green) feeds fire (red). Finally, the ceiling was painted beige—fire creates earth— thus completing the Five-Element Creative Cycle.

Chapter Six:

CLOTHING: USING COLOR TO INFLUENCE THE OUTSIDE WORLD

From soon after we are born until we die, we clothe ourselves in color. The color of clothes both expresses and influences our ch'i, depressing our mood or enlivening our energies, disturbing us or providing us with a sense of peace, wearing down our health or building it up. The uses of clothing colors to influence our inner world—our personality and our health—are detailed in chapter 9, the chapter devoted to ch'i. But the color of our clothes also has an impact on the beholder, on those with whom we interact in our day-to-day affairs and on special occasions. It is this impact on the outside world, the world of love and work, that concerns us here. Colors are highly symbolic, and particular hues will complement certain professions and will help or hinder us in pursuing our goals and aspirations.

Of course, the state of our ch'i is an important factor that must be taken into consideration when examining the effects of clothing color on our environment. The extent to which color affects us differs for every individual. Our personal

reaction to colors is determined by the state of our ch'i, whether it is strong or weak. If our ch'i is good and strong, for example, we can wear any color at any time and we will be fine. If, on the other hand, our ch'i is unbalanced in some way, the colors of our clothes can counteract this imbalance and can assist us in our interactions with the outside world. On the everyday level, our color theory transforms a dull closet into a colorful one. For very special or demanding occasions call for the more formulaic Five-Element Creative or Destructive Color Schemes. Whether your application of our color philosophy is very general or highly specific, be sure that when you look for a job, sell a product, or go on a date, you pay attention not only to the style of your clothing but also to its color.

· *The Color of Clothes in Chinese History* ·

From ancient times, the color of clothes has had great significance in China. At the imperial court, for millennia, everyone from the emperor to unranked officials wore robes and adornment of different colors. These costumes were color-coded, so that the rank of the wearer could be discerned even from a distance. (Motifs, such as the type and number of dragons on a robe, also indicated rank.) During the Han dynasty (202 B.C.–A.D. 221) court officials wore silk ribbons hanging from a leather bag fastened to the waist. Social or official status dictated the ribbon's color: the emperor's ribbon was reddish yellow. Princes wore red, generals and aristocrats wore purple, and officials wore black or blue. Hanging from the official headgear—an elongated mortarboard-type hat—tassels made of varying numbers of colored jewels helped to distinguish rank. The hat of the emperor boasted twelve strings of white jade, while princes and dukes arrayed themselves in seven strings of blue jade. Ministers had to make do with five jade strings.

Although court fashions changed, the use of color as a signal of rank continued throughout Chinese imperial history. Eight centuries later, officials of the third and fourth ranks wore purple formal robes; those of the fifth and sixth wore red; the seventh and eighth wore green, and the ninth wore blue. This hierarchy, which was used by tradespeople as well, was altered only a century later, when scholars began to wear purple gowns.

In addition to indicating rank, the color of robes was deeply symbolic of nature. The emperor—semidivine son of heaven and the central figure in the

Chinese empire—wore a golden robe. The yellow of the emperor's robes signified the earth, which the mandate of heaven ordained as his domain in his role as the go-between from heaven to earth. As the reader may recall, yellow signifies the center, from which all other cardinal directions and powers emanate. The Chinese name for China, Chung-gwo, means "Middle Kingdom." The emperor, garbed in yellow, became the personification and symbol of the hub of power and blessings, where all forces of the universe—the five elements, heaven and earth, yin and yang—converge in harmony. The empress's court jacket was blue and decorated with gold five-toed dragons. It overlay her court robes, which were yellow satin, again embroidered with dragons.

The colors of the emperor's clothing were also linked to the particular powers he was to mediate. When praying and offering ritual sacrifices to heaven in supplication for a year of peace and prosperity on earth, he wore blue ceremonial robes. When praying to the sun, he wore red, and when the moon looked down upon his prayers, he donned white robes.

· Color in the Chinese Theater ·

From early times, color has been paramount in Chinese drama. In costume and in makeup its use has long constituted one of the symbolically charged techniques that indicate to the audience the character, age, and status of a role. Traditionally, the color of costumes and makeup has observed formal conventions that—along with those of acting technique, music, and codified movements and gestures—symbolically narrate the drama.

The conventions of costume and makeup are four: female, male, painted face, comic. Over the centuries, the standard female disguise has been lightly rouged cheeks over a white matte face. Eyes are bordered with deep red, and the brows are extended with a black line. The costume of the female character tends toward white gauze and pale blue. An older woman is represented with a gray wig, no makeup, and somber robes of brown, gray, black, or white. For a male role, beard color can be symbolic, as in the case of a fierce, brave character wearing a crimson beard. The "painted-face" role, which can be taken by a general, a minister, or a supernatural being, uses color more specifically, with red indicating fidelity and blue fierceness. White warns of treachery. Yet to continue the

semiotic subtlety, a round white patch on an actor's face reveals the comic, who might play a servant, priest, rogue, charlatan, or stupid general.

Whatever the convention of the face, colored veils covering it disclose states of being. Red is bridal. Yellow is a sick person. A black veil signifies a ghost.

• Clothes Today: Dressing for Success •

Today, increased color choices for men and women allow for greater expression of moods, feelings, and personal style. Color, of course, is dictated not by rank but by type of profession or a wearer's mood, linked less to hierarchies of social status than to the emotional and physical realm.

On a simple level, one should first be aware of the auspicious colors. From ancient times to the present, the Chinese have believed that red brings happiness and is good for those hoping to marry. The Chinese wedding gown is red. Green is the color of hope. Pink is also a color of joy. Luck and misfortune can come to you through color.

• Clothing Colors by Occupation •

Certain colors complement certain professions. If you can situate the orientation of your career within the Five-Element Ba-gua Color Wheel (see color insert), you can use the correlating color to enhance your career. An example for an international trader is provided below in the Businessperson section.

What follows is an alphabetically arranged list of occupations followed by particular recommendations for that line of work.

ARCHITECT

Since architects must use their brains to create beautiful buildings, they should wear lively colors to stimulate their minds to create positive designs. Red, green, or a cheerful mixture of colors are effective colors for architects. If they wear primarily depressing or dark colors, their designs will be uninspired and aesthetically displeasing.

BANKER

Because credibility is key in banking, bankers should wear blue suits. Clients will find the blue color comforting, giving them confidence in the banker and a feeling that their money will be safe. Avoid white suits. The best tie or accent

CLOTHING COLORS BY OCCUPATION

COLOR / OCCUPATION	BLUE	GREEN	BRIGHT COLORS	RED	WHITE	BLACK/ GRAY	YELLOW	PINK	MULTI-COLOR	PURPLE
Architect		YES	YES	YES		NO				
Banker	YES suit or tie	YES suit or tie		YES tie	NO			YES tie		YES tie
Businessperson, International Trader		YES accents				YES				
College Professor		YES		YES		YES				
Healthcare Worker		YES		YES	YES	YES		YES		
Interior Decorator					YES all white	YES all black				
Lawyer	YES	YES		YES tie		NO				
Meditation Teacher		YES	NO			YES				
Real Estate Agent				YES	YES			YES		
School Teacher	YES	YES			NO	NO		YES		
Stock Market Trader		YES				YES			YES	
Therapist or Psychologist		YES			YES	YES			YES	
Visual Artist or Graphic Designer		YES	YES	YES	NO all white	NO all black	YES	YES	YES	YES
Writer or Editor		YES		YES		YES all black			YES	

The colors in which you clothe yourself (left) not only have an effect on the people with whom you do business; they may also change the way you feel professionally about yourself.

■ ■ ■

colors are blue, green, purple, and, best of all, red. Pink is also an acceptable tie color. These colors are particularly auspicious for bankers because of the ba-gua five-element relationship. The wealth area sits between wood (blue/green) and fire (red), so any combination of those colors will enhance wealth.

BUSINESSPERSON

Those who work for a corporation or company must consider the type of business they are conducting when choosing the color of office clothes. For example, someone working for an international trading company should wear something with life force. In this case, black or gray, or black accented with green or blue, are appropriate colors. These colors, especially black, are particularly effective in the import-export business, because of their place within the Five-Element Ba-gua Color Scheme. Since black is the color associated with

career and water, if an exporter wears black, he or she symbolically enhances his or her career. Water also is a Chinese symbol of wealth, so black symbolically increases business and profits.

Though some people wear black because it may be appropriate for certain events or professions, a wardrobe that is exclusively black lacks imagination and indicates severe depression. There are, however, exceptions. Black is fine for people with limited financial resources, who can only afford a few new outfits, or for those with ritual or religious stipulations, such as nuns who must wear black or gray. After all, what if nuns were to wear red dresses?

COLLEGE PROFESSOR

To assume an air of seriousness, a professor can wear all black, or dark brown. Gray or blue are also fine. Red promotes rationality.

HEALTH CARE WORKER

Wear white for cleanliness; pink, light green, or light blue for hopefulness; or red to symbolize a warm heart. For someone who looks after the mentally ill, white is good, as is red to foster one's own good luck, rationality, and power. Black allows access to calm and intelligence.

INTERIOR DECORATOR

Wear all-white or all-black, so that your clothing does not interfere with decorating.

LAWYER

A lawyer should wear red (in a tie) or dark blue (in a tie or a suit). Red symbolizes success, and blue symbolizes hope. If a lawyer takes on a case that he or she thinks cannot be won, it is advisable to wear something green in the hope of extraordinary luck. Perhaps there will be a mistrial or the judge will make a mistake! A lawyer should avoid wearing black, which signifies no hope.

MEDITATION TEACHER

Wear black or green. These colors help the student calm down and concentrate. Bright colors will be distracting and will stimulate the heart and mind.

REAL ESTATE AGENT

Wear white to encourage articulateness, red to bring out rationality, or pink to warm up buyers and sellers.

School Teacher

Avoid black or white. Favor green, blue, and pink.

Stock Market Trader

Wear dark brown for credit and credibility; gray, black, or green to enhance the mind's ability to pick good stocks; floral motifs or all five-element colors to raise ch'i.

Therapist or Psychologist

Wear white to maintain peace of mind, green for liveliness and energy, black for seriousness, or multicolored clothing when meeting with unstable patients.

Visual Artist or Graphic Designer

Along with multicolored clothing, the best wardrobe choices for a visual artist or graphic designer will be outfits of a single basic color. Exceptions are all-black or all-white clothes.

Writer or Editor

An array of colors can help writers and editors. Multicolored or flowery clothes can help them understand all facts and ideas. All-black outfits encourage calm. Red or green encourage new ideas.

· Clothing Color and Personal Goals ·

Along with its professional uses, color can be employed for personal pursuits and aspirations. The colors we wear can win the heart and mind of the beholder.

Those wanting to sell something, be it a book or a building, should wear clothes with lots of colors. This is because the ch'i of each prospective buyer is different. Some people's ch'i is good, some people's ch'i is negative. Colorful apparel will be effective when dealing with people, no matter what type of ch'i they possess.

If you are looking for work, wear green or blue, colors that symbolize growth and possibilities. Avoid wearing all black or all white. During a job search, these colors represent no hope. Also avoid wearing red or other aggressive colors that may signal combativeness to the potential employer.

Colors can also jump-start our own performance, whether on the job, at home, or in social situations. Children from grammar school to high school should not always be confronted with the same dull colors. School clothing should be purchased

COLOR / GOAL	BLUE/ GREEN	BRIGHT COLORS	RED	WHITE	BLACK/ GRAY	BROWN/ YELLOW	PINK	MULTI- COLOR
To sell something		YES						YES
To find employment	YES		NO	NO	NO			
To lose weight				YES				
To find happiness			YES					
To get married			YES				YES	

COLOR GOAL CHART

The chart on the right offers suggestions for clothing colors that will help achieve particular life or career goals.

■■■

in a variety of colors—not always brown, blue, or green. Though the colors of uniforms are more limited, take advantage of as much variation as allowed. Schools should change the colors of uniforms with the change of the seasons.

Colors can adjust our personal ch'i, enabling us to overcome our usual limitations in dealing with the world. For example, absentminded people can harness their own ch'i and attention by wearing black, yellow, or white, colors effective at increasing discipline and concentration. This type of person should avoid wearing red, which can be a diverting and distracting color. Someone wishing to increase their productivity at work should wear a colorful tie or outfit, or something red or green. White and black, more introspective colors, may decrease productivity. Those hoping to increase popularity should wear peach or rainbow colors. Those seeking to stimulate their minds and increase inspiration should wear multicolored clothes or something blue, red, or purple.

Those hoping to reinforce a weight-loss diet should wear white clothes, since white clothes tend to make the wearer seem even larger than normal, a constant, painful reminder of heaviness that will help to destroy their appetite. White clothes also help enforce the practice of watching what and how you eat. The wearer of white will be less likely to shovel down a meal, as he or she is compelled to be careful not to soil or spot a white outfit.

A person seeking a particular goal can correlate this goal with the color it aligns with on the Five-Element Ba-gua Color Wheel. For example, an actress hoping to get a lucky break might wear the color associated with fame, which is red. An investor might wear the colors of the wealth position, which are

blue, green, red, or purple. Thus one strategically chosen color can improve one's ch'i and luck.

The best color for a wallet is black, symbolizing water, the element linked with money for the Chinese. White, blue, or green are also good colors for wallets, because metal (white) creates water (black), which nourishes wood (green or blue), according to the Five-Element Creative Color Scheme.

Much of this advice on color may come naturally to readers who have been "tuned into" color as part of their daily routine. As most women who use makeup regularly know, soft colors are best for day, while deeper, brighter shades can improve the wearer's nighttime ch'i. If you are seeking a mate, use attention-getting—but attractive— makeup colors.

• Color, Ch'i, and Our Closet •

Clothes selection is a highly personal endeavor. When we choose our wardrobe, we consider fashion, fit, attractiveness, and whether the colors flatter us or not. These are all important considerations. But there is another aspect as well: how the color of clothing affects our ch'i. Some colors oppress our ch'i, while others elevate it. For instance, bright colors raise our ch'i.

Generally, we should wear the colors we feel like wearing but try to vary our clothes palette from day to day. Wearing colors such as navy blue or a deep coffee color every day will make the wearer seem old and stuck in their ways. When we get dressed or buy clothes, our choice of colors indicates our ch'i. We may dislike the color of an outfit because it does not match our ch'i.

Red may look good or bad on us. If we look particularly attractive in black or gray, or select only somber shades of blue, green, white, or black clothes and never wear red or pink, this may indicate that our ch'i is depressed and pessimistic. How we feel about ourselves may be caused less by our sense of aesthetics and beauty and more by this inner state of energy. Our ch'i changes every day. It reacts to different situations and creates individual moods. When we get dressed, our choice of clothing will reflect our ch'i at that moment. If we are happy, we may want to wear a red tie or red blouse. If we feel subdued, we might choose a beige or maroon sweater to suit our state of mind.

Wearing a color that clashes with our mood can be good or bad. For instance, if we feel low and wear a bright color, this may raise our spirits. However, if we are happy we may want to wear a red tie or red blouse, but the red tie may be at the cleaners and the blouse may be ripped. We will feel thwarted and perhaps will wear a gray shirt or tie instead. This will affect our ch'i. The gray shirt may be expensive and of good quality, but it does not suit our ch'i. It isn't what we feel like wearing. As a result, though we began that day feeling happy, we may begin to feel "off" and uncomfortable. This will ultimately affect our daily work and interactions with others.

• Improving Wardrobe Colors •

If we want to improve our ch'i, we can use color as a cure. At first it may be hard to switch from a somber brown and blue wardrobe. If we are not used to wearing bright colors, we may feel uncomfortable.

How can we comfortably alter our inclinations and tastes? Sometimes we may not realize that it is the state of our ch'i, rather than more rational considerations, that is guiding us in our selection of clothing colors. For example, a secretary thought she chose somber clothes because of the serious nature of her job. After a designer friend noted that she always wore browns, beiges, and blacks, she checked her closet and discovered it held only dark and drab colors. After some reflection, she concluded that her mood—she frequently suffered from melancholia and depression—was influencing her color choices. After more self-examination and meditation, she began to feel better and began buying more brightly colored clothes.

Sometimes circumstances and increased exposure to new styles can help change one's color choices. For instance, someone favoring black might travel to New York or Paris and observe people wearing bright colors. When shopping next, that person might select a more vivid outfit, for it may remind them of the liveliness and sophistication of those cities.

Here is a ru-shr, or logical, way to consciously add life force to otherwise drab wardrobes. People who dress primarily in either black or white should seek out and buy clothes having one or two bright colors, or select an item that includes all seven colors of the spectrum. Another way to resolve a dull, depressing wardrobe

is to enliven it with brighter accent colors. For instance, a blond woman may find that brown or black is particularly flattering, while bright colors do nothing for her looks. There are two possible resolutions, one visible and one not. The visible method is to embellish the brown outfit with accent colors that improve her ch'i, colors that may be on earrings, a pin, buttons, a flower, or a handbag. The other method is to line the garment with a ch'i-enhancing color or to wear undergarments with colors that have life force and complement her ch'i.

• The Five-Element Color Scheme •

The Five-Element Color Scheme can improve your ch'i by coordinating clothing outfits according to one of two color sequences: the Five-Element Creative Cycle and the Five-Element Destructive Cycle. These color cycles are highly symbolic and are, in a sense, a meditative form of dressing. They are not so much for everyday use as for important meetings, negotiations, or other occasions when reinforcing one's ch'i, determination, and luck may be crucial. By employing the Five-Element Color Cycle you can greatly enhance chances for success. These techniques are a tool for the visualization of a dynamic state of ch'i that envelops and imbues the body and mind with special life force. The color cycles can help the wearer literally feel the ch'i rising—as each progressive clothing color symbolizes elements creating or overtaking each other in sequence.

THE CREATIVE CYCLE

If you seek to use the Five-Element Creative Cycle, start at the shoes or at the hemline (pants or skirt) and work your way up. For example, one outfit might be red shoes (fire), yellow skirt (for earth, which is created by fire), and white blouse (symbolizing metal, which is mined from the earth). If begun at the hemline, the same scheme might be a red skirt, an orange belt, and a white blouse. The scheme may be employed with as few as three or as many as five colors, always following the colors in progressive creative sequence. For example, shoes could be red, the skirt could be tan, the belt could be white, the blouse could be black, and a necklace or hat could be green and/or blue. For schemes of three, four, or five colors, see the tables provided on p. 108, and the examples in the color section. These schemes can be adapted to particular items of clothing by following a simple rule of thumb: always start at the bottom, and make each new color creative in

FIVE-ELEMENT CREATIVE CYCLE — THREE COLORS					
Top	pink/red	tan/brown/orange/yellow	white	gray/black	blue/green
Middle	blue/green	pink/red	tan/brown orange/yellow	white	gray/black
Bottom ↑	gray/black	blue/green	pink/red	tan/brown/orange/yellow	white

FIVE-ELEMENT CREATIVE CYCLE — FOUR COLORS					
4 (top)	white	gray/black	blue/green	pink/red	tan/brown/orange/yellow
3	tan/brown/orange/yellow	white	gray/black	blue/green	pink/red
2	pink/red	tan/brown orange/yellow	white	gray/black	blue/green
1 (bottom)	blue/green	pink/red	tan/brown/orange/yellow	white	gray/black

FIVE-ELEMENT CREATIVE CYCLE — FIVE COLORS					
5 (top)	pink/red	tan/brown/orange/yellow	white	gray/black	blue/green
4	blue/green	pink/red	tan/brown orange/yellow	white	gray/black
3	gray/black	blue/green	pink/red	tan/brown/orange/yellow	white
2	white	gray/black	blue/green	pink/red	tan/brown orange/yellow
1 (bottom)	tan/brown/orange/yellow	white	gray/black	blue/green	pink/red

ere are three possible ways of applying the Five-Element Creative Cycle in selecting clothing colors to enhance your ch'i and your luck, depending on how many colors you wish to employ.

■ ■ ■

relationship to the one below it. For example, in the outfit just described, if the belt was tan (like the skirt), the blouse would then be white.

THE DESTRUCTIVE CYCLE

In the Five-Element Destructive Cycle, the color scheme starts at the top of the body. The top color/element "destroys" the color/element below it

FIVE-ELEMENT DESTRUCTIVE CYCLE — THREE COLORS					
Top ↓	pink/red	white	blue/green	tan/brown/ orange/yellow	gray/black
Middle	white	blue/green	tan/brown orange/yellow	gray/black	pink/red
Bottom	blue/green	tan/brown/ orange/yellow	gray/black	pink/red	white

FIVE-ELEMENT DESTRUCTIVE CYCLE — FOUR COLORS					
1 (top)	white	blue/green	tan/brown/ orange/yellow	gray/black	pink/red
2	blue/green	tan/brown/ orange/yellow	gray/black	pink/red	white
3	tan/brown orange/yellow	gray/black	pink/red	white	blue/green
4 (bottom)	gray/black	pink/red	white	blue/green	tan/brown/ orange/yellow

FIVE-ELEMENT DESTRUCTIVE CYCLE — FIVE COLORS					
1 (top)	pink/red	white	blue/green	tan/brown/ orange/yellow	gray/black
2	white	blue/green	tan/brown orange/yellow	gray/black	pink/red
3	blue/gren	tan/brown/ orange/yellow	gray/black	pink/red	white
4	tan/brown orange/yellow	gray/black	pink/red	white	blue/green
5 (bottom)	gray/black	pink/red	white	blue/green	tan/brown/ orange/yellow

There can also be three ways of applying the Five-Element Destructive Cycle to clothing colors, according to the number of colors used. Note that the term destructive *does not necessarily connote negativity; rather, it implies the dynamism of regeneration.*

■■■

and so on. An auspicious outfit might thus be a white blouse (symbolizing metal) accompanied by a blue belt (symbolizing wood, which metal chops down) and a beige skirt (for the earth element, which wood uproots). While this wardrobe is stylistically plausible, other five-element color combinations may be less appealing aesthetically. We suggest using the color schemes as guides to shades of each color that are complementary. Another alternative

is to employ the auspicious colors as accents, as for example in the trim color of a sweater or blouse.

When you are at a disadvantage with whomever you are meeting, you can use the Five-Element Destructive Color Cycle to improve your chances for success. For example, a lawyer arguing a case before a difficult judge might wear colors that overpower the judge's black robes. Such an outfit might be a brown jacket (earth), a black belt (water), and a maroon skirt or trousers (fire). Lin Yun says this special cure symbolically diminishes the judge's power, as the earth overcomes water. (The judge is wearing black; because the lawyer's black belt is small in proportion to his or her other items of clothing, the power of the judge will be diminished—water is not large enough to douse the flames of fire.)

· Static Color Schemes ·

Another way to raise one's ch'i is to use static color schemes. In these instances you can put together an outfit that has all the colors of the five elements, or all the Six True Colors, or all seven colors of the spectrum. These colors need only be present and not in any particular sequence. The outfit might be a tie with all the colors of the rainbow or a flowered dress with all the five-element colors. You can also put together an outfit of all five colors—black pumps, white stockings, red dress, navy blazer, and orange scarf.

Chapter Seven:
FOOD AND HEALTH

F or thousands of years, most Chinese, from peasant to court official, have always been aware of the importance of diet as it relates to health and ritual. In aristocratic and wealthier circles, food appreciation reached a high level of connoisseurship. The Chinese believe that food with good dietary and nutritional values should also appeal to the senses, so Chinese dishes must satisfy the three important criteria of color, fragrance, and flavor.

To this day, food is laid out in Chinese rituals to appease "hungry ghosts," or as offerings to ancestors or house gods. On the Chinese New Year the custom is to smear honey on the mouth of a likeness of the capricious kitchen god—a household spy. The honey ensures that when the god's likeness is burned and he rises to heaven, he will only report sweet things about the family. Thus the gods will grant the family a happy and prosperous new year.

The accent on food was so strong in the imperial household during ancient times that the Han Dynasty (207 B.C.–A.D. 220) manual of ritual buildings and

government, the *Chou Li*, records nearly sixty percent of the almost four thousand imperial personnel as having duties related to food and wine.

Today there are two ways in which Lin Yun's rules of color can be applied to food. The first consideration is our daily diet. This relates more to the visual appeal of food, how color can make meals seem more—or less—appetizing. The other application of color and food is a sort of mystical health-improvement regime. This method seeks to use color to heal body organs and physical ailments.

Considerations of diet and health as they relate to food color reflect the relationship between ch'i and color. Color attracts our ch'i, enticing us to eat. As a result, color affects our appetite, health, career, and business. To attract our ch'i, food should not be monochromatic. A meal should be visually satisfying. For example, if the food of a seven-course banquet tastes and smells delicious but is doused with soy sauce or is a monotonous shade of brown from mushrooms and meat, then the meal will appear unappetizing. Colors of Chinese dishes should be lively and varied, as is often the case in Japanese and French cooking. For example, visual appeal can be created by contrasting the white meat of chicken with red or green peppers or complementing the pink hue of shrimp with black beans.

In the food business, color is essential to a restaurant's or food purveyor's success. From a ch'i perspective, if you open a very good restaurant, you will, of course, want the best ingredients: an attractive environment, good service, and the best chef. All these aspects are ru-shr—rational. But even the best seasonings on fresh and expensive ingredients cannot offset unappealing colors. Too many brown or dark colors or too many off-white tones in the food will affect the diners' moods, giving them a heavy feeling. Even though they have yet to taste the food, they may already feel full. This is the effect of color in poor food presentation. If the color presentation of a restaurant's food is not attractive, the guests will not return. The color of the food affects our reaction to a restaurant, and therefore color affects the restaurant's business. The artistic presentation and variety of colors arrayed in dishes will not only visually delight customers and whet their appetites, but also inspire them to return for more meals.

• *Balancing Health with the Five-Element Diet* •

Along with the visual appeal of colorful meals, food color can also affect our health. The Chinese pay attention to some basic philosophical principles relating physical well-being to color. Specific food colors as they are applied to the five elements can be used to nourish health and to treat certain illnesses, such as heart, kidney, lung, liver, and spleen problems. While you should always consult your doctor if you suspect illness, from a chu-shr perspective, you can also use color to treat a person whose health is ailing.

The theory linking food color to physical health harks back to ancient Chinese medicine, which employed not only the five elements but also the theories of ch'i and yin and yang for diagnosis, treatment, and cures. The human body, the Chinese believed, was a beneficiary and a victim of the workings of the cosmos and therefore subject to the laws of Tao and nature. So the body was influenced both by the change in seasons and temperature, as well as by dietary considerations, such as food color, seasoning, and whether a meal had the correct balance of yin and yang. For example, if the body was healthy, overeating a yin-type food might cause an imbalance of yin in the body, resulting in disease or health problems. Disease and personality disorders can arise from disharmony of the organs with the corresponding five elements.

When applying the five elements to the five visceral organs, the heart corresponds to fire, red, summer, and bitter tastes. The spleen corresponds to earth, yellow, the end of summer, and sweets. The lungs correspond to metal, white, autumn, and pungent flavors. The liver aligns with wood, green, spring and sour tastes. The kidney is aligned with water, black, winter, and salty tastes. Thus one way to ease a kidney problem—along with obtaining the best modern medical help—is to eat primarily black or dark food—for water—mixed with green and white—the colors of water's complementary elements, wood and metal, respectively. For instance, a possible kidney cure might be eggplant or mushrooms cooked with scallions or sugar peas and bean curd or scallops. Other dark foods might be seaweed, blue cornmeal, red cabbage, black beans, lamb, or beef.

In general, you can improve your health by eating foods that correspond in color to the organ you seek to heal. If you are hoping to cure a physical ill, use the Food and Health Color Chart on the next page, or see the insert. These visual

FOOD AND HEALTH COLOR CHART				
ELEMENT	**COLOR**	**ORGAN**	**FOOD**	**ACCENT COLOR**
Fire	red	Heart	Shrimp, red peppers, tomatoes, lobsters	blue/green, yellow/orange/tan
Earth	yellow/orange/tan	Spleen	Eggs, yellow squash, curry, carrots	red, white
Metal	white	Lungs	Scallops, egg whites, fish, chicken	yellow/orange/tan, black/dark brown
Water	black/dark brown	Kidney	Black beans, beef, lamb, soy sauce, eggplant	white, green/blue
Wood	green/blue	Liver	Peas, scallions, spinach, celery, cabbage	black/dark brown, red

*Applying
the Five-Element Color Theory
to food, as in the chart
on the right, will help achieve a
positive result when
following a doctor's strict regimen
for your health.*

■■■

aids will help you discern what combination of food colors might help in your healing process.

One must, however, exercise a particular caution: the use of the basic color on its own is inadequate as a treatment. When using this five-element theory, you need the reinforcement of the complementary colors (the mutually creative relationship colors). For example, if you are suffering from a physical heart disease as a result of insufficient bodily fire (as opposed to emotional heart problems resulting from an excess of fire, for which see p. 40), you might have a dish that is primarily red—the color of fire—but you must accent it with green—wood feeds fire—and yellow—fire creates earth (ash). A dish of ripe tomatoes accented with scallions and egg slivers will do.

Chapter Eight:

TRANSPORTATION:
GOING PLACES WITH COLOR

"TRANSPORTATION."

Throughout our lives we are constantly traveling. Transportation is one of the six major life areas to be addressed when we consider the effects of color on our lives. The colors that come under this rubric include those that we see en route to our destinations, as well as the colors of the vehicles in which we travel and the colors we wear while traveling.

Whether we are traveling to the grocery store, to work, or on a long journey, what we see will affect our ch'i. If we open the front door to go out in the morning and the ground is barren, a dreadful brown or gray color, it kills our mood and brings down our ch'i. We think of death and wonder as we venture forth what is going to hit us. We tend to be morose. Yet if when we exit we see a flower, a bush, or a luscious green tree, we feel a life force and this affects our ch'i and mood. The colors of our homes inside and out and even the colors of our neighbors' houses all affect our ch'i. The sway of color continues as we pass by scenery, influencing our

destiny, our road in life. Whether walking, driving, or taking a taxi, we need to be aware of the landscape—the roadside trees, flowers, houses, sidewalks.

The progression to our destinations is instrumental in determining our emotional approach to school, work, and life. If your route to work starts out with lush, healthy trees that then lose their greenness and become barren and lifeless, or you enter an urban setting with no signs of nature, a sense of impending failure and depression may be inevitable. The dry, brown foliage will make you feel that going to work is like going to a funeral, and you may feel preoccupied because your ch'i and mind may linger among the green landscape left behind.

The beauty of one's route to work or school can also have its drawbacks. If there are too many bright flowers along the road, you may feel distracted after you reach your destination. What is left is the memory of the bright flowers; our ch'i remains among them. So while flowers can improve our ch'i, the landscaping should be a pleasant balance, an arrangement of lush greenery accented with flowers. Too many colorful flowers distract not only the mind but also the heart. If an office is close to a park or beautiful square, there will be a tendency after work to linger there or take walks with friends. The plantings can strongly influence us, intoxicate us, make us stray from our established relationships. Too many colorful flowers can give us peach blossom luck, a tendency to have affairs.

Along with the scenery of our journey, the colors of the interiors and exteriors of the vehicles we ride in will affect our ch'i and our lives. For example, if you are a flight attendant or a pilot, the interior colors of the plane will affect you. If they are unappealing, business will be bad, because travelers will choose other airlines. Unpleasant colors and color schemes can also lead to accidents. The best colors for airplanes are clear and bright—blue, green, or red. Clothing colors while traveling are important as well. To ease the fear of flying, for example, utilize the Five-Element Creative Cycle (see p. 108). Either wear red, to help you feel empowered, or wear green, since wood (green) feeds fire (red). If you want to protect yourself on the street, while driving a car, or while flying in a plane, wear black and white or pure black. Another way to ensure success while traveling is to use the Chinese Zodiac Color Chart (see p. 167) as a guide to your correct colors.

A woman born in the year of the dragon—a year that harmonizes with green—reports that when she travels and wears a particular green suit, wonderful things happen. "Twice, I was upgraded to first class—this was not due to my mileage plus

program. Another time, I was waiting for a taxi at the airport and a limo approached and offered to bring me to my destination for the same cost as a taxi. Of course, I was wearing my 'fortunate green suit' on each occasion."

• Cars •

The personality of the driver should be considered when selecting car colors. If the car color can be balanced with a person's character, then that person may drive more safely. For example, if a person tends to be easily excitable, he or she should avoid red cars, especially cars with red interiors. Red, the color associated with fire, will fan the flames of the driver's intensity or aggression so that they overreact and cause an accident. Black (or gray) is a far better color for this type of person, because this color is associated with water and will help balance their impulse to speed or drive recklessly.

Red, however, can be a positive color for a person with a different personality. For example, some people are naturally lazy and slow to react. In these cases, red might be the perfect color for a car, particularly for the interior. Red not only will mobilize the driver's ch'i, but will also serve as a colorful caution sign for the driver to stay alert in the car. Red lights a fire under the poky driver. Green is also a good color for this type of driver because green, the color of wood, fuels fire, according to the Five-Element Creative Cycle.

• The Five-Element Color Scheme •

THE CREATIVE CYCLE

The creative cycle moves from the bottom upward. You might, for example, select a red or maroon carpet, a brown or beige seat, and a white ceiling. This color arrangement is symbolic of fire (red) creating earth—or ash—(brown), which in turn creates metal (white). The other Five-Element Creative Color Schemes are supplied in the table on p. 118.

THE DESTRUCTIVE CYCLE

If you choose to outfit the interior of your car with the Five-Element Destructive Color Scheme, fear not that the word *destructive* might mean certain car crashes or accidents. This color scheme connotes the powerful interactive processes of all the

FIVE-ELEMENT CREATIVE CYCLE COLOR SCHEMES					
Ceiling	gray/black	blue/green	red/pink	tan/brown/orange/yellow	white
Upholstery	white	gray/black	blue/green	red/pink	tan/brown orange/yellow
Carpet ↑	tan/brown/orange/yellow	white	gray/black	blue/green	pink/red

FIVE-ELEMENT DESTRUCTIVE CYCLE COLOR SCHEMES					
Ceiling ↓	red/pink	white	blue/green	tan/brown/orange/yellow	gray/black
Upholstery	white	blue/green	tan/brown orange/yellow	gray/black	red/pink
Carpet	blue/green	tan/brown/orange/yellow	gray/black	pink/red	white

nterior colors of cars can follow either the Five-Element Creative or Destructive Cycle. For married couples, the color scheme chosen can also complement an exterior color selected according to the spouse's birth year.

■■■

basic elements in the universe. We reiterate that both the creative and destructive cycles are positive systems, connoting the continual dynamic workings of ch'i, yin and yang, and the five elements. The Five-Element Destructive Cycle begins at the top and goes downward. For example, you might select a maroon (fire) ceiling, white seats, and a green carpet. This color arrangement is symbolic of fire (red) melting white (metal), which in turn cuts down green (wood).

• Using the Chinese Zodiac to Select Car Colors •

Another method of choosing colors for your car is to choose the colors for the car's exterior that correspond to or complement your year of birth. This method brings in the Chinese form of astrology. While Western astrology is based primarily on birth month, the Chinese stress the year in which you were born. According to the Chinese zodiac, each of us is born in one of twelve animal years: rat, ox, tiger, rabbit, dragon, snake, horse, ram, monkey, chicken, dog, and pig. The twelve animals can be superimposed on the Five-Element Ba-gua Octagon. Each animal year, as a result, can be associated with one or more colors. For example, if you were born in 1960, you would be a rat, and the corresponding color is black. (See Chinese Zodiac Color Chart on p. 167.)

If the color of your car is compatible with your birth year, then you can enjoy smooth driving. One woman born in the year of the sheep chronicled a string of unhappy events in cars of unfortunate colors. First there were the numerous "unexpected accidents" in her bright red car. Then she bought a beige car, with which she endured engine failure, brake trouble, vandals breaking her windows, and even a rear-end collision. After purchasing a jade green vehicle, she claims that she now careens around the San Francisco Bay Area in "comfort, peace, safety, and pleasure." She reasons that green is a color that enhances her ch'i and her birth year, which is aligned with the fire element, for wood (green) feeds fire.

If a married couple shares a car, choose a two-toned car, or select a color for one spouse and then apply a narrow racing stripe in the complementary color of the other spouse. For instance, a tiger-pig couple might have gray or black exterior with a narrow green stripe on it, or a dark green car with a black stripe.

If you take your birth year into account when selecting a car color, you can also choose from the complementary colors of your birth year. To discern your birth year's complementary colors, first identify the year's basic color (see Chinese Zodiac Color Chart on p. 167). Then look at the Five-Element Ba-gua Color Wheel (see color photographs) and identify the element that creates your year and the element that your year creates. You can use the colors associated with these three elements. For example, if you were born in the year of the rat, your element is water, which is associated with the color black. Since metal creates water, and metal corresponds to white, white is also a good color for rats. And because water nourishes wood, which is associated with green, then green will also be good for rats.

Another solution is to make the interior color correlate with one spouse's birth year, and make the exterior a complementary color. Thus, if you were born in the year of the horse and your spouse was born in the year of the dog, the car interior might be red and the exterior white, gray, or black…or the exterior might be red and the interior black.

There is one exception to using the Chinese zodiac in considering car colors. You also should consider your own ch'i and the state of your five elements. Perhaps, for example, you were born in the year of the horse or dragon, and red, the color of fire, is one of your options. You should nevertheless avoid buying a red car if your ch'i has a lot of the fire element in it. Red will increase the

imbalance of fire in your personality, resulting in aggressive driving and behavior and, ultimately, accidents. In this case, although black is not a complementary color to those born in the year of the horse or dragon, it would be an appropriate choice to throw water on the fire, tempering and improving your volatile nature while driving.

Chapter Nine:

CH'I: USING COLOR TO INFLUENCE THE INNER WORLD

■

"CH'I."

■

This chapter deals with the personal realm of color—how color improves our personality and temperament, both of which are aspects of our ch'i. Color can modify our negative behavior and affect the behavior of others toward us. Color can motivate us. There are color cures for problems ranging from faithlessness to paranoia, eating disorders to dullness. The Chinese feel color can improve health, help us get hired, stimulate romance, help us relax, and improve our performance. Those who have achieved "supreme ch'i" will not be addressed here, but for those of us wishing to change ourselves, color can help us to soften our personality quirks, to become more of what we wish we were, and to alter our ch'i.

For there are as many states of ch'i as there are people in the world. One person's ch'i might flow only to the throat. This person has "choked ch'i" and will seldom speak, not being able to express thoughts and feelings. Other people may be compulsive talkers, only able to express themselves in loud,

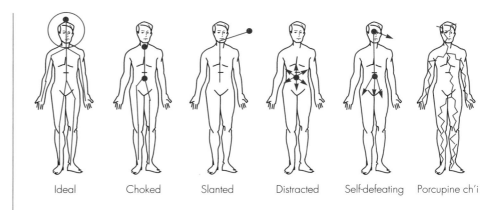

| Ideal | Choked | Slanted | Distracted | Self-defeating | Porcupine ch'i |

Everyone possesses a different ch'i. Ideally, it should flow smoothly throughout our bodies, rising upward through our heads.

■ ■ ■

rapid-fire conversation, literally spraying you with words. This type of person might have "machine gun" ch'i, which only circulates near and out of the mouth, often not passing through the brain. Their bodies are present, but their ch'i is elsewhere. A tap on the shoulder or a loud noise can bring back their ch'i. Those with "porcupine" ch'i needle others physically and verbally, making them uncomfortable. They specialize in sarcastic remarks and will poke or kick for emphasis. Someone whose ch'i doesn't flow to the ears but rises straight up the body has "bamboo" ch'i and will never listen to others. This type of person is inflexible, stubborn to the point of having a one-track mind. A person with distracted ch'i wants to do everything. Every time you see him, he wants to be something different—a doctor, lawyer, pilot. But all his hopes and plans never materialize because he never follows through. Another person's ch'i may be downward moving. This person is self-defeating and sighs often, with an air of hopelessness. Over the years, suicidal tendencies may be displayed, and he or she may avoid social contact, either pretending not to be at home or refusing to go out. If ch'i circulates too much in a person's head, this is a precursor of a nervous breakdown. The person may be suspicious or overly analytical to the point of paranoia.

While visualized color and feng shui both improve our ch'i in general, the color of clothing can also help us to balance our ch'i, to correct our destructive faults, and to attain inner peace, harmony, and health. For example, white, green, and black can enhance creativity, deep green can calm a jumpy person, and red and yellow are said to be able to cure stomachaches. While

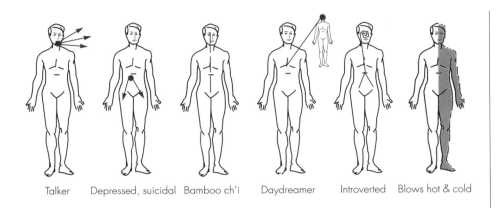

Talker Depressed, suicidal Bamboo ch'i Daydreamer Introverted Blows hot & cold

the specifics of this chapter are based upon Lin Yun's key concepts and systems as outlined at the beginning of this book, they also derive from early Chinese theories of medicine. Keen insight and intuitive suggestion also come into play in selecting color cures to resolve personality problems or to elicit a desired response.

In order to employ some specific ways that color can be used to both diagnose and assist in resolving a variety of imbalances, we will consider human ch'i as an expression of the five elements.

· Using Color to Balance Personality: Ch'i and the Five Elements ·

When considering a person's ch'i and an appropriate color scheme to balance and enhance it, we first examine that person's ch'i by determining the nature of their five elements, for each element expresses personal virtues and personality traits. Black Tantric Buddhism imagines the five elements as a complete circle of 360 degrees, with each element comprising 72 degrees, a fifth of a circle. The ideal amount to possess of four of the elements—wood, fire, earth, and metal—is 36 degrees, the "middle road" of personal balance. With the water element, the ideal is to have the greatest amount of "still" water, and a balanced quantity of "moving" water.

Here is a brief summary of how each of the five elements manifests itself in our ch'i and therefore shapes our character.

Color can enhance our ch'i. The drawings on these pages show various states of ch'i that manifest themselves in particular habits and behaviors.

■ ■ ■

The five elements—wood, fire, earth, metal, and water—have corresponding colors, directions, organs, seasons, and virtues. Understanding the five elements can help us analyze and improve our ch'i. Wood stands for flexibility, fire for the ability to express feelings, earth for loyalty and honesty.

■ ■ ■

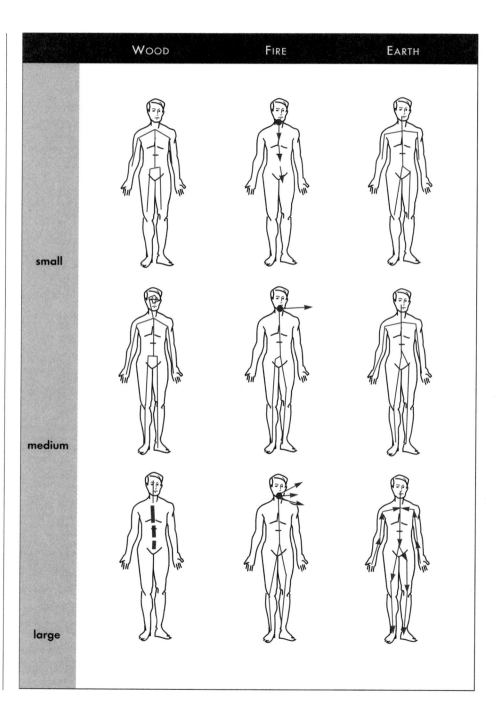

	WOOD	FIRE	EARTH
small			
medium			
large			

WOOD

Wood represents benevolence and steadfastness. Those deficient in wood are like duckweed, which floats on water. When the wind shifts, it is blown this way and that. These people have no strong views of their own. They are amiable and easygoing. They are followers, influenced too much by others. They tend to be wishy-washy, often contradicting themselves in order to agree with prevailing viewpoints. Those with the proper amount of wood are like big trees with luxuriant branches. When the wind blows, they lean slightly with the wind. When the wind stops, the trees stand straight. These people are flexible and receptive. They listen to others, old and young—and use their own reason to figure out their own views. Those with large amounts of wood are like palm trees, which do not move with a subtle wind. If, however, a typhoon or hurricane comes along, it will knock down the inflexible palm trees. These people are prejudiced and biased and do not accept or absorb others' views as options. They may have good ideas and intentions, but these can be undone by their own rigidity.

FIRE

Fire refers to reason, expressiveness, and decorum or courtesy. There are two types of people low in fire. One type tends to swallow their feelings. If, for example, they encounter difficulties, they merely grin and bear it. They absorb their own dissatisfaction, hoping it will go away. The second type of person deficient in fire hides their true feelings then swallows them. But their dissatisfaction does not go away. It festers within them. This type of person will suffer from stomach and intestinal disorders as a result. Those with the proper amount of fire in their personal makeup will stand up against injustice and explain their position articulately and logically. Once they have expressed themselves, they know when to stop and keep quiet. Those with an excess of fire tend to have emotional outbursts. They are aggressive: when they encounter injustice, their ch'i bursts out of them. Even in everyday situations, they are bellicose and will lecture and offend others. During arguments they will fiercely defend their position, sometimes without justification or logical reasoning. They tend to get overexcited and overheated.

EARTH

Earth stands for sincerity and loyalty. Those with low amounts of earth tend to be opportunistic, selfish, and insincere. They are self-indulgent. Those with the

	METAL	STILL WATER	MOVING WATER
small			
medium			
large			

etal represents the ability to speak out. Water is divided into two categories: still and moving. Still water reflects the level of insight and intelligence. Moving water represents a range of business and social contacts and activities, as well as personal drive.

■ ■ ■

proper amount of earth can balance caring for others with caring for themselves. They are fair, reliable, and loyal. They are also equipped to protect themselves or to seize an opportunity, without being opportunistic. Those with a large amount of earth tend to be self-sacrificing and overly sincere. They are generous to the point of self-denial.

METAL

Metal represents righteousness, the ability to speak out and properly express ourselves. Those with the lowest amount of metal cannot say what is on their minds and in their hearts. When something goes wrong, they become verbally choked. They tend to be taciturn and cautious. Those with a medium or proper amount of metal are able to speak out against injustice, because their ch'i first circulates through their brain before they speak. These people know when to hold their tongues. They think before they speak. Those with an excess of metal in their ch'i are compulsive talkers. Their ch'i does not circulate in their brain, so they do not consider others' feelings or the appropriateness of their words before speaking. Their ch'i makes their mouth move constantly, spraying people with their words. They accentuate their words with grand hand gestures. They tend to mind other people's business and to be argumentative (often wrongly) and are self-righteous.

WATER

The Chinese divide water into two main categories: still and moving water. Each of these categories has seventy-two degrees. Still water refers to our cognitive and judgmental abilities: our insight and intelligence. Those deficient in still water are like frogs at the bottom of a dry well, who think the sky is as large as the small opening they see. Ch'i never reaches their brain. They are intellectually limited, ignorant, and narrow-minded. Provincial and often wrong, he or she is like a person napping by a tree who sees a rabbit drop dead next to him and returns each day to the same tree, hoping to catch another rabbit. This type of person is uninterested in world affairs and only knows what concerns him. Those who possess the middle amount of still water are like a swimming pool. They are clear and deep, with defined boundaries that enclose their understanding. Smart but limited, these people know their own environment quite well but are unwilling to try out any other area. Someone possessing a large amount of still water, on the other hand, is

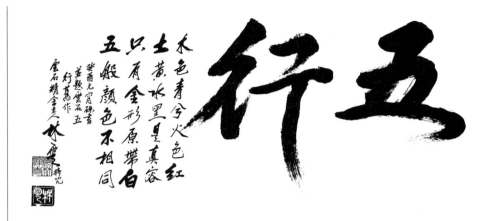

木色青兮火色紅
土黄水黑是真容
只有金形原帶白
五般顏色不相同

五行

The five elements—wood, fire, earth, metal and water— can also be used in analyzing and harmonizing aspects of our individual psyches.

■■■

like a reservoir—clear, reflective, and expansive. This person is highly intelligent, wise, and lucid.

Moving water refers to a person's social and business contacts and activities, as well as personal drive, mobility, and effectiveness. Those deficient in moving water are like brook water trickling down a mountain. These people have little contact with society. They never go out and prefer to stay at home. Someone with the proper amount of moving water is like a river, with more contact with the outside world. This person's life is balanced among many social and business engagements, home time, and travel. People with an excess of water are like oceans, touching all bases, seizing all opportunities. These people are never at home and are constantly on the move, sometimes spreading themselves too thin.

• The Five-Element Color Cures •

Once we analyze our five elements—whether they are deficient or excessive —there are ways to bring them into balance and thus improve our ch'i. One way to harmonize our personal five elements and improve or resolve our character traits is to use color. Many color cures utilize the five elements as they relate to our characters and virtues. Each of the five elements, in fact, represents a virtue. (As far back as Confucius, the Chinese linked a moral order of five virtues—humanity, righteousness, decorum, wisdom, and good faith—with the natural order, as symbolized by the five elements.) Each virtue, in turn, is associated

with a color, as well as with internal organs, seasons, and directions. Earth, for example, corresponds with truthfulness or good faith and the colors yellow, orange, and brown. Fire aligns with courtesy or decorum and the color red. Metal goes with righteousness and white, while wood corresponds with benevolence or humanity and green and blue. Water corresponds with knowledge or wisdom and the color black.

In relation to our own weaknesses, there is an appropriate palliative virtue, and its associated color can help us resolve our personality imbalances, as can the "complementary" colors of this hue. If, for example, you want to improve your intelligence and mental activity, you should wear black and thus increase the amount of water, which corresponds with wisdom. Green, the color of wood, which is fed by water, is also a good color for this purpose, as is white, the color of metal, the element that creates water.

Color cures can be further augmented by using the basic hue's complementary colors as accent or accessory colors. If, for instance, you want to increase your own compassion, use light green as your basic color—wood, the element associated with green, also corresponds to benevolence—and then accent the green with black and red. This is because wood's complementary colors are black (symbolizing water, which feeds wood and aligns with the virtue wisdom) and red (for fire, which wood feeds and aligns with courtesy). Deeper wisdom (black) helps us understand and empathize with others, and courtesy (red) helps us interact with others in a considerate manner. (These colors can also be used separately to increase compassion, as they have a positive relationship to wood.)

Yellow, orange, and brown, the colors associated with earth, the element of trustworthiness, are good colors if you want to cure compulsive lying and cheating. If, however, a person is unkind to others and tries to manipulate, trick, or take advantage of them, green, accented with white or black, can increase his or her amount of benevolence.

Colors can help alter our psychological makeup, as well as our ch'i. If a person does not listen to others and is too subjective and inflexible (bamboo ch'i), they should increase the amount of black worn so as to increase the element of water —intelligence. Light green will be helpful, too. Similarly, someone with porcupine ch'i can soften prickliness and be less critical and physically aggressive by increasing

Color can help adjust and resolve a number of personality flaws to improve our ch'i and thus our lives. While the color cures are primarily meant for clothing, they can also be applied to accessories and bedrooms.

■ ■ ■

PROBLEM	COLOR CURE
Lying and cheating	brown, yellow, orange
Opportunism	green (accented with white or black)
Inflexibility	black, light green
Abrasiveness	black, green, brown, yellow, orange
Passivity	red
Hot temper	black, green
Absentmindedness	green, light blue
Paranoia	yellow, brown, black
Slanted ch'i	dark red
Stubborness	black or light green
Insensitivity	black or red
Selfishness	black or red
Oversensitivity	yellow, beige, brown
Nervousness	green
Anger	black and green
Rudeness	green
Dullness	red and green

black for thoughtfulness and green for benevolence. These colors will make them nicer and gentler with others. Another color cure for porcupine ch'i is to apply the colors of earth: coffee brown, beige, or pale yellow. In China, earth itself is a reminder that, in the end, everything returns to the earth. When you die you are buried in the earth: trees decompose, turning into earth. Soil in this sense equals the world, and this is reinforced by the directional position of the earth element, which is the center. Symbolically, earth and its associated colors can therefore center a person with porcupine ch'i, reining in aggressive energy. Earth also symbolizes the Chinese saying "He embraces everything." Earth tones allow a person to be more open.

Sometimes the color cure literally reflects the properties of the corresponding element. For instance, red, the color of fire, may strengthen ch'i and enliven a passive person, while black, the color of water, will cool down a hot temper. Daydreamers or absentminded people should wear green or light blue, the color of wood, to ground them in reality. Sleepwalkers can paint their bedroom ceiling (or what they see when lying down) a shade of green to root them in their bedroom, or can have something light green to look at in that place. Green, the color of wood, creates a symbolic root, so that the sleepwalker will physically remain in place as he or she dreams at night. If you want to rest or relax, green is the most soothing color.

Sometimes colors can adjust a person's ch'i by being in direct contrast to his or her personality. For instance, a plain, invisible person should wear more cheerful colors to make others more aware of him or her. Someone who is too active should wear subtle colors like beige and pastel to mute their energy. And people with low ch'i who tend to have illnesses or accidents and gravitate toward dark, dull colors like black and gray should try wearing bright colors like hot pink,

kelly green, and lemon yellow to change their luck and brighten their future. Similarly, people with suicidal ch'i can adjust their ch'i by wearing green for hope and bright colors to lift up their ch'i and spirits. If someone is mentally slow, more black will increase wisdom and intellectual activity. If a person wants to be shrewder and see through other people's intentions and tricks in, for example, a business situation, he or she might wear black for wisdom, with white, gray, green, or dark green as complementary colors.

• Psychological Ailments •

Emotional illness can also be addressed with color. For hypochondria, a situation where your ch'i seems to amass in clumps throughout your body, wear an outfit that has all the colors of the rainbow in it. A chronically depressed and unhappy person can brighten their dark outlook and their ch'i with apple green—a positive color of spring—or

TO INCREASE	USE
Patience	light blue, red, tan, coffee, brown
Attractiveness	pink
Happiness	green, pink, light blue
Creativity	white, black, green
Fame	red
Wealth	green, red, purple, black
Insight and shrewdness	gray, green, or black with white
Compassion	green, blue, black, red
Intelligence	black, green, blue
Faithfulness	yellow and white
Seductiveness	flesh-colored
Protection on street	black and white, black
Performance on tests	black, black and green, dark green
Athletic coordination	red and green
Cure for bully	green, light blue, or mixture of white, black and green

Color can be used to improve or acquire assets: positive character traits, personal happiness, or wealth. Color can also help you have better experiences of all sorts—in school, on a date, or in deep personal relationships.

∎∎∎

reddish purple. A paranoiac person, on the other hand, needs to stabilize their ch'i, which is spinning too quickly in their head, with earth colors, such as yellow and brown. Black, the color of water, clarity, and wisdom, can also help alleviate paranoiac anxieties. Someone with downward-flowing, depressed ch'i, which can be suicidal, can start to alter fate with green—a color of hope, spring, and benevolence—and red—a happy and activating color. Black can be helpful also, to increase wisdom and lucidity. (Black and white together are wisdom-producing colors, symbolic of cultivation, as in Chinese calligraphy.) For people with yin-yang ch'i, who run hot and cold, strangely shifting their emotions and opinions at a moment's notice, the colors of earth—beige, yellow, or brown—will help stabilize their intentions, making them more dependable. Someone who has

"slanted ch'i" is untrustworthy and has oblique, misguided intentions. This kind of devious person can straighten up his or her act by wearing a deep shade of red.

IMPROVING MINOR CHARACTER FLAWS

Other less destructive character flaws also can be corrected with color (see p. 130). An insensitive lout can become more considerate by wearing black and red—for courtesy. Similarly, a selfish person's ch'i can be improved with black to increase knowledge and with red to augment rationality. Someone who is hypersensitive can become more thick-skinned and emotionally secure by wearing earth colors, such as yellow, beige, and brown. If a person is very jumpy and nervous, deep green will calm and stabilize ch'i. A hot-headed, angry person who is quick to scold others can cool down with black for wisdom and green for benevolence. A complacent individual, on the other hand, can be enlivened: red, purple, or green can light a fire under them. A shy person will be more confident with red. A hostile or rude person should wear green to relax. A silly person who seems to be full of nonsense should wear red for courtesy. A "weirdo" who can't get along with others, and who does or says strange things, might correct this with white for righteousness, the color of metal. Red and green can bring a spark to a tedious or boring person.

ENHANCING PERSONAL ASSETS

We also can improve the assets we already possess with color (see p. 131). If you want to be more vivacious, wear green, red, or purple. Pink—a wedding, or happiness, color—will make you prettier, more attractive, and charming. Patience can be increased with light blue, red, tan, or coffee brown. Happiness can be increased with green, pink, or light blue. White, black, and green, colors associated with water and mental activity, will enhance creativity. You can increase fame with red, and wealth with green, red, purple, or black. Insight and shrewdness can be increased by wearing black accented with white, gray, or green. To develop intelligence, wear black, green, or blue. According to Lin Yun, we can protect and prepare ourselves with color. If, for example, you are taking a test, you can wear any color. If you are very concerned about whether you will test well, then wear a cure, such as something black (for wisdom), black and green, or dark green.

• Color and Relationships •

Colors can adjust relationships. For example, loyalty to friends and country can be strengthened with white—for metal, the element of righteousness. White and yellow, the color of earth and good faith, are good for keeping a spouse faithful. (The person wearing white and yellow will have no mistress or lover.) Certain other difficulties in marriage are addressed with red cures (see p. 141).

If you want to be especially seductive, wear either a flesh-pink outfit or something satiny or shiny, such as lingerie. The skin tone is elusive and suggestive: although you are wearing something, it appears that you are not.

Age	Color
Kindergarten—6th grade	rainbow colors
Junior high	black, green
Senior high	black, green, red
Middle age	green, red, yellow
Old age	white, green, black

• Color and Age •

Color can affect us according to our age. Color is particularly important for children, to feed character and help develop wisdom early in life. For the young, use green for stability and benevolence, red for increased reason, and black for wisdom. In middle age green will help career development, red will increase reason, and yellow will cultivate trust and fidelity. In old age, good colors are white for expressiveness, green for hope, and black for wisdom.

CHILDREN

The breakdown of colors for youth can be further discussed. For the years between kindergarten and the sixth grade, rainbow colors will ensure that the child receives all virtues of the five elements. The ch'i of a teenager in junior high school will be improved with black (to increase wisdom) and green (to help foster benevolence). These colors are also good for high school, as is red for reason.

In specific cases, colors can balance a child's ch'i. As the child develops spiritual qualities, employ the rainbow colors or the Six True Colors. To increase athletic coordination, use red and green. To rein in a contentious child or a bully, use apple green, light blue, or dark green for benevolence, or a mixture of white, black, and green. For learning-disabled children, white or black can enhance intelligence. Green and blue will encourage intelligence in a slow child, and red will add the

Color can affect us according to age. These colors are particularly compatible with specific life phases.

■■■

power of fire. Thus black or brown may calm down a hyperactive child and also keep him or her straight and loyal. For children in general, yellow will bring out loyalty, honor, and truthfulness.

If a child has asthma, then their ch'i is not smooth and connected, and they must work on their lungs. Green will promote liveliness, as it is the color of spring. Blue is also good. Black should be avoided, as it is too cold and serious; asthma develops when the child is chilled, so red, symbolic of fire, is good. White will encourage articulation. Black will encourage a child to be more serious and to know when to be calm.

• Diagnosing and Fortune-Telling Through Physical Ailments •

PHYSICAL AILMENTS

Color can also be used to diagnose physical ailments. Pallor, for instance, can pinpoint internal problems or can reveal the state of one's ch'i, luck, or personal inclinations. The roots of this idea can be traced to Chinese folk medicine, which aligned the five internal organs with what they called the five external organs. The heart corresponds with pulse; the lungs with skin; the liver with muscles; the spleen with flesh; and the kidneys with bones. Ancient Chinese doctors thought respiratory problems might be indicated by the skin being the color of "blanched and withered bones" instead of healthier "pork fat" white. Spleen trouble was detected if the flesh—seen as different from skin and muscle —was yellow-green, similar to "fruits growing in copses." Flesh as "yellow as a crab's belly," on the other hand, indicated a healthy spleen.[6]

According to Chinese color theory, if a person's tongue or the whites of the eyes are yellow, this may indicate gall bladder problems. A reddened nose may foretell death or lung sickness. A darkening under the eyes may pinpoint kidney trouble.

FACE-READING

The Chinese similarly "read" the color of a person's face in order to tell their fortune. They employ the ba-gua, superimposing it on the person's face and then reading their fortune from red spots or scars, brown spots, black beauty marks, and the position of all those imperfections on the face. Any

[6] Heinrich Wallnofer and Anna von Rottauscher, *Chinese Folk Medicine* (New York: Signet Books, 1972), p. 90.

new spot that appears on your face may indicate a potential benefit or problem in the corresponding ba-gua area of your life. A woman with a scar above her lip might be told to avoid water. (The mouth is in the "career" position, which is also the area associated with the water element.) Another person whose right temple was dark and pale was told that his mother was experiencing problems. That was the "marriage mother area" of his face, and, in fact, unknown to him at that time, she was about to undergo an eye operation and would have legal problems with her brother.

Colors underneath the eyes can be associated with events: yellow brings celebration, black brings illness, white foretells the death of a family member, red brings government or legal tangles, and green augurs anger, shock, and worry. Face color can reveal a person's ch'i and whether they will have a romance or be attractive to the opposite sex. A peachy or rosy complexion may signal that a person is involved in one of the three stages of peach blossom luck (see p. 48). For example, a young man with a ruddy or flushed complexion might possess "marriage" or "happiness" ch'i, so girls will pursue him. Another man might have a dark, shadowy pallor, putting people off.

• Healing Physical Ailments with Color •

As far as small physical ailments are concerned, certain colors can ease our pains. In some cases, you can apply the ba-gua to the body. The ba-gua's trigrams are linked with parts of the human body and corresponding colors of the five elements (see p. 29 and p. 1 of color insert). Red, for example, might ease eye problems, because the eye and the color red are in the same trigram. The stomach as one of our organs is cited in the "marriage" trigram, so red and yellow, the colors of fire and earth, are the best colors to cure a stomachache. A headache can be alleviated by the soothing colors of pink and green—this cure has no association with ba-gua. If you use the ba-gua colors to cure a headache, use white and gray to adjust the "helpful people" area. Nausea can be cured with green. Eating disorders can be brought into balance with white. Because a sore throat is thought to be a result of possessing too much fire in your ch'i, black, the color of water, might douse your pain. Aqua and green are also good colors for soothing sore throats. If you have a physical tic, Lin Yun suggests white and green to relax.

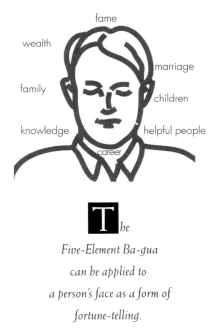

The
*Five-Element Ba-gua
can be applied to
a person's face as a form of
fortune-telling.*

∎∎∎

Problem	Color Cure
Sleepwalking	green, light green
Stomachache	yellow or red
Chronic depression	apple green, reddish purple
Headache	green, pink
Hypochondria	rainbow colors
Suicidal ch'i	green or red
Obesity	white
High blood pressure	black, white, light blue or light green —avoid red
Heart problems	black, white, light blue or light green —avoid red
Sore throat	black, aqua or green
Tics	white or green

These colors may be used in the cure of specific physical and psychological ailments.

To ease renal and back problems, you can use black—the color corresponding to the kidneys—and its complementary colors, white and green. The colors red, blue, or green—for hope and life—are good antidotes for the flu. Lin Yun says that the flu is aligned with water, so the fire element—symbolized by red—will counterbalance it—"boil it up." For childhood illnesses, "the more colors the better." Red, purple, and pink are said to help fight immunological problems.

Those suffering from high blood pressure and heart problems should avoid red and wear black, white, light blue, or light green.

Chapter 7 of this book deals extensively with using the colors of food to adjust imbalances that result in physical ailments. Other mystical cures and healing practices that employ color to address ailments and serious illnesses can be found in chapter 10.

• Mystical Color Cures to Strengthen Ch'i •

The Chinese believe that our bodies, like our homes, can house good ch'i and good luck. Our ch'i is constantly changing: sometimes it is good—sometimes, not so good. When our luck sours, there are a number of methods to purge the bad luck or ch'i from our systems. Our ch'i often functions like a prophetic autoimmune system. When our ch'i is weak, we are more open to absorbing negative external factors—bad luck, bad feng shui, and bad ch'i—that may come our way. We might even attract misfortune. When our ch'i is balanced and strong, we are more resistant to negative and destructive forces, so that we can cope with them better, and they have little impact on our lives.

A number of the ch'i-strengthening cures use colors. Most frequently red, symbolizing auspiciousness, happiness, and longevity, is the predominant color used. Readers interested in learning about these red cures can find them described in detail on p. 141.

Chapter Ten:
MYSTICAL CURES
AND HEALING PRACTICES

"MYSTICAL CURES."

Color is an important facet of Chinese folk and medicinal cures. Color is particularly crucial in BTB mystical practices, which offer cures for everything from reversing bad luck to acquiring a spouse. These mystical practices tend to be ritualistic, and like most rituals their effectiveness is dependent upon the element of oral transmission. No book, obviously, can provide this element, but we can convey to the reader a sense of how important color is in the Chinese tradition of mystical practices.

Some of the "cures" are monochromatic, employing only red, green, or white. Other cures use the auspicious color sequences of the Five-Element Ba-gua Color Octagon, the Six True Colors, or the Seven-Color Spectrum. All cures, no matter what the use of color, should be strengthened with the use of the Three Secrets Reinforcement (see chapter 11).

Among the mystical materials used in the cures are *syong buang* or realgar, a yellowish orange powder, and *ju sha* or cinnabar, a red powder. Both powders

traditionally are used in Chinese medicine and can be employed in BTB cleansing rituals. In addition, red strings, lotus seeds, plants, rice, and chalk are tools employed to achieve a desired result, be it conception or easing back pain.

These cures are *chu-shr*, that which is outside our normal realm of experience. Like many *yi* practices, they are acts of faith. While they may seem superstitious, they are "110 percent effective." Sometimes we need to stretch beyond accepted and rational means to find ways to resolve our problems and improve our destiny.

· Colored Line Running from Heaven to Earth ·

This is a colorful and sacred cure that uses the Five-Element Ba-gua Color Scheme to enhance areas of your life. It employs a multicolored string that you make yourself, in a color sequence based upon the ba-gua. Although the cycle of this sequence is fixed, the beginning color changes according to desired results. By installing the string in one of the eight ba-gua areas of a room, you symbolically channel a wish to heaven and enhance the corresponding area of your life by bringing an answer to your wish back to earth. No matter where the string is installed or what the wish is, the final color at the bottom of the string is always yellow, the color associated with earth.

The color scheme of the line running from Heaven to Earth works this way:
View the Five-Element Ba-gua Color Octagon (see p. 29 and p. 1 of color insert). To make the string, begin with the color associated with the area of your life you hope to enhance. This is the top color. Go counterclockwise on the chart to find the next color. Proceed counterclockwise. The two-tone segments can be created by weaving threads of the two colors together.

For example, if you want to improve your finances, the string should start at the wealth area color—red/green. The next color down will be green (family), followed by green/black (knowledge), then black (career), black/white (helpful people), white (children), white/red (marriage), red (fame), and finally yellow.

This string would then be installed in the "wealth" area of the room and ritually reinforced with the Three Secrets Reinforcement (see p. 148).

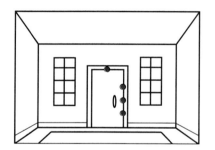

*S*ealing *the Door applies a mixture of a red powder (ju-sha) and strong liquor to a door to rid a residence of bad luck.*

If, on the other hand, you want to improve your marriage, make a string that begins with white/red at the top, then red, red/green, green, green/black, black, black/white, white, and finally yellow. Install it in the "marriage" area.

Other variations include using the Six True Colors, starting at the ceiling and progressing to the floor in this sequence: white, red, yellow, green, blue, black.

Similarly, the Seven-Color Spectrum can be employed starting at the floor and rising to the ceiling in this order: red, orange, yellow, green, blue, indigo, and purple.

· Sealing the Door ·

This cure can be used to cure a house or room that has an unfortunate history. Place one teaspoon of cinnabar (ju-sha) in a small bowl. Add drops of a strong liquor, such as rum, numbering your age plus one. Mix with your middle finger. Dot the inside of the bedroom door, the house or office entrance, the side and back doors, and even the garage door, and then reinforce with the Three Secrets Reinforcement (p. 148).

· Touching the Six Points ·

This is a personal cure to drive away bad luck and bad ch'i and to raise one's own ch'i. It is a physical application of the Six True Colors (p. 28).

Create a mudra—a Buddhist hand gesture—with your left hand by holding your middle and ring fingers with your thumb and pointing the pointer and pinky. In your left palm use your right middle finger to mix a teaspoon of ju-sha with drops of a hard liquor such as rum, numbering your age plus one. Dot the sole of your left foot and visualize your ch'i improving. All bad luck turns into good. Chant the syllable "om." Visualize the color white along with ch'i rising in your body. Reinforce each time with the Three Secrets Reinforcement (p. 148). Then return your right middle finger to your left palm. Dot your right sole, chant "ma," and visualize red. Return your right middle finger to the left hand and dot your left hand, chant "ni," and visualize yellow. After dipping the right middle finger again in the left palm and dotting the right hand, chant "pad," and visualize green. Follow the same ritual, this time dotting the center of the chest, chanting "me," and visualizing the color blue. Finally, dot your forehead. Chant "hum" and visualize black.

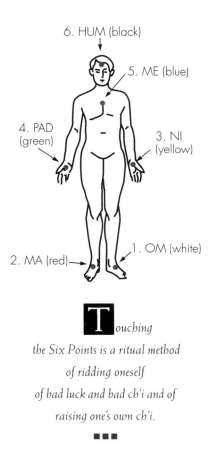

6. HUM (black)

5. ME (blue)

4. PAD (green)

3. NI (yellow)

2. MA (red)

1. OM (white)

Touching the Six Points is a ritual method of ridding oneself of bad luck and bad ch'i and of raising one's own ch'i.

∎∎∎

• Cancer Treatment •

To augment and reinforce appropriate medical treatment for this disease of abnormal cells, Lin Yun recommends that the patient look at the Six True Colors, transmitting their auspicious color sequence to the afflicted cells.

• Housewarming •

If you wish to consecrate and purify your new home, here is a simple blessing. Place nine skins of oranges, lemons, or limes in a medium-size bowl containing water. Flick the citrus water all around, moving from room to room, corner to corner. (With wall-to-wall carpeting, use an atomizer.) Perform the Three Secrets Reinforcement (p. 148), envisioning that the citrus water is cleansing the bad ch'i and bad luck and spreading good ch'i and good luck in its place.

• Prenatal Care •

The colors that an expectant mother sees can influence the subsequent mental and physical well-being of her child. These colors will also affect the mother's health.

Professor Lin refers to the application of color as "prenatal education." For the best education of the fetus ch'i, the expectant mother should look at a wide range of colors. The colors should be joyful and full of life force. For example, green, the color of spring and new growth, is considered full of life. Pink, a variation of red, symbolizing happiness ch'i, is also a positive, pleasing color during pregnancy. The range of rainbow colors is also recommended, as they activate and help cultivate the ch'i of both fetus and mother-to-be. Rainbow colors are considered in BTB theory to be highly spiritual. Lin Yun also suggests that during the prenatal stage, the expectant mother view the Constantly Turning Dharma Wheel (p. 151), through visualization or a picture. The Constantly Turning Dharma Wheel is a dynamic image and blessing, consisting of the Six True Colors spinning in sequence. In addition to specific colors, the mother-to-be should also look at pictures of life-fulfilling and joyful scenes, or at pictures of religious entities such as the Buddha, Christ, or the Madonna and Child, depending on her belief. Normally any pleasant picture of a mother and

child will do. These pictures should be colorful rather than monotone. The expectant mother can also adjust the "children" area of her bedroom by installing a white object there.

• Red Cures •

CURE AGAINST NIGHTMARE

If you have a nightmare, you can either immediately perform the Red Sunlight Meditation (see p. 155) or within three days write with black ink on a round red piece of paper:

> I had a nightmare,
> And now write on a high wall.
> As the sun rises and shines on this,
> All bad luck will change to good fortune.

Paste the paper outside on a high place or on a bulletin board at night.

RED EGG REBIRTH

One of the more potent ch'i cures is the Red Egg Rebirth, a ritual that seeks to expel bad luck and ill ch'i, so that it is replaced by good luck and positive ch'i. On its deepest level, this cure symbolizes a sort of spiritual rebirth. All sadness and negativity are purged, and you can start anew. This cure can be performed on your birthday, Chinese New Year, or whenever you feel it is necessary to exorcise bad dreams or bad luck.

Buy a carton of eggs. Don't let anyone see them after they have been purchased. During the best hours of your birth year (see chart, p. 166), boil the egg. Don't let anyone look at it or disturb you. Use the Three Secrets Reinforcement (p. 148), visualizing the process of driving away bad luck. In the palm of your hand, mix one teaspoon cinnabar with drops of strong liquor, numbering your age plus one. Mix with your middle finger. Roll the hard-boiled egg in your palm. Place the egg on a napkin. Rub your palms together until they are dry. They will be a rusty red. Visualize all bad ch'i leaving you. Only good ch'i remains and prospers. Carry the egg outdoors. Crack the egg lightly and peel the shell off. Be careful to keep all of the shell in a paper bag or napkin. Don't drop any of the shell. Visualize the egg being higher than table height. Envision the eggshell as an old cicada shell being shed. As it is shed, you are

This is a transcendental (chu-shr) cure for the disquieting effect of a nightmare: by using a mystical cure such as this, you can be released from suffering and recover a sense of well-being and good fortune.

■ ■ ■

shedding your old ill fortune. Then imagine a new shell forming and you returning to your original, pure self. You become like a newborn, unhindered by bad luck. You are spiritually reborn. Eat part of the yolk and part of the egg white—or if you're inclined, eat the whole egg. Throw away the rest of the egg (not the shell) in four different directions. Envision the egg feeding the hungry ghosts, who depart, satisfied. Perform the Three Secrets Reinforcement. Crush the eggshells and throw them to the four different directions. Imagine that you are throwing away bad luck. Be careful not to step on the shells. Perform the Three Secrets Reinforcement .

he Four Red Strings Cure is a sort of mystical phone wire linking earth with heaven. Invoke celestial powers to help you surmount the insurmountable.

FOUR RED STRINGS CURE

This cure is used when you confront problems in life that appear insurmountable.

In each of the four corners of your bedroom, install a red string from ceiling to floor. These four strings symbolize the legendary four columns that hold up the canopy of heaven. They also represent a sort of mystical phone line linking heaven and earth, invoking the power of heaven to intercede on your behalf on earth and remove your difficulties. Then at the point midway between ceiling and floor, attach a nine-inch red string, fastening it at its center. This nine-inch string symbolizes human beings—the string when held out at a downward angle resembles the Chinese character "ren," 人 which means "human." Perform the Three Secrets Reinforcement. Envision that you are at the juncture between heaven and earth and thus will receive universal ch'i to help you overcome all your obstacles.

FOUR RED RIBBONS MARRIAGE CURE

If your marriage is rocky and one spouse does not listen to the other, try a simple cure using four red ribbons or strings. Take a yard of red string and cut it into four nine-inch lengths. Stick each one up high in four of the eight ba-gua areas: the "helpful people" corner, the "career" area, the "family" position, and the "wealth" area. Reinforce each installation with the Three Secrets Reinforcement.

ACQUIRING AUSPICIOUS OR MARRIAGE CH'I

This is a cure for anyone hoping to locate a potential spouse, get married, or simply increase happiness. Indeed, those who are already married can also follow this cure, because the ch'i of a wedding is considered among the best and the happiest.

Select nine items, most of which you might wear or use. Avoid objects that may disappear with use, such as soap, food, or lipstick. It is better to choose jewelry, pens, keys, etc.

Wrap the selected items in a red cloth or envelope, or place them on a red cloth, and take them with you to the wedding. Have the bride and/or groom touch the items while you perform the Three Secrets Reinforcement (p. 148), visualizing that their auspicious ch'i will positively help you bring a happy and romantic scenario into your life. Then wear, carry, or use the items as often as possible to increase your chances of happiness. (Prior to using the items, you can opt to place the objects in the "marriage" position of your bedroom for nine days.) If you cannot attend the wedding, have the couple bless the nine items within ninety days before or after the wedding day.

RED CLOTH TRAVEL CURE

There are certain times when your ch'i is weak and it is unwise to travel, move, or venture into a new business or environment. Or perhaps your wedding date falls within such a period! If rescheduling is simply impossible and you have to venture forth at such a time, use the Red Cloth Travel Cure. The red auspicious color will lead you to a new, higher stage in your life. For a wedding, red symbolizes the bride or groom in an auspicious arrangement between the blue sky and the brown earth.

Buy a six-foot length of red cloth. Before you go out or embark on the journey, lay the cloth across the threshold of your entrance, with three feet on either side. Walk over the red "carpet" as you step over the threshold, envisioning a safe and smooth journey. Perform the Three Secrets Reinforcement (p. 148). If you are spending the night out of your home, take the red cloth with you and position it evenly on the threshold of the hotel room and walk over it to enter the room. Reinforce with the Three Secrets Reinforcement. Repeat when you leave the hotel room.

• *White Cures* •

HEART DISEASE TREATMENT

Here is Lin Yun's heart disease treatment, which he cautions should complement medical treatment:

Place nine pieces of ice in a white pot. (If the pot is white, the ice will seem white.) Add a tablespoon of camphor. Then place the pot with ice and camphor under your bed, directly beneath where your heart will be when you lie down. Bless with the Three Secrets Reinforcement (p. 148).

CURE FOR LITIGATION

In order to purge all litigation from your life, during the most auspicious time (see Chinese Zodiac Chart, p. 166) mix one teaspoon of Borneo camphor crystals with nine pieces of ice in a bowl of water. For fifteen minutes, clean the top of your stove with the camphor-ice solution. Reinforce with the Three Secrets Reinforcement.

Perform this for nine consecutive days.

CURE FOR BACKACHE

One BTB cure for a backache is to place nine pieces of chalk in a rice bowl that contains a small amount of uncooked rice. Place the bowl under your bed, directly beneath the sore area of your back.

STRING OF PEARLS CURE FOR
DETERMINING THE GENDER OF YOUR CHILD

The "pearls" can be costume jewelry, white wooden beads, or lotus seeds strung together.

For a girl: Hang a string of nine white flowers in the "children" area of your bedroom. For a boy: Hang a string of nine lotus seeds in the "children" area of your bedroom. (To discern the "children" area, consult the Ba-gua Octagon.)

• Green Cures •

CONCEPTION RITUAL

Since plants are associated with life and growth, it is not surprising that they are used in a BTB conception ritual.

The wife takes her husband's lunch or dinner bowl—without rinsing or cleaning it—and puts nine raw lotus seeds and nine dried dates into the dish. She then fills the bowl with water to seventy percent of capacity and puts it under the bed (directly below her stomach). Before installing the bowl under her bed, she exposes the bowl and its contents to the moon and invites the ling

u Nei
is a feng shui blessing used to
adjust an interior's ch'i
and to resolve an unharmoniously
shaped room or building.

■■■

particles in the atmosphere to enter her house. (These ling particles are embryonic ch'i.) She reinforces this cure with the Three Secrets Reinforcement (p. 148).

The first thing every morning for nine days, the wife throws out the old water and replaces it with fresh water. Again she exposes the bowl to the moon and invites inside the ling of the universe. After nine days she pours the contents into a houseplant and buries the lotus seeds and dates in the soil. Then she places the plant near the front door and performs the Three Secrets Reinforcement.

This entire procedure is repeated two more times. She should place the second plant in the living room near the entrance door, and the third plant in the bedroom in the "children" area. She should reinforce the placement of the pots with the Three Secrets Reinforcement each time. Dusting under the bed or moving it should be avoided.

OPERATION CURE

Plants can also be used as part of a simple cure to ensure a safe operation and speedy recovery. In your or the patient's bedroom place nine small plants in a line from the door to the bed. Reinforce with the Three Secrets, visualizing a successful operation without complications and a quick recovery. The nine plants can also be placed along the windowsill so that you don't trip over them.

YU NEI—INTERIOR BLESSING

This is a plant cure for bad health or strange problems. Yu Nei is an important BTB cure to adjust ch'i and resolve an unbalanced room or house shape.

Divide the room or building into rectangles. Connect each corner to the middle point of the opposite line and then connect the opposite corners. An inner polygram will be formed by this crisscross pattern of bisecting lines. The polygram is the inner center. Place a living plant or a wind chime within the polygram.

Chapter Eleven:
VISUALIZED COLOR: MEDITATIONS

T he following meditations have their roots in Buddhism, but they may be used by people of all faiths, as well as by readers with no religious affiliation. When you seek color in the mind's eye you can imagine the Buddha, Mary, Christ, Allah, Yahweh, or simply light and color. The visualization of color can improve our moods, behavior, health, physical movement, language, and business. Often, visualizing color is a way either to cleanse or empower the soul.

This chapter begins with the Three Secrets Reinforcement, which is referred to throughout *Living Color* as a way to add strength to any color treatment or cure. We then provide specific details for eight meditations, the purposes of which are listed below.

These visualizations are part of an oral tradition. Written down as they are here, they lack the vital ingredient of personal transmission. Nevertheless, they provide an idea of what can be possible through the visualization of color.

• *Three Secrets Reinforcement* •

While the Three Secrets Reinforcement does not directly relate to color, it adds extra strength to any cure. The Three Secrets are three mystical ingredients—expressed by body, speech, and mind—that combine to create a potent blessing. They are the basic components of meditation.

BODY: THE MUDRA

In the ritualized gesture of the mudra, the hand or hands assume poses similar to those of the Buddha. The mudra is a form of body language, a silent physical invitation. In everyday life, you may wave your hand to greet someone or extend it to show friendliness with a handshake. A mother might raise her hand to warn a misbehaving child. Black Sect Tibetan Buddhism has a number of mudras, each used for a different purpose.

THE EXPELLING OR EXORCISM MUDRA, OR THE THREE SECRETS MUDRA

The most commonly used mudra is the Three Secrets Mudra, also known as the expelling or exorcism mudra, which serves to drive away bad luck and malignant spirits and to improve ch'i. Generally, when practicing this mudra, a male will use his left hand and a female will use her right.

THE HEART-AND-MIND-CALMING MUDRA

The Heart-and-Mind-Calming Mudra is used at the beginning of a meditation to calm down the heart and mind. To assume this mudra, place your left hand on your right, palms up, and create a right angle by touching your thumbs together.

THE BLESSING MUDRA

The Blessing Mudra is assumed for offerings, blessings, and for paying the highest respect.

SPEECH: THE MANTRA

The mantra is a chant that is recited in order to pray or to attain a proper spiritual state of mind and thus to achieve a positive result. As with the mudra, there are a variety of mantras used in specific situations.

THE SIX-TRUE-SYLLABLES MANTRA

The most commonly used mantra is the Six-True-Syllables Mantra: "om mani padme hum."

The Expelling Mudra (used in the Three Secrets Reinforcement) is a ritual gesture that with the Six True Syllables and correct visualization can add strength to any cure.

THE HEART-AND-MIND-CALMING MANTRA

The Heart-and-Mind-Calming Mantra, naturally accompanies the Heart-and-Mind-Calming Mudra. While it is simple, this mantra is considered powerful: "gatay gatay boro gatay, boro sun gatay, bodhi swo he."

MIND: VISUALIZATION

This is the conscious intention, will, or prayer expressed in our minds that accompanies the mudra and mantra. It is a visualization, the power of the mind used to achieve a desired result. This might range from a simple wish or prayer to an elaborate visualization to help yourself or loved ones. For example, if you are gravely ill, you might reinforce modern medicine by visualizing a positive scenario of recovery from sickness to healing to health. You can also use visualization to reinforce any of the ba-gua cures.

· Visualizing the Sun-Moon Dharma Wheel ·

The Sun-Moon Dharma Wheel Meditation is used to improve your physical and mental health, stimulate your mind, improve your ch'i, and deepen your spirituality. This meditation is a variation of the Heart Sutra meditation.

You begin this meditation with the Heart-and-Mind-Calming Mudra and Mantra.

(You can perform the Om-Ah-Hum Purification Practice here, if you choose. See p. 158.)

Once you have reached a calm state of mind, envision a lotus appearing in the center of your heart. This image is attained without relying on any exterior visual forms or forces. This lotus flower appears in an instant, a split second. On top of the lotus are a sun wheel and a moon dharma wheel. The moon wheel is red and stationary. It shines a red light. The sun wheel is white and spinning. It radiates a bright silver sunlight, almost the color of mercury.

Slowly, the red moon wheel begins to rise from the center of your heart, glowing like a red lightbulb. Bright red and radiating a bright red light, the moon wheel rises through your throat, into your head. Suddenly, it multiplies into ten, fifteen, twenty red balls. And these bright red balls are tightly compacted inside your cranium. All these red balls, glowing like lightbulbs, concentrated in your head, radiate energy, heat, light, and color, so that your scalp becomes a glowing red color, like molten iron. The red ball begins to descend along your spine, so that it

The Heart-and-Mind-Calming Mudra, along with the Heart-and-Mind-Calming Mantra, is a technique to calm you when you begin to meditate.

■ ■ ■

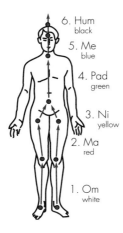

6. Hum
black

5. Me
blue

4. Pad
green

3. Ni
yellow

2. Ma
red

1. Om
white

he Six-Stage Ch'i Improvement Method is a meditation that uses a visualization of the Six True Colors, proceeding in sequence, to raise one's ch'i.

■ ■ ■

too gradually becomes a molten red color. The red color extends along your ribs, which one by one also become an iron-hot red. Gradually this bright red light extends along the entire frame of your body. You are now a skeleton that is bright red in color and radiating heat and light. The energy of this state is an intense and concentrated force. All the while the white sun wheel still spins at the center of your heart.

At this point, your skeleton glows in a vat of molten-iron red so intensely energized and smoldering that it ignites a fire in your chest. This fire burns away and thus expels all the negative aspects of your existence. All the bad karma accumulated in your past and present lives, all the bad luck that may be plaguing you or loved ones, is burned away. And it is only now that the concrete and mundane aspect of your physical existence disappears, leaving you in a state of emptiness, except for the red, glowing, energized skeleton.

At this point, visualize that the surface where you stand or sit is not a chair or floor but a large pale pink lotus. This lotus begins to grow inside you and wrap around you to form a new you. A bright white sunlight radiates out of the sun wheel and mingles with the red light of your body. The dappled red-and-white light radiates and sends blessings toward the millions of Buddhas, then the sentient beings, then loved ones, teachers, your family members, and friends whom you wish to help...blessings to the entire world in hopes of peace and harmony.

• Lyio Dwan Jin: Six-Sector Meditation •

This visualization employs the Six True Colors and Six-True-Syllables Mantra to improve your ch'i. The Six-Sector Meditation can also help cure depression and sickness. Assume the Heart-and-Mind-Calming Mudra (p. 148). Chant the Heart-and-Mind-Calming Mantra (p. 149). Then, maintaining your posture, perform a simple breathing exercise: inhale deeply and exhale—in eight short breaths and one long one—nine times.

Then visualize two small suns under each foot. Your soles can feel these suns radiating heat and light. Imagine that slowly from the suns two white lights imbued with the sound "om" enter your body through your arches. The white lights travel up through your feet, your ankles, your calves. When the white lights reach your knees, they become two red lights radiating the sound "ma." Gradually

these red lights travel through your thighs to your pelvis. When the lights hit your pelvis, they merge and become a warm yellow light, emitting the sound "ni." This warm yellow light travels a short distance, to three inches below your navel. At this juncture (known to the Chinese as *dan tien*) the light becomes green and the sound will become "pad." Slowly this green light fills your chest area, your heart and lungs, your abdomen. When the green light reaches your throat, it turns into a blue light and the sound is "me." This blue light rises into your head, filling your brain to the level of your third eye (the center of your brows). At your third eye, the color of the light becomes black, and this blackness and the sound "hum" fill your head from your brows to your crown.

Recite the Six-True-Syllables Mantra (p. 148) nine times.

• *The Constantly Turning Dharma Wheel* •

The Constantly Turning Dharma Wheel is a colorful feng shui blessing that cleanses and enlivens the ch'i of a home or office. It is a difficult meditational juggling act: you must visualize a network of revolving, spinning balls. The balls are in an ordered sequence of the Six True Colors: white, red, yellow, green, blue, black. Here, white symbolizes a blank slate. When the Six True Syllables and the Six True Colors are united, they progress from white (om) to red (ma) to yellow (ni) to green (pad) to blue (me) to black (hum). Here black stands for all colors, or all things, united.

The Constantly Turning Dharma Wheel is a feng shui blessing that uses a dynamic image of the Six True Colors, spinning counterclockwise, to enliven and cleanse an interior's ch'i. Each color, in turn, is encircled by Six True Colors (as shown here around blue), and then each of those is surrounded by a further set of the six colors (as around the red disk shown here), ad infinitum.

∎∎∎

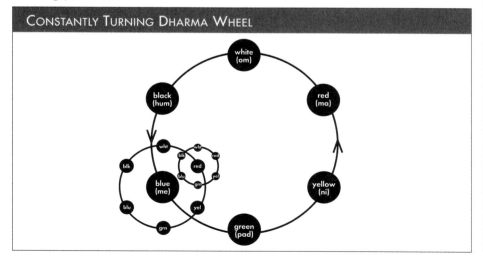

CONSTANTLY TURNING DHARMA WHEEL

white (om)

black (hum)

red (ma)

yellow (ni)

blue (me)

green (pad)

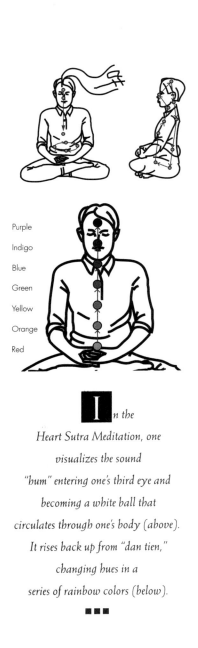

Purple

Indigo

Blue

Green

Yellow

Orange

Red

In the

Heart Sutra Meditation, one

visualizes the sound

"hum" entering one's third eye and

becoming a white ball that

circulates through one's body (above).

It rises back up from "dan tien,"

changing hues in a

series of rainbow colors (below).

■ ■ ■

This house-cleaning meditation begins as you enter the house. Look around briefly, then exit, and perform the Heart Sutra Meditation (below).

Reenter the house, bringing with you blessings and good wishes for its residents. The Heart Sutra Meditation is empowering you with the strength of the Buddha to add sacredness to the blessing.

Then envision a colorful wheel—the dharma wheel—spinning in front of you. The dharma wheel encompasses light, sound, and thought. It is made up of a sequence of six different colored balls that embody the Six True Syllables. Each ball is spinning while it revolves in a counterclockwise direction with the other five balls. Each ball is further surrounded by a rotating ring of six spinning balls in a sequence of the Six True Colors, embodying the Six True Syllables ad infinitum.

• *The Heart Sutra Meditation* •

This is a meditation to steady and deepen the self, as well as improve the health. First, sit, stand, or lie in a comfortable mudra (p. 148). Chant the Heart-and-Mind-Calming Mantra (p. 149) nine times.

Next, imagine a silence and out of this silence a distant soft sound, "hum," which as it approaches gets louder and louder until it enters your body through your third eye. At the point of entry the sound "hum" becomes a small white ball. This ball then descends to the "dan tien," a position three inches below the navel (see p. 151). It circles horizontally in a clockwise direction nine times. Then the ball spirals up the front of your body to the top of your head, continuing down your spine to your crotch and up to the dan tien position. After the ball circles the body a total of three times, it becomes a series of colors. As it rises to the third eye the ball converts to red, orange, yellow, green, blue, indigo, and purple. At the third eye, the ball throbs, first purple, then indigo, blue, green, yellow, orange, and finally red.

Then visualize the red ball exiting your body and carrying with it your ch'i. It travels into the presence of a higher being, a deity or light. Pay your respects (see Om-Ah-Hum Purification Practice below) and visualize your ch'i leaving the red ball and entering the third eye of the Buddha. Imagine your ch'i expanding until it fills the Buddha's entire body. Then envision your ch'i, now united with the Buddha's ch'i, exiting the Buddha through the third eye, filling

your body so that you and the Buddha are one. Perfect Buddha wisdom fills your head, compassion fills your heart, power fills your body. The Buddha's color becomes your color. His (or her) image and appearance becomes your own. In all ways you and the Buddha are one entity. Then visualize a fire burning your eyes, nose, ears, tongue, your entire body. Nothing is left except your Buddha self. Then visualize an eight-petal lotus opening in your heart. Inside the lotus are two balls, one red and the other white. Under your feet are two lotus blossoms, and you are also sitting inside an eight-petal lotus. In your heart the red ball is stationary while the white ball radiates light, filling your entire body. Imagine this light radiating out of your body and emanating throughout the universe of the myriad Buddhas, as well as to the six realms of sentient beings. The six realms are: heaven, jealous gods, human beings, animals, hungry ghosts, and hell. As your light radiates it liberates them from the chains of suffering, releasing them into a state of contentment. Their light will reflect back to you.

Then send your Buddha light to relatives—children, parents, siblings, friends—bestowing blessings on them, wherever they are. They, in return, will send blessings back to you. Then send your Buddha light to all animals and beings in the world, or send blessings for health, success, wealth, marital harmony, or cultivated spirit. Conclude this meditation with the Heart-and-Mind-Calming Mudra and Mantra (pp. 148, 149), chanting the mantra nine times.

This meditation can be practiced at any time of the day.

· Green Tara Meditation ·

You can use this meditation, the Recovery Practice, if you have a friend or relative who either is sick or has encountered some horrible, unexpected events that have brought sudden tragedy or disaster. Assume a comfortable position, sitting in a chair or in the lotus position. Don't meditate in bed. Calm yourself down with the Heart-and-Mind-Calming Mudra and Mantra.

Then visualize that the Green Tara, in all her robes and splendor, enters or unites with your body and becomes one entity with you. For instance, if you are sitting in a chair facing east, she will be sitting inside of you facing in the same direction. Whatever your posture, she will hold that same posture within the shell

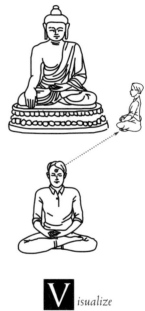

Visualize a red ball carrying your ch'i. It exits through your third eye and travels into the presence of the Buddha.

■ ■ ■

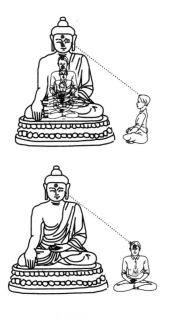

isualize
you are in the presence of the
Buddha. Your ch'i
enters the third eye of the Buddha,
growing to fill the Buddha's
entire body. It exits the Buddha's
third eye and returns
to your body. You and the
Buddha are one.

∎∎∎

of your body. She merges with you instantly. You and the Green Tara become one entity. Visualize and feel that now you have all the attributes of the Green Tara: her wisdom in your head, her compassion in your heart, her supreme and infinite power permeating your entire physical being. Then visualize a jade stone at the center of your heart. This jade stone is the "seed mantra" and has a sound—"dome"—beating in the center of your heart. This dark green stone is moving, pulsating. Around the stone are nine round green stones. They are smaller and a lighter shade than the seed mantra. These nine stones are syllables, forming the mantra of the Green Tara: (om), da reh dri da reh du li swo he." The nine stones circle the jade stone horizontally, clockwise, continually emitting the Green Tara mantra while within the center the jade stone pulses: dome, dome . . ." The mantra beats with your heart, radiating its own color, from the dark green of the jade stone out to the lighter green of the Green Tara mantra stones.

Then visualize on the outskirts of the nine stones an even lighter shade of green moving counterclockwise. It should be noted here that for beginners it is often difficult to visualize the nine stones circling clockwise while the lighter shade turns counterclockwise around it. Some beginners have said they felt dizzy from this part of the meditation. If this happens, instead visualize that on the outskirts of the nine stones a very pale green light emanates from the stones out into the universe. More advanced students can visualize the palest green light circling counterclockwise, turning and turning as the nine green stones continually emit the Green Tara mantra sounds: "da reh dri da reh du li swo he." Simultaneously the dark green stone pulses: "dome, dome . . ." Then visualize the palest green light that encircles the nine green stones emanating out from your body, farther and farther away, until this light reaches the millions of Buddhas—or supreme deities. And the Buddhas or deities shine their light—a combination of all colors, bright as sunlight—back toward you. When a wheel of rainbow colors spins quickly, it becomes a bright white color. This is the first step of dedication. Then think about the six realms of sentient beings—heaven, the jealous gods, humans, animals, the hungry ghosts, and hell. Send your light to these sentient beings: relieve the suffering of their existence and thus bring them closer to happiness. They will then radiate their light, which will shine back on you. (Their light may

be white or green, or any color that comes to you that instant in the medi tation.) During the meditation, your own light will maintain the lightest shade of green. The next stage is to shine your light toward a "guru" or teacher, if you have one. If you don't have a spiritual teacher, you can visualize your own house. Shine your light toward the front door, where it will enter. Use the visualization to direct your light and let it travel through the entire house, one room after another, until with your visualized light you have purified the house, removing all sickness, tragedy, pain, and bad luck. Your house now radiates an auspicious light. For those without a religious affiliation, this light can be perceived as a universal light: auspicious, peaceful, harmonious, and healthy. If you are using this meditation to help a loved one, visualize your palest green light entering their body through their third eye, blessing them, freeing them from the tragedy that has befallen them.

To complete the meditation, bring your light back. Then you can make wishes, asking for help in order to improve health, change bad luck to good, increase prosperity, bring harmony into your life, increase your spiritual depth and power. Conclude the meditation by reciting the Green Tara Mantra nine times.

· Visualizing Red Sunlight ·

To recover from a nightmare and purify the dream world, this meditation should be performed the morning after your bad dream, while the dream is fresh and you are still lying in bed. Perform the Heart-and-Mind-Calming Mudra and Mantra. Visualize that above you there appears a bright red sunlight—similar to a red ball radiating a bright red color. This red orb approaches you from afar. It will enter your body through your third eye. Imagine this bright red light filling your entire body, radiating to each extremity.

Gradually, the red light will rise up from the soles of your feet. As the light rises, envision it removing all bad karma, bad luck, and negative ch'i—the unpleasant residue of your nightmare. As the red light exits your body through your third eye, all ill effects of the nightmare leave with it and return back to the universe.

Repeat this part of the visualization eight more times, imagining the red sunlight entering your body more deeply each time, turning your entire physical body red inside and out.

It should be noted that the red in this meditation is not only a color but also a red light—similar to that of a red sun emanating red rays. The capacity to envision the red sunlight depends on one's level of spiritual development and power. For instance, a beginner may only visualize the meaning and positive use of this meditation and feel better after the exercise. This is fine. However, after years of practice, you may begin to feel that when the red light moves, it seems to carry away with it all your bad karma and ill fortune or whatever unpleasant feelings that you may feel are bothering you. With each cycle, you begin to feel lighter and brighter. You feel almost translucent, even though the red sunlight maintains the same intensity and brightness. After a number of cycles of the red light entering, filling, and then exiting your body, you will feel as though your own karma, troubles, and anxieties have been lessened or even removed. You feel lighter. The sense of transparency is a physical sense, as though your physical existence is translucent, and thus you become one with the universe. Free of bad luck and karma, you are pure and auspicious. You can then recite the Six True Syllables: om mani padme hum.

· *Visualizing the Great Sunshine Buddha* ·

This is a meditation to heal bodily ills. To perform it, you can either stand outside or visualize the sun's rays entering your body.

PHASE I

Stand with your feet a shoulder's width apart. Raise your hands above your head, with your palms and your forehead facing skyward. Visualize the sun spinning in the sky getting closer and closer, larger and larger, hotter and hotter. Then visualize the sun's white rays entering your body through the center of your palms and the middle of your forehead. Envision the sunlight bathing your body in restorative light, so that you feel warm and bright. The light then exits from the soles of your feet. Rest your hands at your sides.

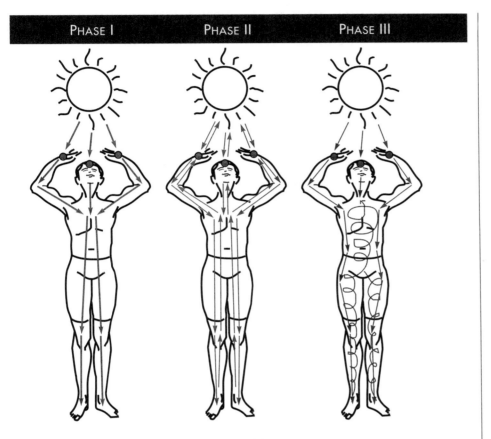

PHASE I	PHASE II	PHASE III

Visualizing the Great Sunshine Buddha is a three-step meditation, using the image of the sun's rays to heal bodily ills.

∎∎∎

PHASE II

Stand with your feet apart again. Visualize the sunlight entering again through your palms and third eye. Imagine the light racing through your body, filling it to the soles of your feet, then quickly rushing back up and traveling out of your body through your soles and through the same points at which it originally entered, giving you a strong feeling of motion. Rest your hands at your sides.

PHASE III

Assume the same posture. Visualize white rays of sunlight entering your body through your palms and third eye and shooting down to the soles of your feet. Once the light hits your soles, your feet will feel warm. The light will be like two small suns. The tempo will change: the sunlight will begin to rise slowly in a

circular motion through your body. As the light spirals upward, visualize it removing all your pains and sick cells from the unhealthy parts of your body, then exiting your body, taking all illness with it. Envision your entire body glowing with health.

Rest your hands.

Repeat these three phases nine times daily for twenty-seven days.

• Om-Ah-Hum Purification Practice •

The specifics of this practice, which is for spiritual purification, depend on where you meditate. If you are not at an altar, first perform the Heart Sutra Meditation (p. 152). Perform the Heart-and-Mind-Calming Mudra and Mantra. As the white ball is at the dan tien, envision the ball's color changing to red and beginning to move up to your third eye, changing hues as it goes: red-orange-yellow-green-blue-indigo-purple. As the ball turns to purple, it begins to pulsate, like a horse at a gate ready to run a race. As it pulsates at the third eye the ball again changes from purple to indigo to blue to green to yellow to orange to red. After the ball progresses finally to red, visualize the red ball encapsulating your ch'i and—acting as sort of a magic carpet—carrying your ch'i into the presence of a Buddha or statue of a Buddha or, if you choose, paradise. This is where you start the Om-Ah-Hum Purification Ritual.

If you are starting the ritual here and are standing at an altar, first recite the Heart-and-Mind-Calming Mantra, holding the Heart-and-Mind-Calming Mudra. Light a stick of incense and clasp it between your palms, with your thumb acting as a base for the incense stick.

Chant "om," extending the note and holding your palms at the top of your forehead. As you are extending that syllable, envision all the bad karma you accumulated during your past lifetimes and carried over to this lifetime being purged from you. As you exhale the syllable "ah" and move your hands to the level slightly below your mouth, visualize all the bad karma gathered during this lifetime being purified from your existence. As you utter "hum" and move your hands to the level with your heart, will that all the bad karma yet to be encountered during the future and future lifetimes will be expelled. As you say "sha" and push palms downward, envision the successful completion and purification of your karma. Pause.

Again, raise your palms to the top of your forehead and chant "om." This time visualize that all the bad karma accumulated in past, present, and future lifetimes, by wrongful physical acts, harmful and cruel actions, or crimes committed by your body are purged from your body. As you move your palms to about chin level and chant the syllable "ah," imagine all bad karma created by wrongful words you expressed during all three lifetimes being erased from your existence. Moving your palms to chest level, chant "hum" and visualize all negative karma brought on through your own heart and mind being extinguished from your past, present, and future lifetimes. Then push your palms in a downward motion and utter the syllable "sha" to reinforce your visualization and ultimately bring it to fruition.

Next, raise your palms pressed together slightly above the head and chant "om." Visualize that all bad luck and evil, unfortunate events that have plagued you through your lifetimes, whether recent or continual, are long gone, removed with the utterance "om." Lower your palms to chin level and chant "ah." Envision all physical and mental sickness leaving your body. For example, you can envision cells regenerating—new healthy cells replacing sick old ones. Imagine all vital organs—lungs, heart, kidneys, liver, intestines—functioning properly. The sickness you seek to expel could also extend to emotional problems. To bring peace and stability of mind, envision that all depression, instability, and rage are resolved and removed from your mind and heart.

When you say "hum" after moving the palms to the chest level, visualize that all bad karma or luck, wicked occurrences, and sickness now have left you, freeing your physical existence so that you have room to let in good karma and luck. The good karma includes all the good deeds you have either consciously or unconsciously performed in the past, whether in this lifetime or during a previous existence. These good deeds, and subsequent good karma, now have room to prosper, grow, and expand within you; their light will radiate outward from within your body. Finally, press your palms apart in a downward motion facing down and utter the syllable "sha," so that all your intentions are successfully realized.

• *Visualizing the Rainbow Body* •

Before commencing this visualization, which is used to improve virtue and prepare for death, assume a comfortable position. Perform the Heart-

and-Mind-Calming Mudra and Mantra. Visualize countless Buddhas, millions of Buddhas surrounding you. Imagine they are shining their brilliant light on you. This light is so strong and sacred that it envelops and purifies you. It permeates throughout your body, removing all your negative karma. You can envision the Buddha's light removing sickness from your body.

Then envision your flesh, muscles, and organs disappearing. You become completely empty; only your skeleton is left. Your skeleton is in the position you were holding at the beginning of the meditation. If you were standing, your skeleton is standing. If you were sitting, your skeleton is sitting. Visualize your skeleton a natural bone color and feel the universal light of the Buddha continuing to shine on you. Suddenly, in an instant, envision your skeletal remains turning a bright shade of molten-iron red. This bright red color gradually radiates red light outward from all parts of your skeleton. As it radiates light, imagine the light removing from you all bad karma. The red light emanates outward, so that the entire universe is bathed in red. Near and far, it is red. Then visualize your skeleton returning to its natural bone color while all around you the universe remains red.

Instantly, your skeleton becomes orange in color. The skeleton radiates an orange light to the millions of Buddhas. And as it radiates light, it again removes your bad karma. The orange light radiates outward, filling the universe. Then envision your skeleton returning to its natural bone shade, but brighter than the first phase. Your surroundings, both near and far, are bathed in orange light.

As you continue along the spectrum, and the color leaves your skeleton in each phase, envision the skeleton becoming brighter, cleaner, and purer—attaining the brilliance of sunlight.

In the third sequence, your skeleton instantaneously becomes yellow and shines a yellow light out to the Buddhas. You can envision here the auspiciousness of the Buddha's golden light. After the yellow light fills the universe and removes your bad karma, imagine your skeleton returning to a natural bone color.

In the next phase your skeleton turns green. Here you can associate the green light that radiates from your skeleton with that of spring, growth, and the Green Tara. This light removes all ill health and bad or evil events. Then your skeleton returns to a bone color as the green light remains, surrounding you.

Then visualize your skeleton aqua and radiating a blue-green light to the Buddhas and throughout the universe. As it rids you of bad karma, you can envision the assistance of the Medicine Buddha, easing physical pain or sickness. Your skeleton will return to a bone color, leaving the aqua aura in the universe.

Next imagine your skeleton becoming an indigo shade and emanating an indigo light to the Buddhas and throughout the atmosphere, removing residual bad karma. Again, the indigo light remains in the atmosphere as your skeleton returns to its natural but brighter bone color.

After your skeleton turns purple and emanates a purple light, blessing all things in the universe, your skeleton will become a color that emanates a very pure and brilliant sunlight. So your entire skeletal frame is emanating light.

At that moment, visualize that you are sitting or standing on a lotus flower that grows and envelops you. Envision that you and the Buddha are one—there is an immediate union between you and the Buddha. This Buddha or bodhisattva can be one of many—Sakyamuni, Amitabha, Green Tara, the Medicine Buddha, or Kuan Yin—and is called your "guru Buddha." The "guru Buddha" is the Buddha that, in an instant, you visualize. For example, you may feel a close attachment to one particular Buddha, such as Kuan Yin. The unity you attain with this guru Buddha underlines and symbolizes the basic Buddhist belief that each of us has a Buddha residing within us. This meditation is an exercise that helps us to recognize this identity with the Buddha and all that he or she symbolizes. (If you don't want to use the Buddha, you can imagine a god, Mary, Christ, Allah, Yahweh, or universal light.)

When you feel that you and the Buddha are one, pure and unattached to the material and sentient world of existence, you are in a sense reborn—a new you.

Complete this meditation by dedicating your light to the Buddhas, the sentient beings, your family, guru, home, etc.

Chant "om mani padme hum" nine times.

• Crystal Rainbow Body Disappearing Meditation •

This is a meditation to be performed in order to reach a higher state of spirituality. Holding the mind-calming mudra, recite the mind-calming mantra nine times. Visualize that all is quiet. Everything—fame, wealth, worries, sorrow, sickness, your own image—dissolves into a complete void.

Visualize myriad Buddhas appearing. The ceiling and the floor disappear, and the whole universe becomes a shrine.

Visualize sparks of light sparkling from the dan tien with a "tsu" sound (like the sparks from an acetylene welding torch). The sparks fill up your entire body and gush high above your head. After the "tsu" sound fades away, the sparks stop sparkling and start to fall. At the moment the sparks fall on you, your body either vanishes or turns to crystal. Repeat three times.

Visualize sparks or light sparkling from the dan tien filling up your entire body and spewing high above your head in the sky with a bright white sparkling radiance. When falling, the sparks turn into the rainbow spectrum colors: red, orange, yellow, green, blue, indigo, purple. As soon as the sparks fall on you, your body either vanishes or turns into a crystal body. Repeat nine times.

■ ■ ■

Imagine your body becoming a crystal body as well as a rainbow body that is transparent and yet radiates the light of the spectrum. In an instant, your crystal rainbow body disappears into thin air. The faster you can visualize the better. Repeat nine times.

■ ■ ■

Visualize your physical body sitting and meditating or offering incense. When you open your eyes, you are back.

■ ■ ■

Visualize an eight-petal lotus flower blooming in your heart. On the lotus flower sits a Buddha. The Buddha expands and gradually fills up your whole body. The Buddha and you become one entity. You are the Buddha, and the Buddha is you. You now possess Buddha's complete wisdom, great compassion, and infinite power.

■ ■ ■

Visualize yourself radiating light, which is the Buddha's light and shines upon:

1. Myriad Buddhas in the universe;
2. All sentient beings of the six realms of existence (liberating them from all sufferings);
3. Your spiritual teacher;

4. Your family, relatives, and friends (removing their sickness, obstacles, etc.)

5. Your house or office (cleansing all negative ch'i).

Make a wish, and chant the Six True Syllables nine times.

Appendix

生肖與掌相

ne method of determining auspicious colors is to employ the Chinese zodiac with the Five-Element Ba-gua Color Scheme. The Chinese zodiac, traditionally employed to choose spouses, partners, and auspicious dates, can also be used to determine auspicious colors for application in every area of your life. You can apply the zodiac colors to your car, your clothes, your home.

· The Chinese Zodiac ·

The Chinese zodiac consists of twelve-year cycles, made up of twelve animals. The animals also can be applied to other time spans: twelve months in a year, twelve phases in a day (two hours each).

If you find that members of your family have been born in incompatible years, put a ribbon with the animals of the Chinese zodiac applied to it under your bed.

Here is a brief synopsis of the twelve animals of the Chinese zodiac:

THE CHINESE ZODIAC

he

*Twelve Chinese Zodiac
animals are
associated with years, months, and
hours, as well as colors.
The tables on the
following pages explain specific
applications
of the Chinese Zodiac.*

■■■

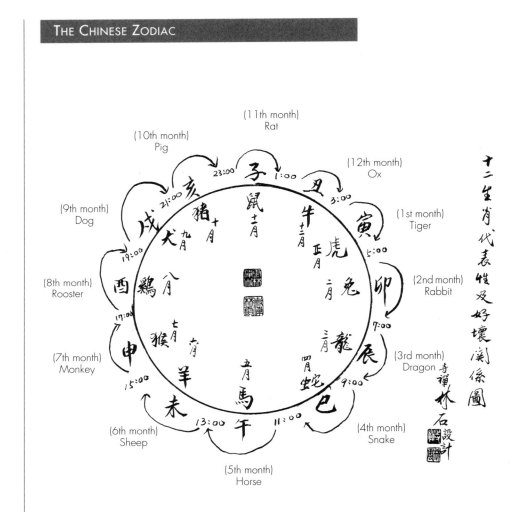

(11th month)
Rat

(10th month)
Pig

(12th month)
Ox

(9th month)
Dog

(1st month)
Tiger

(8th month)
Rooster

(2nd month)
Rabbit

(7th month)
Monkey

(3rd month)
Dragon

(6th month)
Sheep

(4th month)
Snake

(5th month)
Horse

(Note: the months are of the
Chinese lunar calendar)

						CHINESE ZODIAC COLOR CHART					
Rat	**Ox**	**Tiger**	**Rabbit**	**Dragon**	**Snake**	**Horse**	**Ram**	**Monkey**	**Cock**	**Dog**	**Pig**
1900	1901	1902	1903	1904	1905	1906	1907	1908	1909	1910	1911
1912	1913	1914	1915	1916	1917	1918	1919	1920	1921	1922	1923
1924	1925	1926	1927	1928	1929	1930	1931	1932	1933	1934	1935
1936	1937	1938	1939	1940	1941	1942	1943	1944	1945	1946	1947
1948	1949	1950	1951	1952	1953	1954	1955	1956	1957	1958	1959
1960	1961	1962	1963	1964	1965	1966	1967	1968	1969	1970	1971
1972	1973	1974	1975	1976	1977	1978	1979	1980	1981	1982	1983
1984	1985	1986	1987	1988	1989	1990	1991	1992	1993	1994	1995
black	black	black	green	blue	blue	red	brown	brown	white	white	white
	green	green	blue	green	green	pink	red	red		gray	gray
	dark green	dark green		pink	pink		pink	pink		black	black
				red	red						
				purple	purple						

The rat (1900, 1912, 1924, 1936, 1948, 1960, 1972, 1984) can be amusing, charming, honest, and meticulous. As a result, rats make good advisors, yet they have a hard time making up their minds regarding their own affairs. Rats, at times, are drawn to power and wealth, leading some to be gamblers and others to be schemers. This greed can, ultimately, lure them into a destructive trap. Color: black.

The ox (1901, 1913, 1925, 1937, 1949, 1961, 1974, 1985) is hardworking, patient, and organized. They enjoy helping others to the point of self-sacrifice. Actually, there are two different varieties of oxen. An ox born in the winter will be well tended and enjoy the help of others. At times, oxen may seem stubborn and slow, but this manner may hide an active mind. Colors: black, green, dark green.

The tiger (1902, 1914, 1926, 1938, 1950, 1962, 1974, 1986) can be a charismatic and dynamic leader. The tiger tends to be passionate, rash, and independent. Those born at night are seen as especially rotten. The Chinese avoid having children during this year, because female tigers are considered unseemingly ferocious. Colors: black, green, dark green.

The rabbit (1903, 1915, 1927, 1939, 1951, 1963, 1975, 1987) tends to be quick, clever, and ambitious, but is easily distracted. The rabbit is adept

Use this table in conjunction with the charts overleaf to determine which years and colors one should avoid when selecting a mate or color.

■ ■ ■

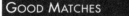

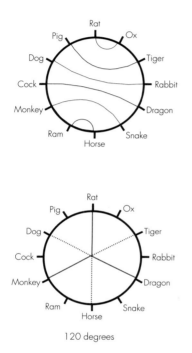

120 degrees

Used

together with the chart

on p. 167, the

diagrams above and opposite

give examples of the

compatibility and incompatibility

of certain animals,

years, and colors.

■ ■ ■

socially—tactful, calm, and sensitive to others. This calm, at times, can seem cool or aloof; the sensitivity can be thin-skinned; and the cleverness can be arch and dilettantish. The rabbit tends to be lucky: with little work, it can go far. Color: green or blue.

The dragon (1904, 1916, 1928, 1940, 1952, 1964, 1976, 1988) is a versatile creature, deemed by the Chinese to possess magical powers. It is capable of flying through the heavens or plunging to the depths of the sea. Shrewd, robust, and vital, the dragon also is intuitive, artistic, and lucky. The dragon has a dark side. It can be stubborn, hot tempered, and even aloof. The dragon has a hard time settling down. Colors: blue, green, pink, red, purple.

The snake (1905, 1917, 1929, 1941, 1953, 1965, 1977, 1989) is often called a "little dragon" and is considered a lucky year. Snakes are wise, thoughtful, and calm. They tend to be physically attractive but often fickle. Snakes easily glide into the world of fame and success, but if they are confronted in the wrong way can be selfish and venomous. The ease of success can make them lazy and self-centered. And their elegance can border on pretension. Colors: blue, green, pink, red, purple.

The horse (1906, 1918, 1930, 1942, 1954, 1966, 1978, 1990), pleasant and positive, is a very likable person. Diligent, poised, and quick, the horse early acquires power, wealth, and respect. The horse is forthcoming, but this frankness can be tactless. The horse's ambitiousness can be ruthless at times. Horses can also be stubborn. Colors: red and pink.

The ram (1907, 1919, 1931, 1943, 1955, 1967, 1979, 1991), artistic and bright, makes a good businessperson. Good-natured and selfless, he can be a bit wishy-washy. Rams may have family problems and tend to be melancholy. Colors: brown, red, and pink.

The monkey (1908, 1920, 1932, 1944, 1956, 1968, 1980, 1992) is lively, amiable, and quick-witted. Creative and bright, monkeys are good problem solvers and can be accomplished in business. Monkeys can be too smart for their own good and can be meddlesome and opportunistic. They can be lazy and sometimes don't see the forest for the trees. Colors: brown, red, and pink.

The cock (1909, 1921, 1933, 1945, 1957, 1969, 1981, 1993) is industrious, ingenious, and talented. Self-assured, the Chinese cock is courageous, not like Western chickens. Socially, cocks are charming, amusing, and lively. However,

cocks can be too cocksure, anxious, and proud, which can be off-putting to friends and loved ones. Color: white.

The dog (1910, 1922, 1934, 1946, 1958, 1970, 1982, 1994) is a loyal, honest, and courageous friend, with a deep sense of what is right. The dog is prosperous and inspires confidence, accomplishing goals quickly while at times tending toward magnanimity. Dogs can be guarded and defensive, never relaxing. Despite appearing to be low-key, the dog is always alert. Colors: white, gray, black.

The pig (1911, 1923, 1935, 1947, 1959, 1971, 1983, 1995) is sensitive, kind, and indulgent. Pigs balance their intelligence and culture with bawdiness and earthiness. At times, their indulgences can border on gluttony. This is their weakness. Matched with a trusting sweet nature, they can be taken advantage of and often cannot defend themselves. Lazy, helpless, and insecure, pigs fortunately tend to be lucky. Colors: white, gray, black.

· BTB Palmistry ·

According to the Chinese, our bodies are like road maps, indicating our past, present and future. The topography of our bodies, faces, and hands reflects and reveals our life course. Some of the bumps, color blotches, and spots on our bodies indicate medical problems, while others, such as scars and freckles, are mystical.

There are many varieties of palmistry in China. BTB palmistry is a hybrid of traditional Chinese methods mixed with the five elements and the ba-gua, with color playing an important role.

In BTB palmistry, both the left and the right hand are regarded as offering insights into our destinies. This view differs from that of traditional Chinese palmistry, which inspects a male's left hand and a female's right hand. In BTB practice, a man's left hand represents his prenatal destiny—that which was determined before his birth. His right hand reveals his present and how influences after birth, combined with his own personal development, have helped to create his life and thus alter his prenatal fate. For example, diligence, feng shui, or meditation may improve his destiny, while stubbornness, laziness, or stupidity may change his original destiny for the worse.

With women, the right hand is prenatal and the left is post-birth.

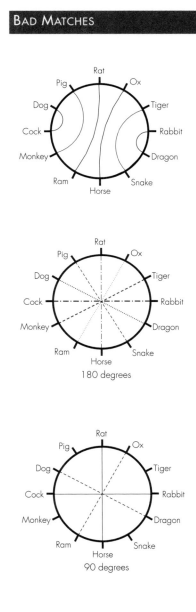

BAD MATCHES

180 degrees

90 degrees

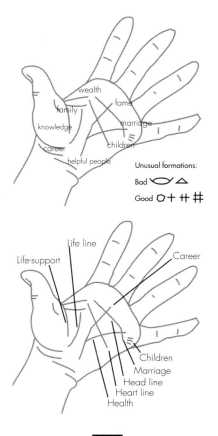

wealth
fame
family
marriage
knowledge
career
children
helpful people

Unusual formations:
Bad
Good

Life line
Life-support
Career

Children
Marriage
Head line
Heart line
Health

he palm

exhibits lines, facets, and colors

that reveal our life's course.

The Five-Element Ba-gua

Color Scheme can be

applied to a palm: formations

and lines can indicate luck

or misfortune in the

corresponding life areas.

■ ■ ■

Read the prenatal hand first. While the lines of a hand rarely deal with color, we include this information so that the reader can, if he or she pleases, use the complete BTB version of palmistry.

Read the heart line from side to center. If the heart line is very distinct and solid, emotions will be stable. If it branches out, watch out for a string of romances. A solid and long life line foretells a safe and long life with good health. Read the life line from the top (birth) down. A broken line may auger accidents, operations, or sickness. To the outer side of the life line is the life-support line. Depending on where it runs, the life-support line can prevent or lessen the effects of an accident or illness. It also represents emotional support, such as the help and patronage of others. The career line runs from the bottom up. A break indicates a career change. The health line, which branches off the career line, foretells our physical and mental well-being.

All palm lines incorporate age-specific information. For example, the heart line may bisect the career line at age thirty-five. Farther up the career line, it is bisected by the head line at age fifty-five. A break in the career line at the interval between the heart and head line may mean a career change in your forties.

FIVE-ELEMENT BA-GUA PALMISTRY

The Five-Element Ba-gua Color Scheme can also be applied in palmistry. The palm has configurations that can be interpreted as either positive or negative. Dividing the palm into the eight ba-gua areas, colors can be read as omens. A bump in the "wealth" area of your palm will indicate financial rewards. If that area is indented, then expect monetary losses. A vertical line in the "career" area of the palm may auger a promotion or a bonus, while a horizontal line may foretell a demotion or job loss. A triangle caused by bisecting lines in the "knowledge" area of your palm may bring scholarly failure, while a square configuration of lines will bring scholarly success.

There are colors or hues that you can make out if you take a toothpick and press down on an area of your palm. For example, if you make out a green line—the color of wood—when you depress the "wealth" area of your palm, you will enjoy a good income. If, however, the hue is red, which is the color of the fire that destroys wood, then your source of wealth may come to an end. If you see a hint of green at the "family" area of the palm, you will enjoy a good home life. If you see a red hue where you depress the "fame" area of the palm, you will enjoy a

good reputation. A black line in the "fame" area will indicate a tarnished name. If you make out a green tone in the "fame" area, you will also have a good name. This is because green, the color of wood, feeds red, the color of fire and fame.

Colors of your palm can indicate aspects of your personality. Manners or etiquette sit in the "fame" area. Righteousness can be found in the "children" area. Sincerity and faithfulness sit in the middle (earth) area. Wisdom lies in the "career" area. Comparison resides in the "family" position.

Colors that may appear when the palm is pressed in a specific area, as well as their mutually creative colors, indicate a presence of specific virtues in that life area. The presence of a mutually destructive color indicates an absence of a particular virtue.

The Five-Element Color Scheme can also be superimposed on our fingers. Fingers represent friends and relations. The thumb stands for parents. The pointer is siblings. The middle finger represents the self. The ring finger includes spouse and friends. The pinky represents offspring. The five-element colors are applied as follows: the thumb is green; the pointer red; the middle finger is brown or yellow; the ring finger is white; and the pinky is black. If you are experiencing problems with a relative or friend or if a loved one is ill, according to BTB, you can wear a ring of a complementary color on the finger representing that individual. For example, if one of your siblings is sick, wear a red ring or a ring set with a red stone on your pointer to reinforce the medical cure or help remind you of your sibling's problems.

Bibliography

Birren, Faber. *Color Psychology and Color Therapy*. Secaucus, N. J.: The Citadel Press, 1961.

Chang, K. C., ed. *Food in Chinese Culture*. New Haven and London: Yale University Press, 1977.

De Bary, William Theodore, ed. *Sources of Chinese Tradition*. 3 vols. New York and London: Columbia University Press, 1970.

Garrett, Valery M. *Traditional Chinese Clothing*. Hong Kong, Oxford, and New York: Oxford University Press, 1987.

von Goethe, Johann Wolfgang. *Theory of Colours*. Cambridge, Mass., and London: M.I.T. Press, 1970.

Kueppers, Harald. *The Basic Law of Color Theory*. Woodbury, New York, London, Toronto, Sydney: Barron's, 1982.

Ladau, Robert F., Brent K. Smith, and Jennifer Place. *Color in Interior Design and Architecture*. New York: Van Nostrand Reinhold, 1989.

Lancaster, Lewis, ed. *Prajnaparanita and Related Systems: Studies in Honor of Edward Conze*. Berkeley: Berkeley Buddhist Studies Series, Regents of the University of Berkeley, 1977.

Meyer, Jeffery. *Peking as a Sacred City*. South Pasadena, Calif.: E. Langstaff, 1976.

Plopper, Clifford H. *Chinese Religion Seen Through the Proverbs*. New York: Paragon, Reprint, 1969.

Rossbach, Sarah. *Feng Shui: The Chinese Art of Placement*. New York: E. P. Dutton, 1983.

———. *Interior Design with Feng Shui*. New York: E. P. Dutton, 1987.

Rowley, George. *Principles of Chinese Painting*. Princeton, N.J.: Princeton University Press, 1959.

Saso, Michael. *Taoism and the Rite of Cosmic Renewal*. Pullman, Wash:. Washington State University Press, 1972.

Scott, A. C. *An Introduction to the Chinese Theatre*. Singapore: Donald Moore, 1958.

———. *Chinese Costume in Transition*. New York: Theatre Arts Books, 1960.

Smith, Lauren, and Rose Gilbert. *Your Colors at Home*. Washington, DC: Acropolis Books, Ltd., 1985.

Sze, Mai-mai, trans. and ed. *Mustard Seed Garden Manual of Painting*. Princeton, N.J.: Bollingen Series, Princeton University Press, 1963.

Wallnofer, Heinrich, and Anna von Rottauscher. *Chinese Folk Medicine*. New York: Signet Books, 1972.

Zhou, Xun, and Chunming Gao. *5000 Years of Chinese Costumes*. San Francisco: Chinese Books and Periodicals, Inc., 1987.

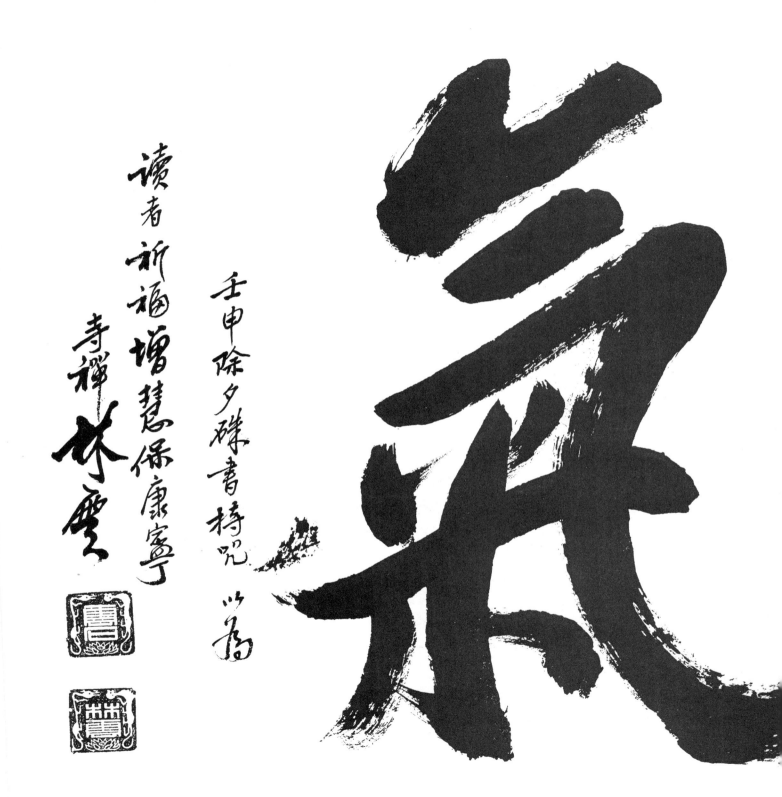

義

讀者祈福增慧保康寧

壬申除夕礫書持呪以為

寺禪林雲

人要生氣你你不氣

你若生氣中他計

不氣不氣不能氣

氣壞身體沒人替

■

"Ch'i"

"Don't become angry if someone irritates you.

Don't be caught in their trap.

You should never be angry, because

anger affects your well-being.

And if anger takes over, who can take your place?"

■

 in Yun

wrote this in cinnabar powder.

As he did so, he chanted a mantra

to wish all readers of this book

blessedness, wisdom, health, and peace.

■ ■ ■